Freedom in the Wilds

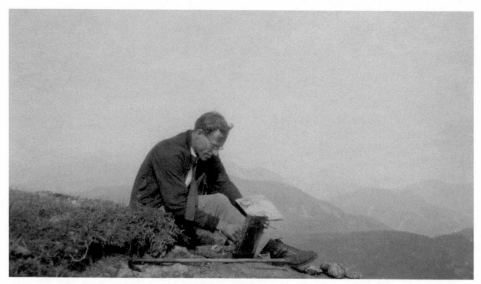

1. Harold Weston sketching on Mount Marcy, 1922. Photograph by Esther Weston King. Harold Weston Foundation.

FREEDOM
IN THE WILDS

An Artist in the Adirondacks

THIRD EDITION

HAROLD WESTON

Edited and with an Introduction by Rebecca Foster

SYRACUSE UNIVERSITY PRESS

08 09 10 11 12 13 6 5 4 3 2 1

The paper used in this publication meets the minimum requirements of
American National Standard for Information Sciences—Permanence of
Paper for Printed Library Materials, ANSI Z39.48–1984.∞™

For a listing of books published and distributed by Syracuse University Press,
visit our Web site at SyracuseUniversityPress.syr.edu.

ISBN 13: 978-0-8156-0899-8
ISBN 10: 0-8156-0899-3

Library of Congress Cataloging-in-Publication Data
Weston, Harold, 1894–1972.
Freedom in the wilds: an artists in the adirondacks/Harold Weston ;
edited and with an Introduction by Rebecca Foster.— 3rd ed.
p. cm.
Includes bibliographical references and index.
ISBN 978-0-8156-0899-8 (hardcover : alk. paper) 1. Adirondack
Mountains (N.Y.) 1. Foster, Rebecca. II. Title.
F127.A2W43 2008
974.7'5043—dc22
22007046116

Manufactured in the United States of America

To our grandchildren,

and to those of their generation who welcome opportunities to maintain forever wild and uncontaminated areas of freedom within themselves as well as in the fast-diminishing wilderness tracts throughout the nation.

Contents

Illustrations

Color Plates

Preface

I HAVE BEEN A DEVOTEE of the dews of the wilderness since childhood, and do not pretend to be without strong prejudices on its behalf. This saga reflects the memories, experiences, and reactions of only one man, an artist, during large portions of a lifetime in a limited neck of the woods. A major thrust of my intent is to emphasize nature's power to stir and sustain the spirit whether among the mountains or by the sea, and to demonstrate that long observation of the ways of the wilds, of the clouds and the sun and the moon can stimulate greater appreciation of the potential vastness, varieties, and intimacies of life for each one of us whatever our immediate surroundings may be.

One of the rich rewards of a wilderness tract is the disorderly order that the laws of nature produce with infinite variations. The complex confusion of a mass of fallen timber or a wind-blown collection of autumn leaves contain interrelated spatial units, form movements, and color sequences that result in both dissonances and harmonies that seem totally accidental but give forth vibrations akin to those of which beauty is composed. It is precisely the rich profligacy and conflicts of untamed nature, simultaneous decay, and tempestuous regrowth doomed to die that infuriate the academically trained foresters. I say, let them manage their impeccable little "Black Forests" outside the Blue Lines established for the Adirondack Forest Preserve, and leave the wilderness areas alone.[1]

The quiet ripples that Henry David Thoreau stirred up on Walden Pond are still expanding. Something about them speaks to the condition of American youth today in the quest for new values and revised priorities. Thoreau's experiment and to a degree his stance about rules and regulations have encouraged youth communes and spurred the determination to escape from the gilded cages of suburbia and seek more direct contacts with nature and the wilds. My own motivations for living as a recluse were different. Building

a studio at St. Huberts, New York, in 1920 seemed a viable way to pursue my career as a painter. I have had great fun digging up and reexamining these half-forgotten nuggets from my past, and I must foreswear the temptation to give advice to those youthful adventurers who should be free to find their own way up to summits or across deceptive swamps. Oncoming generations may wish to discard old-fashioned guidelines and traditionally structured routes in order to search for new dimensions in the vast wilderness of life, bushwhacking in their own turn.

It is my hope that this chronicle, based on my long association with and love of the High Peaks area of the Adirondacks, will add a note of urgent warning to other voices past and present calling for protection of virginal tracts in the Adirondacks that have not yet been raped by commercial interests. And, even more important, I hope this book will help recruit support for strenuous efforts to reestablish an uncontaminated environment on this good earth.

<div align="right">

Harold Weston
February 14, 1971

</div>

Acknowledgments
to the First Edition

I WISH TO EXPRESS my gratitude to the many friends and relatives who helped me gather the material for this book and to all those who generously contributed to the fund that made its publication possible. My special thanks are extended to William P. Dunham and the directors of the Adirondack Trail Improvement Society (ATIS) for allowing this endeavor to be carried out under its auspices; Carolyn Payne King for serving as secretary of the book committee; and Henry U. Harris and Morgan K. Smith, past presidents of the Adirondack Mountain Reserve-Ausable Club, for encouraging me to undertake this intriguing task.

Beyond all, I wish to thank my wife, Faith Borton Weston, whose devotion has made possible the life we have led at the edge of the forest these past forty-eight years, who has endured the hardships and shared in the rewards of primitive living, and who has given constant assistance in the writing of this saga of the wilderness.

Harold Weston

Acknowledgments
to the Third Edition

WESTON KNEW how to torment an editor: Cobble together a manuscript and go to print without one citation, one note, or one permission, and yet make it so good that there would have to be another edition. The challenges of the revision compelled me to rely on a large number of people for their esoteric knowledge. I must begin with Pat Galeski at the Keene Valley Library Archives, who dug and pondered and dug some more to come up with answers to my obscure questions. I am also indebted to the archive volunteers—Nina Lewis Allen, Louise Gregg, Dorothy Irving, Nona LeClaire, Mary Hope Mason, and especially Nancy Lee, who took a personal interest in the project. Relie Bolton, Courtney Iglehart, Carolyn Payne King, Brett Lawrence, Bobbie Neilson, and Bill O'Connor shared nearly lost pieces of history that made their way into the book. Tony Goodwin was an indispensable source for ATIS history and for wisdom about the Adirondacks' contemporary woods and wilds.

A book by and about an artist would be nothing without paintings. I am delighted that so many private collectors, as well as the Phillips Collection and the Fogg Art Museum, wished to lend paintings for reproduction. For their photographic treasures, thanks to the Harold Weston Foundation, the Keene Valley Library Archives, and the Archives of American Art of the Smithsonian Institution. I am grateful for George Adams's invaluable photographic help and constant attentive interest. Many thanks to the ATIS directors for transferring the book's copyright to the Harold Weston Foundation, and in turn to the foundation for subsidizing the book's illustrations.

Jim Goodwin, Old Man of the Mountains, long ago encouraged me to create a revised edition of *Freedom in the Wilds.* Its publication would not have been realized, however, without the enthusiasm of Mary Selden

Evans, executive editor of Syracuse University Press. I am grateful for her appreciation of Weston both as an artist and as a raconteur, and to the press for taking on Weston again so soon after *Wild Exuberance: Harold Weston's Adirondack Art* (2005).

For their inexhaustible fascination with and support of All Things Weston, my everlasting thanks to Nina and Esty Foster, who never flinched when asked for one more box of letters, one more photograph unearthed, or one more recollection. To Hart for sweet exuberance, to Sevi for gentle perceptions, and to Kevin for loyalty to the essential, I give thanks.

Rebecca Foster

Introduction

Rebecca Foster

[The Adirondacks] is where I belong. No where else is my home.
—Harold Weston, draft of *Freedom in the Wilds:*
A Saga of the Adirondacks

HAROLD WESTON PLACED this quotation prominently at the conclusion of a draft of *Freedom in the Wilds.* In the end he omitted it, because upon scrutiny it did not tell the full story of his life. He was at home as an adventurer on the Persian plains teeming with bandits, and he was at home running board meetings of headstrong New York City artists who were trying to change the government's attitude toward the arts. His deep-rooted ideology of service and leadership even led him to the nation's capital as a high-powered negotiator for global famine relief. He was at ease experimenting in art and personal relationships in France in the 1920s and in Greenwich Village in the 1930s. To each of these life episodes he brought such full-bodied intensity that he might have argued his home was anywhere he had been.

Yet the Adirondacks in northern New York State provided the narrative through-line of Weston's varied life. No sooner did his grandfather, Charles Hartshorne, arrive to the Keene Valley area in the nineteenth century than he participated in one of the nation's first private conservation efforts: the purchase of a vast tract of wilderness land comprising many of the High Peaks, called the Adirondack Mountain Reserve (AMR). Long summers in the High Peaks impressed the rhythms of the woods upon young Harold Weston, and he lived by the belief that the untouched wilderness was a moral good. Spirituality in nature guided his painting, and the Adirondack mountains, lakes, and forests became his artistic "home,"

as well as the place where he would spend more than twenty winters and sixty summers.

In 1969 Weston was urged by summer residents of St. Huberts, New York, to write a "substantial brochure" about the history of the AMR.[1] Increasingly excited about the project, he expanded it into a fully illustrated book that would soon become a classic. Thirty-seven years after the publication of *Freedom in the Wilds: A Saga of the Adirondacks,* the most compelling aspect of the book is no longer its broad, original "saga," but that which insistently found its way into the telling: his personal story. This revised edition is still a history of the High Peaks region, after a fashion, but I have brought Weston's stories to the fore and eliminated much of the history to which he did not bring a distinctive point of view. Ironically, the general is discovered through the specific: Narrowing the focus to one man and his artistic responses to the place he loved makes the book less bound to time and place—it is the universal story of a creative mind.

As the book grew, Weston inserted new segments with no regard to organization other than chronology. "My desire is to work out a sort of rhythm of pace," he wrote to Page Edwards, who courageously volunteered to edit the book. But, he confessed of its eighty-nine subsections, "this is really not possible." He openly called it "a shot-gun approach in assembling this chronicle."[2] Warm, witty, and richly anecdotal it is indeed—and disjointed. I have reorganized the book so that it is more thematic. The author's animated and reverent voice is untouched, however, and apocryphal tales, such as the Doe's Baked Bean, stay, emphatically. Like collecting luxuriant moss from the north side of trees, I found new material in Weston's tape recordings and writings that I used to chink crevices and cracks in the book. For a man whose mantra was the toppling of outmoded conventions, Weston nevertheless may have been ambivalent about the revision of his own work. Carolyn Payne King became enthralled with Weston's creativity, humor, and fund of knowledge when as a young woman she helped type the manuscript. She warned me: "I have a feeling he wouldn't want you to touch it."[3] With such a commanding personality as Weston's—even from beyond the Big Mountain in the sky—an overhaul could be done only at a safe, posthumous distance.

The controlling side of Weston's personality was leavened by a bohemian sensibility. He sympathized with the hippies so culturally prominent

at the time he wrote *Freedom in the Wilds,* giving their search for personal freedom a nod or two in its pages. As a young man following an artistic calling he felt the burden of Edwardian rigidity and judged his intellectualism and Harvard education an affliction to be overcome. "I wish I could be more child-like in my attitude towards things, less analytic, calculating, self-conscious," he pined.[4] Life in the woods, which he chose in 1920 when he built his studio in St. Huberts, brought him close to his instinct, to his inner wilderness. Weston frankly admitted that in a land of rugged lumbermen and hunters he was an anomaly. Nobody could quite figure out what he was doing there, with one leg paralyzed from polio, in a place where survival depended in no small measure on physical ability. With a passion for paint more powerful than common sense he stayed on mountaintops past sunset, hobbling back down on his good leg in the dark. The wilds were not an abstract metaphor for him, but a living presence through which to attain the freedom to create.

Weston hoped the book's environmental message would galvanize a love of the wilds and lead readers to advocate on its behalf. "We rarely stop to consider how few places on any continent with good soil, plenty of water and a moderate climate are left more or less untouched by man," he wrote in a draft.[5] He made the case for protecting the wilderness—and the very idea of wildness—as a spur to human consciousness and creative possibility in a world too often bent on its suppression. Weston's entreaty to preserve an area of inner "forever wild" accounts in part for the popularity of the book. Readers long to live some of the Westons' life for its romanticism. "I envy you the wonderful full life you and Mrs. Weston have been able to enjoy in the Adirondacks," wrote R. Stewart Kilborne, former conservation commissioner for New York State.[6] A remote life at the edge of the wilderness was hardly possible by the time Weston wrote the book, and it is even less so today. The book fulfills a nostalgia for an unrepeatable past, and makes his conservation plea for the remaining wilderness all the more poignant. At the time of publication in 1971 the public's environmental understanding was just emerging. With great cheer Weston clipped and saved a 1972 editorial from the *New York Times* that read in part, "the sudden emergence of the environment as a high-priority public concern constitutes one of the great forces of change of our time."[7] Paul Brooks ventured that *Freedom in the Wilds* would play a role and "help to preserve the country [Weston] loves." Acclaim from Brooks, a

"well calloused" editor-in-chief of Houghton Mifflin "known for his dour criticism," was hard won. He called the book "a stunning demonstration that true appreciation of wilderness is a creative act, whether it be expressed in words or in paint. Harold Weston has command of both. And like Thoreau, he has achieved a broad margin to his life."[8]

Through the years critics compared Weston to large characters in history, including Rudyard Kipling, Vincent van Gogh, and Henry David Thoreau. Perhaps the most touching appraisal of his book came from Helen Appleton Read, the art critic, art historian, and gallery owner born in 1897 who first went to the Adirondacks as a child with her sister. "Your paintings are an integral and essential part of your book—not just in themselves as works of art but because they give us the artist's creative reaction to his experience of the Adirondack. I like the Thoreausque simplicity of your style and your philosophy. Yes, my sister and I feel that you are the Thoreau of the Adirondack."[9] Weston did not advance new philosophical ideas about humans and nature. His unique contribution was in living with a keen awareness of his intimacy with the wilderness, and translating that exhilarating relationship into paint. His interpretation of the Adirondack High Peaks is rich, varied, and personal. "Others would be lost following his trail," one critic wrote in 1925, calling Weston a "stray poet." "Like Blake he will find a small number of kindred natures whose emotions toward nature spring from similar sources."[10] As it happened, more than a small number followed Weston's trail, and yet the point of his singularity as an artist is well taken. With a continually evolving style, he is not easily understood. And the very fact that he was at home as an activist working for the public good even as he was fully actualized as an artist working in seclusion is not only rare, but adds to the significance of his contributions in both areas.

Most of Weston's papers have gone to manuscript collections at the Smithsonian Institute, Syracuse University, and the Library of Congress (see bibliography), but the family held onto his diaries and much of his correspondence. His wife, Faith, carefully bundled the letters in string and stored them in old suitcases for some purpose not quite articulated. For this edition of the book I have added a section with excerpts from those youthful letters and diaries, now held by the Harold Weston Foundation, to give insight to the growth of his ideas about art and nature that relate most to the mature man who would write *Freedom in the Wilds*.

Youth can be enlightening—and insufferable. As in most things, the raw and turbulent phase of working out one's ideas is infinitely more captivating than the certitude and confidence that often come with success. By analogy, in 1921 Weston wrote to a friend about the process of painting:

> The happiest days are when you start with throbbing enthusiasm. To finish a painting has some of the sadness together with some of the properly proud dignity of completing a well-rounded life. I am as yet at a stage when I want to keep my children naïf and curly-haired. I hate to see them grow up with the straightened looks of dogmatic assertion and express limited idiosyncrasies of character.[11]

It turned out that Weston's ability to sustain a high pitch of enthusiasm was a lifelong skill and consequently his paintings rarely lack the idiosyncratic quality born of an eager yearning that he prized. Even so, his thoughts were never more rapid and tumultuous as in the few years before he married at age twenty-nine. His earnestness might become unbearable but for his humility and sharp self-criticism. The self-indulgence we see on glorious display is an heirloom variety that is not merely about self, fortunately, but about what that self can do in the world. "Too many people are inclined just to enjoy being what they are," he groused in the 1950s. "The world cries out for people who will do something to help solve some of the world's present difficulties."[12] *Freedom in the Wilds* stands as an icon of what it means to be free and yet take responsibility, especially for the wilderness that gives rise to that very freedom.

This book is also a love story. Weston's writing was enriched by falling in love with Faith Borton and by her resistance to his almost overpowering courtship, primarily conducted through letters. Her reluctance inadvertently forced him to justify his profession and his ascetic life in the wilderness. Daring to ask her to share in the uncertainty of his livelihood and the discomforts of his living arrangements required a prolific outpouring, of which only a small portion is included here. Serendipitously, Weston got a kick out of writing letters, felt an urgent need to share his thoughts, and did so with colorful detail, assuming all the while that the recipient would be as engrossed in his emotional states as he was. I remember Esther Weston King, his sister, telling me that her poor brother Carl in spite of his brilliant legal mind never wrote an interesting letter in his life. Harold, she said, could write a page-turner about eating a sandwich.

In contrast to the wiser, more judicious voice used in *Freedom in the Wilds,* the writing excerpts give us Weston's direct, unpremeditated, hasty, and impassioned voice—the voice that would have said he belonged in the Adirondacks, "no where else."

Brooklyn, New York
June 21, 2007

Freedom in the Wilds

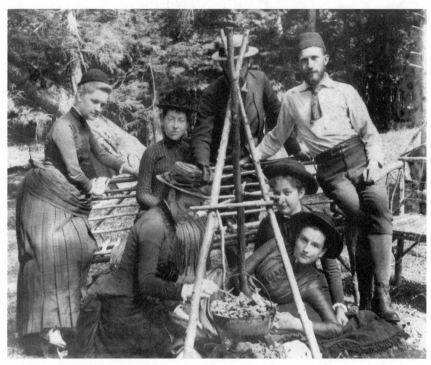

2. An Adirondack smudge pot that was used at St. Huberts in 1886. The young
man at the right in knee-breeches and Turkish fez is the author's father, S. Burns
Weston. Courtesy of the Archives of American Art, Smithsonian Institution.

1

The Art of the Adirondack Smudge Pot

THE FOREST FLOOR in a wilderness area often appears cluttered with disorder and profusion. If my saga similarly seems to permit confusing new thoughts to crop up where they do not belong, only to die for lack of growing room or proper soil, my claim is that in selecting from the vast accumulation of impressions about an area and epoch I have known so well, I feel it is best to be guided, as an artist almost always is, by impulse and instinct rather than by reason or intellect. In a sense it might be said that I have written this book in the spirit of tending a smudge pot. These self-contained happenings, histories, and anecdotes succeed one another, each trying to make the most of its brief moment of incandescence. So let me begin by heralding the Adirondack smudge pot. Readers can see which way the smoke is drifting and dodge around, the better to savor their favorite aromas of the wilds.

During several decades before and after the turn of the twentieth century, every cottage porch, every cabin clearing, focused on a center of activity more obsessively than suburbanites do today on the charcoal broiler in the backyard. The product from each smudge pot had individuality. Its quality, quantity, and effectiveness in banishing (momentarily, at least) the no-see-ums, midges, black flies, mosquitoes, and other unwanted guests depended directly on the degree to which the operator had mastered the art of the smudge pot.

Superficially, the smudge was a simple instrument to play upon—a tripod, fashioned without set rules, consisting of three slender saplings, crisscrossed and fastened together near the upper end. A chain or wire suspended a two-quart pail, or an iron cauldron for those who took the art seriously, a foot above the ground. From the bowels of the pot poured forth a gamut of aromas as varied as a piano's notes, delicate scents with innuendos of

3

imminent invasion of aphrodisiac incense, heavy acrid stenches that might have risen from a burning garbage dump. Provided the player had properly prepared the ingredients and possessed the manipulative skill to smoke out the potentials, all ranges of odor from the most malodorous to the most seductive were subject to the whim of the smudge-pot player.

The nature of the kindling or the active base for the smudge-pot fire was not complex, although using dried cedar or balsam bough ends as a starter added a definite *je ne sais quoi* quality to the brew. The crux of this art was what you put into the pot after a tidy little fire was burning, how much you put in and kept at what temperature, and finally whether in the process you were able to keep your pot fire from going out. Some choice ingredients included green sweet grass, wet straw, mildewed leaves or compost, dried fungi or dampened mosses, and a whole slew of other forest products, each with its own cachet in the smoke world, each with its physical and psychological consequences noted and esteemed. If you wanted to break up a dull gathering, the formula was crude and effective. If you wanted your companion to relax and be friendly, the practiced hand knew just what to slip into the cauldron to produce a change of mood.

Smudge potting was essentially but not exclusively a manly sport, its rich barnyard pungency making it suitable only for the great outdoors. In the parlor or boudoir, ladies of the house made a custom of lighting josh sticks with almost ceremonial ritual. This sisterly counterpart of the stalwart smudge was a long stem of wood as slender as a stalk of marsh grass with a six-inch narrow stamen like a miniature, elongated cattail that glowed red at the tip as it slowly smoldered. The fragrance suggested dried dung laced with oriental spices. Alas, using this instrument was as dull as playing variations on a whistle with only a single note, and a muted one at that.

We condemn youth today for smoking grass, but in a subtler way their country forebears knew how to ward off pests and at the same time produce kicks and influence people by playing the old smudge pot. They were happily oblivious to the air pollution these hundreds of smoking smudge pots caused and even set them up, as Winslow Homer has recorded, when camping in the wilds. It was not easy to take them along when climbing or fishing. For such times, the woodsman smeared himself to the gills with a noxious ointment made of tar mixed with rancid bear's grease that was reasonably effective for a while if the wearer wanted to be left strictly alone.

The use and the art of the smudge pot, however, is a thing of the past. We have succumbed to a day of insecticides and competitive varieties of bug dope, sprays, grease sticks, and foams. With drier summers than in the past and more people to feed upon, the bug problem, like so many other things, "ain't what it used to be" in the Adirondacks. Of course, if you want to tempt Providence and work in the garden on a muggy day or fish on a rainy evening or leave a screened window open after dark with the lights on, well, then, you'll surely get your comeuppance.

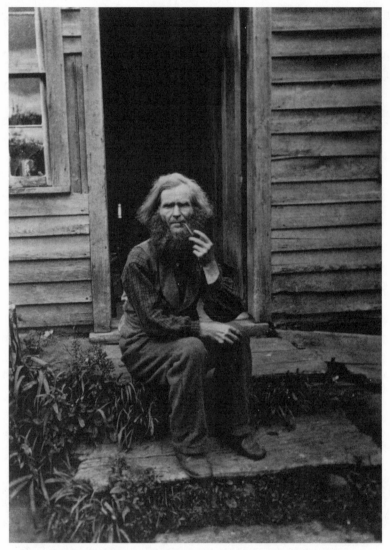

3. Orson S. Phelps, Adirondack guide, c. 1890. Photograph by George
W. Baldwin. Courtesy of The Adirondack Museum.

2

People

Early Settlers and Guides

MANY A YARN has been told around a smoldering smudge pot, especially about the first people to come to the Adirondack mountains. Most stories have been proven wrong, but it seems safe to say that small bands of Native American hunters and fishermen migrated seasonally in the Adirondacks along with the game that provided their food. They left almost no evidence of their passing through the forest, but they did settle in and cultivate the surrounding river valleys.

Of the early European American hunters and trappers who came to the vast stretches of the Adirondacks' unexplored wilderness in the eighteenth century, many became settlers and a few lived in the woods as hermits, appearing twice a year in towns to sell furs, buy a few staple supplies, and have a ball. These few adventurous pioneers got along well with the Native Americans from whom they acquired knowledge of the woods, of where to hunt and trap, and how to endure the severe winters. After the War of 1812 veterans were given tracts of land in upstate New York provided they cleared some of the forest for farming, thus providing a kind of resident garrison on the frontier.

The first generation of white hunters and trappers passed along to its children not only what it had acquired of expertise of the wilds and knowledge of terrain but, more important, its love and philosophy of the wilderness. Many of the boys became renowned Adirondack guides. Considerable public interest in the Adirondacks was aroused in the mid-nineteenth century by tales of abundant trout and game, which circulated among urban sportsmen who soon competed for the most famous of these guides. The 1881 edition of Wallace's *Guide to the Adirondacks* listed 546 guides.[1] Lumbering had been the major industry of the Adirondacks, but in the High Peaks it started to

7

give way to catering to summer residents and tourists. Attracting people to the area depended in good measure on the preservation of the forests.

At least twelve of the local guides built camps on the Upper Ausable Lake in the High Peaks region. They owned their own guide boats, which they often made themselves out of very light virgin cedar or pine. The boats had to be light enough to carry back and forth between lakes. It seems hard to believe unless you have seen it, but the fibers of this virgin wood, particularly the cedar, were so close-knit and resilient that the blade of a hunting knife could be thrust through the bottom of the boat and, when withdrawn, the fibers would spring back and the boat would not leak a drop.

The guides' camps were primitive, often just a lean-to, sometimes a small closed kitchen, where certain supplies would be safe from animals, and a covered porch for a dining room. The roofs, originally made of sheets of birch bark or overlapping broad curved slabs of spruce bark, were usually leaky. No thought was given to sanitary arrangements, and the early camps were poorly maintained. In her *Recollections,* Eleanor Alderson Janeway dramatized the limited cooking equipment of these camps. One morning she was taking her time using a tin washbasin when John Brown, at whose camp she was staying, was lingering near her. He became impatient and asked to have the basin. "Why?" Eleanor asked. "Well, I'd just like to beat up them flapjacks when you're through."[2] Guides entertained the summer guests around the campfire with their stories. When I was a youth, Mel Trumbull told colorful Civil War tales about saving the day against the Confederates as a bugle boy while pointing out the place where a bullet was still lodged in his body.[3]

Old Mountain Phelps became the most famous of the guides in the High Peaks, partly due to eccentricities of character and appearances and partly due to stories about him by Charles Dudley Warner, who wrote humorous anecdotes about the region. Phelps boasted that "Soap is a thing that I hain't no kinder use for." His clothes gave the impression of having grown on him like bark on a tree. But, more than any other Adirondack guide, Phelps had a passionate love for the mountains, for wilderness and its "scenery." Historian Alfred L. Donaldson commented about Phelps:

He brought a strange temperance to bear on his enjoyment of nature. He once led Mr. Warner and some others to the Upper Ausable Lake, near which rise the uniquely beautiful Gothics. The party wished to camp on the south side of the lake, which would give them a constant

view of the mountains. But Phelps objected, much to their surprise, and urged the north shore, which did not command the desired view. The pros and cons were debated, and finally Phelps drawled out: "Waal, now, them Gothics ain't the kinder scenery yer want ter hog down!"[4]

The guides established a Keene Valley Guide Association sometime before 1890 that drew up regulations for qualifications necessary to be a guide, including the ability to cook. Curiously, there was no provision that guides must know how to swim, although much of their work was done in boats or canoes. A tragic result of this omission was the drowning one windy day in 1913 of James Owens, one of the most popular guides. He was later found on the bottom of the Lower Ausable Lake, clinging to a big camp basket full of canned goods.

Encouraged by the Keene Valley Guide Association, the town built a cycle path alongside the winding dirt road from St. Huberts to Keene Valley, three miles to the north, and kept it much smoother than the road. Cycling was so popular that a Keene Valley Bicycle Association was formed in 1897. One used to see guides with big camp baskets on their backs pedaling from the valley to the foot of the steep St. Huberts hill, which did not have a bicycle path. Coming back from the Lower Lake on the three-and-a-half-mile Lake Road, many guides could coast all the way from the lake to the tollgate at the edge of the forest, pedaling only a short spurt at the one-mile hill. Hikers, hearing the guides' bicycle bells ringing, leapt hastily out of the road as the guides sped by. Keene Valley was proud of its progress, for nowhere else did Adirondack guides adopt the wheel as a means of rapid transit. By the mid-twentieth century, however, every guide had his pickup truck or Jeep.

The Doe's Baked Bean

Some guides take an annual week off in the woods hunting with a few buddies. Generally women, even those who have won the town turkey shoots, are excluded from these parties. The one constant complaint among the men is being camp cook. The story is told about _____, who was well overweight and lazy except when hunting season came around. Then, each year, he got in trim with a little—just a little—conditioning. A group of seven friends regularly composed the hunting party of which he was a member. The previous year, in spite of drawing straws for their respective turns as chief

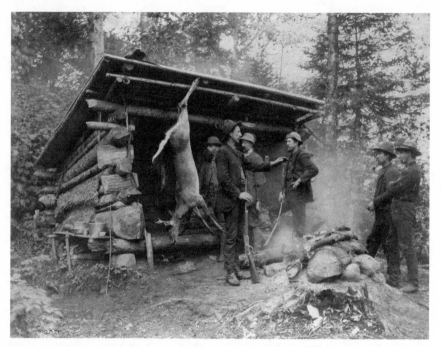

4. Beede's Camp, Upper Ausable Lake, 1886. The man standing half inside the lean-to nearest the buck is Charles Alderson. His friend, William G. Neilson, did not like to be photographed. At a similar spot the idea of saving the forests in this area was conceived. The primitive lavatory arrangements can be seen to the left of the lean-to. Courtesy of Edward Janeway and the Archives, Keene Valley Library Association.

cook and bottle-washer—for bottles did figure and at times even had to be rationed—there were so many complaints about the food, how it was or was not cooked, and griping about having to get back to camp early to do this job anyway, that they all made a solemn pledge for the next year that whoever made any complaint at all would have to cook for the rest of the week.

As any seasoned hunter knows, the first night at camp is always a bit disorganized. Three of the men went out to get some "camp meat" (usually doe); a few cut camp wood; others repaired the roof, put away provisions, and tidied up the place after the winter. By the time the camp meat was dragged to camp, darkness had set in and the meal had to be prepared in a hurry. Before long the men were seated on logs around the fire enjoying their first venison of the season. Suddenly our overweight friend held up his

fork to the light. "What's this? I didn't know we were having baked beans tonight!" Then, as his eyes caught the look on the faces of his comrades, he paled and quickly added, "That ain't kickin'—I love 'em!" and gulped down the doe's bean.[5]

Summer Guests

More and more of the settlers found it profitable to take in boarders. By 1881, in the town of Keene Valley and the hamlet of St. Huberts, there were fifteen boarding houses that advertised accommodations for a total of 513 guests! Of these, the largest was the Beede House at St. Huberts. Similar resorts were springing up all over the main settlements in the Adirondacks, and these became the summer homes of untold thousands. Teachers, writers, and philosophers, several of them friends of Ralph Waldo Emerson or Mark Twain, came to the area. The most noted were William James, Felix Adler, and Thomas Davidson (all of whom brought followers or disciples), as well as Charles Dudley Warner. These professionals had long vacations and, once the arduous journey was made, usually stayed for two or three months. Summer visitors were not tourists, as we think of transients today. These boarders were a major factor in the local economy—just as property-owning summer residents are now.

A number of prominent artists came to admire the region's forests, streams, lakes, and mountains, and through their work made the public aware of the area's beauty. Among the best-known artists were Asher B. Durand, William Trost Richards, Winslow Homer, and Alexander H. Wyant. For a while there were twenty-one painters working in Keene Valley.[6] A few, such as Roswell Morse Shurtleff, built studios and took up summer residence for the rest of their lives. In 1869, Wyant stayed in David Hale's barn at St. Huberts because the farmhouse was packed full of summer boarders. Wyant engaged the guide Mel Trumbull to camp with him for ten days near the ledges on Noonmark Mountain. Wyant did a painting of the mountains across the valley. As he worked on the canvas, he realized that the two major humps of the range looked like the jaws of a wolf, so he named them Wolf Jaws, and the name has become official.

Many of the mountains, only a few of which had trails, were climbed and named for the first time during the mid-nineteenth century. The Upper Lake

was a favorite starting point for Mount Marcy and Mount Haystack. When Old Mountain Phelps was climbing Marcy with some others in 1849, they first went over Haystack. Phelps remarked, "That mountain is a great stack of rock," and then added, "It resembles a stack of hay." So he said it should be called "Haystack." A few years later, around 1852, Phelps was sitting on the top of Marcy with Frederick S. Perkins, one of the first artists to visit Keene. Together they suggested the names for the mountains "Skylight," "Basin," "Saddleback," and "Gothics."

Verplanck Colvin

Maps had been drawn of the main mountain ranges in the Adirondacks and other features such as lakes and rivers, but these were far from accurate, being based on calculations without precise instruments or on verbal accounts or rough drawings by hunters or guides. The Adirondack Survey was initiated by New York State in 1872 under the direction of Verplanck Colvin, who was dismayed by the "monstrous errors" and "glaring mistakes" on the old maps.[7] He brought to the task tremendous enthusiasm, showed superhuman energy in overcoming obstacles, wrote voluminous reports, made numerous on-the-spot sketches, and prepared the ground for accurate maps. He was a severe taskmaster but one who never asked others to suffer hardships or take risks that he was unwilling to undergo. He was arrogant and made enemies, but when the legislature granted inadequate funds some years, Colvin supplemented them from his own pocket.

The last quarter of the nineteenth century has been called the Colvin Period. He not only established the height of the most important mountains and located or adjusted essential boundary lines, but he also, more than any other individual, first pointed out the main arguments still used today for a state park. These are: conservation of water supply, prevention of erosion, preservation of the forests, the beauty of the wilderness, and the benefits of an uncontaminated environment. He helped open the Adirondacks to the public by laying out trails. He largely initiated the idea of a state forest preserve and promoted the concept of an Adirondack park. How active Colvin was in efforts to include the "forever wild" principle in the state constitution I have not discovered. In any case, one can reasonably claim he was either father or godfather to that important concept.[8]

Colvin's life work, which he never completed, was the preparation of an outline map of the great northern wilderness of New York State. Township and boundary lines were obscure. Corner stakes had rotted away or were hidden by windfalls so that the land owned by the state was not at all clearly marked. Using this excuse, every year the state was robbed of several thousand dollars' worth of timber, rather obviously taken by lumbermen. Colvin conducted a courageous attack through the years against these timber thieves who, in revenge, were partly responsible for a widespread campaign against him. This hampered his work, and by 1900 he was forced to resign before the work he had set out to do was done. Even if he had finished his map, his methods were less accurate than the geodetic survey conducted by the state in 1891–92, and in turn many inaccuracies in these were revealed by the far more precise method of basing maps on overlapping photographs from airplanes. In view of the obstacles Colvin had to overcome, it is amazing how nearly right he was in most of his calculations.

The difficulties of accurate measurement of a mountain's height are illustrated in Colvin's *Seventh Annual Report on the Progress of the Topographical Survey of the Adirondack Region of New York,* published in 1880. In 1875 he established the exact height of Marcy by extending "a line of datums from Westport-on-Lake-Champlain, forty miles backwards into the Wilderness to the summit of Mount Marcy." He continued:

> The leveling party was out early at its work, being still on the muddy trail below the Lower Lake. Taking one guide I made a reconnaissance down the river as far as a beaver meadow, where a low notch was known to extend to the trail, and it was thought might enable us to avoid ascending a high ridge. . . . Concluded that it was best to continue along the trail, as the notch was very densely wooded and the banks of the river above difficult to work along. Urged forward the work and at 2 p.m. had surmounted the hill, descended and made a bench-mark on a great rock at the east end of the sand beach of the Lower Lake, whose dark waves reached away southward between the black mountain walls rising canyon like, more than two thousand feet above its surface.[9]

The forty miles of line had to be cleared of all branches and brush by guides with axes, bush hooks, and bowie knives. In the dense thickets of scrub fir trees near mountaintops, this was no small order. Surveying equipment as

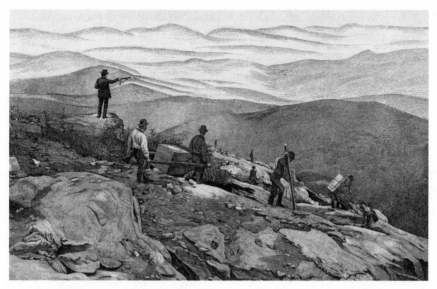

5. "Triangulation: Survey Party leaving Summit of Mt. Hurricane, The Guides carrying the Grand Theodolite and Telescope %c," Plate No. 12 from Verplanck Colvin's *Seventh Annual Report on the Progress of the Topographical Survey of the Adirondack Region of New York, to the Year 1879.*

well as food had to be lugged to the highest peaks. On certain mountains twenty-inch theodolites, three-hundred-pound instruments that measured vertical and horizontal angles were temporarily installed. To guard against vibration in the wind, these were fastened to the summits with iron screws leaded in the rock.

While working on this Marcy line, Colvin's party of guides and assistants camped at Panther Gorge at the base of Mount Haystack on the Marcy side. The work had progressed slowly, and they were getting short of food. Colvin related that, "The guide who had been sent out [to Keene] for supplies returned, bringing, in place of other provisions, over seventy-five pounds of bear's flesh, the only meat he could procure. The new provision caused some wry faces in camp, but we made a hearty supper while listening to the guide's narration of the killing of the bears."[10]

To complete his surveying method of triangulation, Colvin had to establish tripods on many mountains to serve as signal towers and observation stations, which he had to staff in order to discharge simultaneous flash signals or gunpowder shots at prearranged times, for there were no other means for rapid messages through the wilderness. Colvin reported in 1876 that almost

all the previous trigonometrical stations were destroyed "by the furious hurricanes which sweep those bleak summits." For larger signal towers, some of them twenty-five feet high, "the timber had to be procured a thousand feet below the summit—the dwarf timber on the upper ridges being worthless for this purpose . . . a single timber at times taking a day's work for three powerful guides to bring it to the summit."[11] Some of the copper bolts on summit rocks still can be seen today. Climbing the mountains in my boyhood I saw the bleached timbers of many of these towers, most of which were fast disintegrating. The one on Noonmark Mountain was kept repaired and reinforced by wire for several years by young enthusiasts. A large weathervane was put on top of it and a long mariner's telescope was installed at the inn at St. Huberts so that guests could tell which way the wind was blowing almost without leaving their rocking chairs on the porch.

Colvin's first ascent of Gothics, "the wildest and most rugged of the Adirondacks," was from the Johns Brook side in October 1875. Snow and ice were on all the higher slopes. "With fingers benumbed with cold I hastily sketched the wild landscape," he wrote. "Deep in the basin to the eastward lay a dark, narrow pool—black as ebony between its even darker walls of rock—the lower Au Sable lake; further south the Upper lake, like a bright jewel set in the gorgeous autumnal forest."[12] How vividly that recalls similar moments over forty years later when I was painting on mountaintops. In early October 1923 I painted the sunset from the top of Gothics, and then with my wife, Faith, started down the precipitous side of the mountain toward the Lower Lake, dodging slides and slashes without a trail, without a flashlight, and only a sliver of a moon to guide our way. Since I have to walk with a cane or staff, I slid along in the dark slowly as a snail probing ahead with his feeler. We reached the road home after the moon had set and walked back to St. Huberts under the stars.

Stagecoaches and Transportation

As more people came to the area in the nineteenth century, considerable effort was made to improve transportation. Main roads were widened and sump holes filled. The few horse-drawn wooden snowplows were used within the township, and most of the local roads became quagmires in spring. During the summer, stagecoaches made daily runs from Keene Valley, and later St. Huberts, to the Port Henry railroad station, which was twenty-two miles by

the dangerous winding road through Chapel Pond pass. In three or four places
the road crossed sand slides with a deep ravine below. My mother recalled
coming to the Beede House that way in 1886 with a four-horse double-decked
stagecoach. At those places where the road was crumbling away, the driver,
cracking his whip to get past the danger sooner, shouted to his frightened pas-
sengers, "Lean to the hill!" so the coach would be less inclined to tip into the
ravine. The route from the Westport railroad station to St. Huberts was three
miles longer but was preferred even though all male passengers were asked to
walk up the two sandy miles of Spruce Hill.

A Quaker relative from Philadelphia wrote to my Aunt Anna in 1888:

> My dear Anna, Thy nice letter from the Adirondack camping ground
> was so delightfully interesting, that it quite inspirited me, and took me
> back to the happy time I spent there, some twenty years ago, when it
> was not so widely known and frequented. Those grand mountains, Mt.
> Marcy, Hurricane, et cetera, I can never forget, and it is ever a happi-
> ness to recall the magnificent views we had. . . . We were at Edmond's
> Pond [now Cascade Lakes], which was very beautiful, and we spent
> half the day driving over a corduroy road along its banks, which I did
> not recover from for a very long time.

It might be interesting to contrast the methods of travel necessary then
with today's half-day trip by car from any big city in the east. The routine
followed annually by my family when I was a boy started with a carriage trip
to the town railroad station in Merion, Pennsylvania; local train to Philadel-
phia; express train to Jersey City; ferry to Manhattan; walk or horse-drawn
trolley to the Hudson River Nightline Pier; overnight to Albany by boat;
early morning local Delaware & Hudson train (cinders and scenery) to West-
port-on-Lake-Champlain;[13] two-horse surrey to Elizabethtown, stopping at
Deer's Head Inn for lunch and watering the horses; and finally the tedious
four-hour drive via sandy Spruce Hill to Keene Valley and St. Huberts. Total
travel time: nearly thirty hours.

Life at the Beede House

Sometime after 1850 Smith Beede cleared land and built a farm adjacent
to the Chapel Pond road as it left Keene Valley, crossed Beede Brook, and

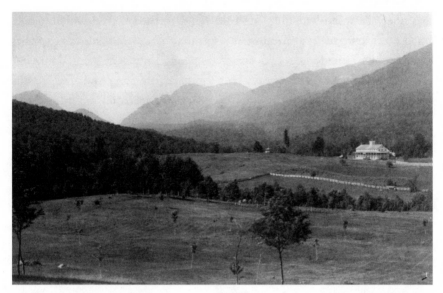

6. Beede Heights Hotel and surrounding fields, n.d. Courtesy of Archives, Keene Valley Library Association.

headed toward the Chapel Pond hill. The Beede family rode the crest of the tide of summer guests. To feed their guests, they cleared more land on the heights directly to the west for wheat and potatoes. The potatoes grew to the size of footballs in the virgin soil among the tree stumps that dotted the knolls.[14] The Beedes added small buildings at the farm to accommodate more visitors but were still bursting at the seams. In 1858 they bartered two thousand bushels of wheat for taking title to six hundred acres on the hill then called Beede's Heights.

The Beedes decided to build a three-story hotel to be called Beede's Heights Hotel—but it was always known as "The Beede House." It was built in 1876 on almost the exact site of the present Ausable Clubhouse. It was the largest resort in the area and could accommodate 150 people, yet the Beedes continued to turn guests away. A large wing was added in 1886.

"It was a free and easy life devoid of comfort," wrote Helen Adler, Felix Adler's wife, in a vivid sketch of life at the Beede House. The road was barely passable in wet weather, which seemed to be the rule. Children sailed their boats on mud puddles in the middle of the road in front of the hotel, which, by the way, was painted in front but not in back. The extent of the plumbing

was one washstand with running cold water in the office at which people lined up to take turns at mealtimes. Upstairs there were cold-water spigots at each end of the long corridors. If you wanted water in your room, you had to fetch it yourself in a heavy china pitcher. The long row of bedrooms on either side of the corridor had only the barest necessities—primitive furniture and no carpets on the floor or superfluous decoration on the walls. You made your own bed. The guiding spirit was Smith Beede, who had help from his sons, Fletcher (at athe time the sleepy assistant) and Orlando. The two Beede sisters brought in platters of food, which were ample but most monotonous, consisting largely of mountain mutton (venison), no fresh vegetables, and chicken on Sundays "shot from the trees where they went to roost."[15]

Having moved to the top of the hill with magnificent views and plenty of room for expansion in all directions, the Beedes sold their original farm and part of the land they owned along the Chapel Pond road to a Boston group in 1877. The initial group, including the physicians James Putnam and his brother Charles, and the prominent Harvard philosophy and psychology professor William James, established the collection of buildings as Putnam Camp. Within a few years, James moved to the other end of Keene Valley to East Hill attracted by Thomas Davidson—the "knight-errant of the intellectual life," as James put it—who founded the Glenmore School for the Cultural Sciences in 1889.[16] Such eminent scholars or educators as John Dewey, James Angell, Josiah Royce, and Felix Adler gave lectures at that school over the course of twenty years. Some of them built cottages on East Hill, and many of their followers became regular summer visitors at that end of the valley.

This was a period of increased building of private cottages, and a real community life with strong intellectual emphasis began to develop at Beede Heights, later renamed St. Huberts. At Adler's suggestion, a campfire was held in a cow pasture to raise funds to build a Keene Heights library. At that campfire my father and mother first met.

Weston Family Background

The St. Huberts area of the Adirondacks has always aroused especially deep attachment on my part, not only because I have lived here so many years, but

also because my parents met here and remained devoted to this region the rest of their lives. They were introduced to St. Huberts by two very different people. William G. Neilson enthused to his Philadelphia friends about the Beede House as a fine place to spend the summer. Several of them began coming up with their families. My grandfather, Charles Hartshorne, brought some of his children with him in 1886 and 1887, including Mary Hartshorne. My father, S. Burns Weston, came to St. Huberts to help prepare to become a leader in the Society for Ethical Culture under its founder, Felix Adler, who had built a summer home at St. Huberts in 1883–84.

S. Burns Weston was born near Skowhegan, Maine, the son of a poor farmer whose major accomplishments seem to have been breeding twins and playing his trombone in the Skowhegan brass band. When my father was only twelve, on her deathbed his mother made him promise to become a minister. From the age of thirteen he supported himself, working his way through Antioch College and Harvard Divinity School. At Harvard he showed a great independence of mind. He was basically religious, as his later life showed, but strongly anticlerical, antiestablishment, and bitterly opposed to discrimination due to color, sex, or creed. One "happening" influenced him profoundly: Ralph Waldo Emerson came to the Divinity School to read an essay in which he envisioned the religion of the future focusing on con-duct, not creed. Halfway through Emerson's discourse, the gas lights suddenly went out. Father and a few other boys whose rooms were nearest rushed to get their kerosene study lamps. Father happened to get back first and later said, "The statements Emerson read from the light of my lamp guided me for the rest of my life."

After graduation in 1879, Father took charge of a Unitarian church at Leicester, Massachusetts. During his two years there he preached a series of sermons on controversial subjects, such as the "Divinity of Christ—Is It Unique?" and "The Virgin Birth—Myth or Symbol?" These caused a tre-mendous commotion in the little town, and Father was anxious to be relieved of this post and not be ordained. He had become interested in the Free Reli-gion Association and in the teachings of a young rabbi-trained "religious radical" with extraordinary intellectual abilities, Felix Adler. In 1876 Adler formed a new religious movement in New York City based on ethics. He called it the Society for Ethical Culture. Father went to see Adler, who was impressed by his spirit but felt he had too little background to be the leader

of an ethical society. At Adler's suggestion, Father borrowed five hundred dollars on a life insurance policy and went to study for two years at Berlin and Leipzig Universities. He lived frugally and during the summers walked through Germany, Austria, and parts of Italy. He came back with nearly two hundred dollars of the loan in his pocket.

Upon Father's return from Europe, Adler engaged him as an assistant for a couple of years of training and then in 1885 sent him to Philadelphia to found a Society for Ethical Culture there.[17] During the summer months, Father and half a dozen other disciples of Adler and artist friends camped out in tents or shacks they built among the sugar maple trees by the side of the Otis cow field near the Chapel Pond road. By today's standards these young disciples of the ethical movement were a serious, even conservative, group. But all were more or less heretics of the standard forms of Christianity or Judaism; all had a touch of socialistic idealism; some even wore red felt, black-tasseled Turkish fezzes, made popular during the revolutions of 1848 in Europe. They were the hippies of the 1880s. To a birthright Quaker and influential rail and coal administrator such as my grandfather Hartshorne, these young radicals were highly suspect.

Mary Hartshorne was no more enthusiastic than her father, but in 1888 an episode took place that began to thaw out her attitude toward Burns Weston. Three young men and three young women agreed to climb Nippletop, which at that time had no trail. The forests on the north shoulder of Nippletop were strewn with big boulders covered by deep moss, and stepping on the moss you could never tell whether your foot would sink down into the crevice or not. The women wore ankle-length, heavy, full, corduroy skirts with voluminous woolen and muslin petticoats and billowing cotton bloomers underneath, a combination guaranteed in wet or hot weather to absorb a woman's weight in water. Forced by etiquette to keep their limbs out of sight, they did not dare to take anything off in the heat. The pace was slow. By noon a beautiful morning had clouded over, and before they reached the ridge of Nippletop they were in the clouds. The thick firs through which one had to fight were dragging at the wet underwear and skirts, and the men were having great trouble clearing the branches. The party decided to turn back. With wet, heavy garments and visibility in the woods rapidly decreasing, their pace back was slow. Before they reached Gill Brook it was too dark to see anything, and it was raining. Burns had been gathering scrolls of birch bark

7. S. Burns Weston lying in the grass to the far right with an open book in front of the tents and shacks that were part of the Ethical Culture philosophers' encampment in the early 1880s. Courtesy of Archives, Keene Valley Library Association.

and twisting them tightly at the bottom to make torches. When night came each man held a burning torch so that the women could keep their hands free to detach themselves from snags. Father, who led the way, became quite a hero in Mother's eyes, which was evident from the way she told the story many times and many years later. And Mother, to Father's delight, proved to have more stamina and to be a better sport under trying circumstances than he had dared to hope.[18] Even after Burns became formally engaged to Mary, he was still not allowed to come to Charles Hartshorne's house for a meal until they were married. Subsequently, having lost a second daughter, Anna, to one of these free thinkers (Walter Sheldon, who later founded a Society for Ethical Culture in St. Louis), my grandfather broadened his ideas. The Adirondacks became a strong bond between my grandfather and father.

A slab shack Father built on the cow field in 1883 or 1884 was hauled up by oxen on sledges to a site he bought and cleared beside Icy Brook in 1888. The shack became the first half of the dining room at Icy Brook Camp, which was where I spent my childhood summers beginning in 1895. Among his other activities, Father served as the editor of the *International Journal of Ethics,* a publication to which the foremost philosophers of the day contributed. He built a study in 1903 to provide quiet for editing. Clinging to a rock

ledge at treetop level, it overlooked a falls of Icy Brook that before the forest fire that year had been a substantial stream. When William James visited that study, he exclaimed: "A man who has a place like this in which to work is in heaven."

A Pussy Cat at Close Range

For many years my father's twin brother Stephen and his wife Nellie ran the Glenmore School for the Cultural Sciences, high on East Hill about ten miles north of St. Huberts, where the school's founder, Thomas Davidson, is buried. Several intellectual leaders spent their summers there and, together with ethical culture professionals from many parts of the country, took part in the lectures and seminars. My aunt and uncle went early to Glenmore each spring to get the cottages ready for the summer crowd. In 1901, after a bad siege of scarlet fever that winter, my brother and I were sent up to stay with them from early May until the Weston family reached Icy Brook in mid-June.

This interlude was all the more appreciated by us boys because it meant getting out of school a month early. Most of the time we were free to do whatever we wished. I especially remember the little water canal we dug. It began at the tiny stream back of the big dining room–kitchen building, which had an upstairs meeting hall able to seat well over a hundred people for lectures. Our miniature canal wound along the side of a grassy hill for a couple of rods, then made a right-angle turn with a steep drop to a retaining wall, where we placed a homemade water wheel of some eight inches diameter. It worked day and night until a late spring freshet washed it out and down the stream to oblivion.

We were supposed to do chores, but this largely boiled down to going for the milk each evening, less than a half-mile walk to the Hale farm, taking along the empty cans and toting them back full. Since only a few of the summer staff were at Glenmore and none of the guests, either one of us could have carried the milk. When we suggested alternate turns to Uncle Stephen, he expressed opposition and insisted we must not only go together but stay together, too. A week or two later we found out why.

Old man Hale had a flock of sheep, which at that time of year was grazing on his upper pastures—land he had cleared some years earlier after cutting

off the trees for firewood to sell to summer residents. During the previous couple of weeks, a bear had made away with two or three of Hale's lambs. All native Adirondack bear are black bear, generally inoffensive but sometimes dangerous, particularly in the spring when young cubs are around. Hale had set a trap to try to catch the marauder. The method was to place a good-sized piece of meat in a cavity or corner formed by an overturned tree or between rocks. If necessary, the sides were blocked by a pile of branches. Then a powerful steel trap was set at the spot where the bear would more or less have to step to get hold of the bait. The trap was fastened to a sturdy chain with heavy links, which was wrapped around and securely stapled with big spikes to the middle of a solid eight-foot log some ten feet away. The trap and chain were carefully camouflaged under a layer of twigs and old leaves. Furthermore, when Hale was setting a trap he smeared the trap, chain, and his hands with bear grease to obliterate human smell, which it certainly did.

If the bear sprang the trap and its paw was securely caught, the chances were that it would take off up the mountain dragging the log behind him more or less broadside. It was inevitable that sooner or later the log would get stuck between two trees no matter how hard the bear pulled. The bear did not have intelligence enough to reverse its tracks and dislodge the log. It then remained pinned down there until the farmer came to shoot it. Not infrequently in its desperation the bear would chew off its paw in order to escape. In that case, the farmer could usually follow the tracks to where the bear died from loss of blood.

At that time the state still paid a bounty of ten dollars for a bear killed, though this law was annulled when fewer farmers kept flocks of sheep and more hunters took to the woods, keeping the bear population down. Originally the farmer had to cut off a bear's ear and send it to Albany to get the bounty. Some farmers started sending in the bear's two ears separately to draw twenty dollars in bounty per kill. So the rules were changed and two ears had to be submitted each time. It was worth following a three-legged bear quite a ways for its two ears for that ten dollars.

Hale had luck. The bear was caught between two trees not far from where the trap had been set. He did not chew off his paw and two shots finished him. It was the biggest bear Hale had ever killed, estimated to weigh some five hundred pounds. Because there were so many ways to make use of the carcass, because the weather had remained cool that spring and the bear

had not yet begun to shed his hair, and because the spot where he was killed was much nearer to tote roads than usual, Hale gutted the bear, hitched up his team to a jumper so as not to harm the pelt when skidding the carcass out, got a neighbor to help him pry the heavy load onto the jumper while his very restless and startled horses pawed the ground, and then skidded the bear down to his barn. There, again with the neighbor's help, he skinned the bear and with hoists hung the carcass up, the full eight-and-a-half feet of it when thus strung out, with ropes tied to the forelegs spread apart over a heavy beam in the barn. We boys did not see the bear until after it had been skinned and strung up. Of course we had seen butcher shops, but in the dim late afternoon light of the barn that huge gruesome pink-white mass of animal flesh made a lasting impression—it looked almost like an animal being crucified.

We listened as Hale explained to Uncle Stephen, who had come down with us to see the bear, that he figured he would get more out of the bear than the worth of the lambs the bear had eaten. First there was the ten-dollar bounty. From the cured skin Hale could make either a rug or blanket, sell the former, or use the latter in his one-horse sleigh. If, as in this case, the bear was killed not too soon after hibernation, some bear steaks could be eaten at home or given to friends; some local people considered them a tasty if somewhat gamey treat. Much of the tougher part of the meat could be boiled up in small chunks and fed to hogs and chickens or even the cats, though Hale's favorite dog turned up its nose at bear meat no matter how carefully cooked. Hale added that this one bear, because of its size and good condition, would supply him with enough bear grease for a couple of years. This bear was a male and probably a loner. Sometimes the male stayed near the female and her cubs, usually two, in the early part of the season. Hale "allowed there's no use taking chances." He set his trap again but caught no more bear that year.

Some ten days after seeing the skinned bear, when Carl and I were on our way to fetch the evening milk, I noticed near the split-log fence that enclosed a field a handsome black and white cat with a bushy tail that arched proudly over her back. I commented to Carl what a lovely pet she would make and suggested, "Why don't we catch her?" "Bet you can't," said Carl, taciturn as usual, knowing full well that this was just enough of a goad to set me off. I dropped my milk can and was halfway through the fence when I

answered, "Bet I can." Now Carl, in contrast to me, kept things very much to himself. He had a keen sense of humor and liked to play practical jokes but was poker-faced about them, even after they were over. To this day I do not know if my brother knew what his dare had set up for me or whether he was as innocent at that moment about wood pussies as I was.

My pet started to lope toward the woods on the other side of the field but without any sense of urgency. I was fast closing the gap between us, and I kept calling in as dulcet tones as I could summon, "Here pussy. Here kitty cat. Good kitty cat." All at once she stopped running, arched her back and stood on her toes just as a cat does when it wants to be petted. She swung her rear end around to face me with the seductiveness of a stripteaser. Her tail stood erect with distended bushiness and twitched, somehow like a pitcher limbering up his arm before throwing a fastball. A tingle of triumph swept over me. She was ready to make friends. How sleek her striped coat looked when you got really close. With a final "Good pussy cat," I leaned over to pick her up. All at once my eyes were blinded. I was choking for breath. My mouth, as usual recklessly open, had a most horrible bitter taste. My clothes were as sprayed down as if I had dashed under Uncle Stephen's garden hose and had been caught full force, a game we all liked to play.

The object of my quest had disappeared. I wondered where the kitty went, leaving in my mouth a taste no toothpaste could overpower. Dear kitty cat indeed! Half blinded and miserable, I stumbled back to the road. "I say you lost and that cat won," said Carl, starting to guffaw, which was not exactly in keeping with his character. He only stopped when I came near. Then he ran down the road holding his nose and called back, "Don't you dare come near me." Mrs. Hale would not allow me in the house and told Carl to get the milk. "Don't let your brother carry any of the milk tonight," she added. She summoned her husband from the barn where he was doing his evening chores. He came at once, got down his rifle from the two front legs of a deer, which projected high up from the kitchen wall, and said to Carl, "Now you show me where you saw that damned skunk. He's been stealing my chicks and by jeepers I want to get him." Then, turning to me he ordered, "You boy, you stay to the leeward and well behind us."

I wanted to say I was the one who saw the pussy cat first and knew just where she had been, but Hale had started to stride off, his gun ready to cock. I was the one who had reason to be mad at that kitty and here I was being

banished from taking part in the excitement of the kill, a real hunt with a real gun. Of course there was no trace of kitty, and in the growing dusk the hunt was soon given up. The farmer and my brother came back across the field. I had been told not to leave the road. Now Hale gestured for me to go on toward Glenmore before they came out on the road. I sulked all the way home and felt sorry for myself.

It was near midnight when the third and last bath and scrubbing was given to me, standing in a big galvanized washtub on the porch of the cottage where Carl and I had our rooms. It took quite a while to heat up so much water on the stove. The stench was so bad that Aunt Nellie, who made less fuss about it, and Uncle Stephen took turns scrubbing me with a stiff wooden-handled brush until my skin was all red and in places getting sore. The hair on my head had been shaved; my fingernails cut to the quick; all the clothes I had on were put in the stove and burnt, except the new leather shoes of which I was so proud. Uncle Stephen had come to the conclusion they were just too good to throw out. The cook, a native of Keene, told him the smell might disappear if he buried the shoes in the garden for two or three months. Uncle Stephen taught at Antioch College on a subsistence salary and ever since his youth of near poverty the dollar value of a thing loomed large to him. He was a little sheepish about burying the shoes, so he did it the next morning before anyone was up and only told Aunt Nellie.

In the middle of August, long after the Weston family had settled for the summer at Icy Brook and the affair of the skunk had taken its place with records of children's adventures in the past, Uncle Stephen arranged to rent Hale's buckboard and drive over to St. Huberts with Aunt Nellie for a family visit. As I recall, it was a hot morning, rare in the mountains, and as lunchtime approached we all gathered on the porch facing the road waiting for the visitors from Glenmore. All at once Mother lifted her long aristocratic nose high in the air and sniffed. I have always maintained that Mother's nose had an acutely sensitive smeller in it. She sniffed again. "I smell skunk," she announced. Then she sniffed a third time. "Yes, I am sure of it now." A moment or so later Uncle Stephen's cheery voice was heard as Hale's horse plodded slowly up the drive.

The first thing Mother said after greeting them was, "Did you by any chance meet a skunk on the way over and run over it? I seem to detect its odor on your buckboard." Uncle Stephen loved to joke so he replied, "Skunks? Yes,

indeed, several of them. In fact you might say we brought one with us." After a dramatic pause he went on. "Those fine new shoes of Harold's, they were just too good to throw out. I was told that if they were buried for a couple of months, that skunk's stink would drain out. Had them in a corner of the garden until this morning. They are in a box in the rear carryall. Have to admit the cure didn't work yet. Thought you might like to go on with it."

He had hardly finished speaking when Mother turned to Father. "Burns," she said, "get a shovel right away, make a hole in the woods somewhere, put those shoes in it, and never dig them up. Then we can have lunch."

That adventure did not dampen my enthusiasm for making friends with animals, including wild ones. Thereafter, I always took great care, however, when tempted to bend down over a seductive pussy cat and look before getting too close to see whether that kitty had a big bushy tail that stood erect and twitched.

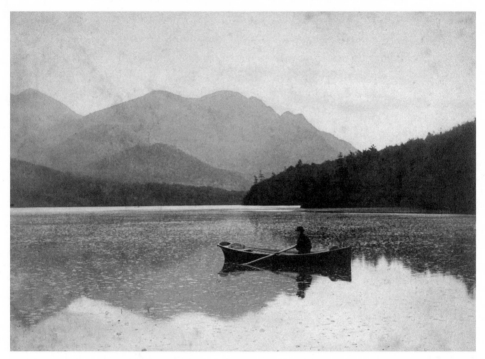

8. Guide boat on the Upper Ausable Lake, 1888. Photo by Seneca Ray Stoddard. Harold Weston Foundation.

3

A Wilderness Preserve

Lumbering on the Ausable Lakes

THE ADIRONDACKS' great virgin forest had attracted the covetous eyes of the lumber industry well before 1850. A drive was made in 1854 to call the state legislature's attention to the "enticing forests." A spokesman for the lumber interests proclaimed: "Vast quantities of spruce and hemlock timber existing in the upper half of the Township of Keene are suitable to be converted into saw logs." He urged the legislature to authorize a modest appropriation to build a dam at the Lower Ausable Lake, which would "do much towards floating the logs to market." At his behest a small part of that year's appropriation "to improve the water ways and water resources of New York State" was set aside for this dam.

A first dam was started incompetently in 1855 and was washed out before completion. A more substantial dam was constructed early in 1856 together with a small sawmill. This raised the level of the lake nearly ten feet, according to the records in Albany. However, on September 30 heavy rains not only increased the pressure of the lake on the dam but also brought a slide from Gothics down Rainbow Brook. Debris from the slide collected where the brook meets the river just below the dam. Water backed up and undermined the dam, which burst. The Ausable River valley was flooded forty miles all the way to Keeseville. Pigs, sheep, chickens, a few cattle, produce, topsoil, many fences and barns, and two bridges were swept away, and half a dozen people drowned. The state was sued. In the lengthy testimony of 1858, one farmer demanded twenty-five cents per bushel for one hundred bushels of potatoes lost and then added, "There were three persons carried off and drowned"—but he did not make any claim for their loss! Finally, the court declared that the flood was "an act of God" and all claims were dismissed. The dam was rebuilt the next spring after the flood.[1]

Timber dams constructed on the basis of log cribs are as native to the North Country as maple sugar and have far more permanence than most people imagine. Wood that is under water or kept constantly wet generally does not rot or deteriorate unless it is cut by razor-sharp ice or pounded by heavy ice cakes. Certain types of wood get harder as they become water-logged, which is the preliminary stage to petrifying, and they become almost as heavy as a similar volume of stone. The objective in building these dams was almost always to impound an appreciable body of water in order to release it when needed to increase the flow in a river when "running" pulpwood to paper mills. Timber cut to be sawed into lumber was apt to be damaged if driven down a rocky river bed and thus was rarely transported to sawmills, in contrast to paper mills, unless the water was deep enough for it to float with-out being buffeted about too much or having sand ground in that would dull the saws. Most of the many log crib dams in the Adirondacks were originally built by lumber companies for paper mills.

After clearing part of the land beside the Lower Lake dam, David Hale, who ran the sawmill there from 1857 to 1887, built a house for his family and a barn for his cow. Years later, when bushwhacking to a high ledge between Rainbow Falls and Beaver Meadow Falls, I came across one of Hale's well-worn trapping lines. His lumbering was small scale, a tree here, a tree there; only the lighter softwood trees were cut and then only if they were near the shore or where the logs could be conveniently floated down the Carry River between the Upper and Lower Lakes. The system was to back up water in the Upper Ausable Lake by blocking the outlet with a couple of big logs chained together; these would be pulled aside to increase the flow of water in the river when floating logs to the Lower Lake. The prevailing south wind on the Lower drove the logs with a bit of encourage-ment to the sawmill.

My mother remembered seeing oxen drag sledges piled with rough-cut boards down the Lake Road from the Lower Lake to St. Huberts in 1886. The "road," which was mostly mud with corduroy logs in the worst places, was rebuilt in 1887. The cost was so high that a toll was charged for horse-drawn carriages and saddle horses. I recall from my youth the little old woman who collected tolls and usually sat knitting in the tiny room by the tollgate where she sold diminutive baskets and picture frames made of sweet grass, scissor holders and pin cushions, balsam pillows and camp baskets of

all sizes, and dozens of other things that were made in the vicinity by local Native Americans. I remember her warm sympathy when I came back one rainy morning from fishing on the river with a fishhook firmly in my thumb and only one trout in my basket.

David Hale's son, LeGrand Hale, was born at the Lower Lake. In my youth, he told me many stories of the early days, one of which seems worth repeating here. One fall evening when LeGrand was quite young, his father, who was a man of few words, took him to the shore of the Upper Lake and said, "Sit here, son. I want you to hear something." They sat quietly for a long time. Then there was a distant "moo-bellow." "That's a moose, boy, only one you'll hear—maybe the last one left." Moose Mountain is an appropriate name for the small hump beyond Stillwater where the last moose of our vicinity was heard. Moose survived a few years longer in the lake area of the Adirondacks further west.[2]

Lumbermen Purchase High Peaks Tract

In 1866 two influential lumbermen, Thomas and Armstrong of Plattsburgh, New York, bought Township 48, consisting of twenty-eight thousand acres carved from the huge Totten and Crossfield Purchase of 1771. The new property included all of the Lower Lake, most of the Upper Lake, and most of the High Peaks mountains, including Haystack, Basin, Saddleback, Gothics, Sawteeth, Armstrong, Wolf Jaws, Colvin, Dial, Nippletop, a part of Dix, Marcy all the way to Lake Arnold, and a bit of Colden. David Hale was employed to keep an eye on their property, which they were holding in order to sell the timber at the proper moment to the highest bidder.

One of Thomas's sons was a geologist. He was intrigued by the legend, believed in Keene Valley, that the Native Americans had a secret lead mine near the Lower Lake. The tale was told that one of the early settlers had been taken blindfolded by Native Americans to see this mine, but by such a circuitous route that he could never locate it. Young Thomas spent much time searching for this mine, which has not yet been found. Some day it may be. About this time the large iron mines over at Tahawas were being vigorously exploited while the many small but inefficient local iron mines and smelters had been abandoned. The Adirondack Iron Works at Tahawas closed down before 1875.

9. *The Lumberman,* 1922, Harold Weston. Cheryl C. Boots.

In the 1881 edition of the *Descriptive Guide to the Adirondacks,* a full-page advertisement for the Thomas and Armstrong holding was published: "20,000 acres! Good Timber Lands For Sale, Situated in the Adirondack Wilderness." It went on: "All this land is heavily timbered with the choicest trees of the forest, usually borders upon large streams or lakes, and will be sold at a GREAT BARGAIN to close an estate. No finer opportunity has ever been offered to lumbermen or manufacturers."[3]

Founding the Adirondack Mountain Reserve

The Upper Lake was a favorite spot for guides to take hunters, fishermen, and hikers. In October 1886, William G. Neilson, his Philadelphia friend W. Charles Alderson, and several others engaged Ed Beede's camp at the Upper Lake for two weeks (see ill. 4). While there, they were dismayed to learn that Thomas and Armstrong were about to sell the timber to the Finch Pruyn Paper Company of Glens Falls. Neilson and Alderson, determined

to save the incomparable wilderness beauty of the Ausable Lakes, immediately called upon several other Philadelphians of means. By most strenuous efforts, enough cash (I believe forty-four thousand dollars) was put up by December 1, 1886, to hold up the sale of the standing timber on the twenty-eight thousand acres of Township 48. With remarkable speed, the group acquired all this land by paying an additional forty thousand dollars on May 17, 1887. Charles Hartshorne was one of the Philadelphia group that purchased the land.

The foresight and courage of this small group of people inspired their successors to cultivate this heritage and planted the seeds of devotion to this bit of wilderness which by now has extended roots down six generations. In the western lake region in the same period large tracts of land were bought up by wealthy financiers. Much of this land is still being held as private parks by their heirs.

The new landowners met in Philadelphia on May 13, 1887, and named the tract the Adirondack Mountain Reserve (AMR). The first trustees, under the leadership of Neilson, who served as president from 1887 to 1906, were cagey in the way they handled the most thorny aspects of taking over this property. The residents of Keene Valley, particularly the guides who were respected leaders in the community, had strong, possessive feelings about the wilderness area on which they and their boarders had hunted, fished, and camped heretofore. They openly resented any curtailment of this freedom. It took many years and much tact to convince some people that restrictions were required to preserve forests, game, and fish; that forests and lakes kept unspoiled attract people who build summer residences and engage guides, cooks, and caretakers; and that more prosperity comes to the township by this kind of development than by passing sportsmen, temporary visitors, or by lumbering or other exploitation.

The AMR allowed guides who had built their own camps on the Upper Lake to continue to operate the camps but with no hunting or fishing. Guides were not permitted to sell their camps or transfer them to relatives. Eventually, some guides lost interest and abandoned their camps, which soon disappeared. The majority continued to guide very actively for the next twenty years. The hunters and fishermen they used to take up were more than replaced by members of the AMR and their families anxious to enjoy the property of which they were now part owners. The AMR purchased

outright Wesley Otis's camp, called Inlet, and appointed him (a noted off-season hunter) game warden of the reserve. The system of guides' camps available for rental through the summer was a great boon both to the AMR and to the guides.

Scott Brown

In 1888 a prominent resident of nearby Elizabethtown, W. Scott Brown, was engaged as superintendent of the AMR. He was a distant cousin of the abolitionist John Brown, whose "body lies a-moulderin' in the grave" near Lake Placid.[4] He was exceptionally knowledgeable about animals, birds, and the history of the region. He had some legal and surveying experience. He recommended stocking the river and lakes with ten thousand fingerling trout in 1889, a precedent followed with variations ever since. Scott Brown was an occasional composer of poetry about the beauties of nature in general and the Adirondacks in particular. He was full of enthusiasm about the wilderness objectives of the new owners of this large tract, which at one time during the thirty-five years of his tenure as superintendent consisted of around forty thousand acres. A home was built for Scott near the AMR tollgate where he and his wife could keep an eagle eye on who went up the Lake Road.

Although Scott Brown was far more of an intellectual than the average guide and was not himself a hunter, he was still "one of us" to the men, and he understood their resentment about being deprived of their inherited "right" to hunt, fish, camp, and cut wood for their families on the reserve. The privilege of getting winter wood on the reserve was gradually decreased, the last guide to have this "right" being Mason Hale. Mason, after all, was the grandson of David Hale, who had run the sawmill at the Lower Lake during summers and maintained a farm and winter home at St. Huberts well before the Beede House was built. Furthermore, Mason, with his wife and two charming little girls, was for several years the summer attendant for the AMR, living at the Lower Lake cottage. Parties frequently went there for tea, flapjack breakfasts, or suppers prior to moonlight boat rides on the lake.

Scott sensed the importance of allowing the local guides a little freedom as long as they did not take in outside hunters. He winked his eye at small hunting camps they set up on Casey Brook and Sand Brook beyond Stillwater, even though it was AMR property. The hunters promised not to

hunt along the Inlet or around the Upper Lake, and they were glad to act as informal AMR game wardens to discourage poachers from the south. In addition to maintaining a camp or two, they were permitted to take their rifles and supplies up through the lakes and bring out their bucks officially tagged (see ill. 44).

Adirondack Trail Improvement Society

In the 1890s adults as well as youngsters derived most of their pleasure and recreation from walking or climbing. Yet in a region that boasted the finest mountain views, forests, lakes, streams, and spots of natural beauty in the state, if not east of the Rockies, there had been no attempt to organize and finance trail-cutting and maintenance.

In the summer of 1897 three men were climbing Noonmark together— Felix Adler, William Augustus White, and S. Burns Weston. Adler was a short, stocky man who jogged daily (typically ahead of his time) up and down the road at St. Huberts. He also liked to climb smaller mountains in spite of his short legs and heavy body. Halfway up Noonmark a massive blow-down blocked the trail with no suitable way to crawl under or to circumvent. When Adler, helped by White and Weston, was finally perched astraddle the uppermost tree, he paused and from this temporary pulpit pontifically proclaimed, "My friends, we should at once establish an Adirondack Trail Improvement Society." Thus the ATIS, the first trail maintenance group to operate exclusively in New York State, was first conceived.

During the first decade, White generously paid for much of the trail-cutting and clearing done by the guides. The first trail over the Lower Range—Deer Brook to Lower Wolf Jaws Mountain and down Wedge Brook to the West River Trail—was cut later in his memory. My father and some friends marked a trail to Fairy Ladder Falls on Nippletop at the upper end of Gill Brook, a showplace advertised in guidebooks of that era when there was more ample rainfall. They also made an exciting trail with numerous long ladders up the then-spectacular Upper Chapel Brook (utterly ruined by the fire of 1903) to the Giant's Dipper and Washbowl. This trail passed through a grove of virgin pine in a secluded hollow near the Dipper, which the fire skipped over. These trees were so tall and straight they were taken out intact after the fire, although at considerable expense, to be used for masts

of ships. We watched one slender sixty-foot tree trunk being lowered down
the steep side of Rocky Ridge Mountain by about a dozen men with ropes,
and brought out to the road beyond Chapel Pond.[5] Both of these trails have
long since disappeared, but the ATIS has cut many new ones, including the
S. Burns Weston Trail up Round Mountain. In spite of turning over several
major trails to the state or to the Adirondack Mountain Club in the 1920s,
the ATIS still maintains about 112 miles of trail, nearly two-thirds of which
is now on State land.

Disastrous Forest Fires of 1903

At the turn of the century a small forest fire began to burn near the top of the
north ridge of Lower Wolf Jaws Mountain behind the hotel at St. Huberts.
When the manager's attention was called to it, he looked up at the overcast
sky and remarked casually, "We don't own that part. It looks like rain and
anyway there ain't no trail up there." Most fortunately the rain did put it out
before it made any headway.

The devastating effects of a major forest fire can hardly be imagined
unless you have seen them. Before the fires of 1903, the ATIS trail to Dix
Mountain went up along the side of Round Mountain through virgin for-
est to the Noonmark Notch. This being on the north side of the moun-
tain, the luxurious mosses that covered the forest floor were a foot deep in
some places. Round Mountain had no view from the top since it was thickly
wooded. Many of the trees on top were old giants, up to three feet in diam-
eter at the base. Thirty-five years later I painted the upturned roots of one of
these, which looked like a piece of modern sculpture as it stretched its gaunt,
blanched limbs against the sky. After a fire it can take fewer than fifty years
to renew a semblance of tree covering, but if much of the duff—the rich
accumulation through the centuries of needles, leaves, and forest debris, in
some places ten feet deep—gets burnt, it may require a good two hundred
years before all traces of that fire disappear.[6]

In the spring of 1903 there were four forest fires, three of them huge. I
base the following account of those disastrous fires on the 1903 report to the
AMR stockholders given by its president, William G. Neilson.[7]

No snow or rain fell from April 18 to June 8, 1903. The winter snow
melted rapidly and the ground dried very fast. As Neilson described it: "The

country is dust covered, grass crop about lost, streams very low, duff in the woods so dry as to be almost dust when stepped upon." The first fire started in May, slightly beyond AMR property near the lower part of the West Branch of the Bouquet River. A crew of men, largely from the reserve, got it surrounded by a fire trench and almost "whipped out" after nearly five weeks of strenuous effort. In the meantime another fire had started some twelve miles away on the east side of Dix Mountain. When this fire worked its way to the steep slope of the mountain, it suddenly ran rapidly to the top. A heavy south wind swept it over the ridge of Dix near the reserve line. The wind became almost a tornado as the fire rushed down the west slope, and in about two and a half hours it traveled some five miles by great leaps across the valley of the Bouquet up the south side of Noonmark to its summit. Ten thousand men would have been powerless to stop it. It rapidly spread eastward over the slopes of Round. That afternoon and evening there was a roar that could be heard for miles. Fortunately the slopes of the Noonmark-Nippletop range afforded protection from the winds on the north side and slowed down the fire. For the next ten days, the AMR superintendent, Scott Brown, and a large force of men succeeded in stopping the progress of the fire on Noonmark.

In the meantime the fire spread east, reaching Chapel Pond, and west, working over the summit of Bear Den and threatening the Lower Lake. Practically all of the men of Keene Valley were "warned out" (required to fight fire) and the J. & J. Rogers Company, paper manufacturers at Au Sable Forks, sent up a considerable force of men. Temporarily this second fire was under a degree of control. However, it had burnt already some five thousand acres of AMR property and also some twenty-five thousand cords of pulpwood that the J. & J. Rogers Company had cut and paid for in the Dix valley.

The third big fire was started near Saranac by a man burning brush. This fire, moving past the south side of Lake Placid, consumed thousands of acres of forest in the end, destroyed the small but popular hotel at the Cascade Lakes, and utterly ruined the beauty of those two charming ponds. It was propelled by a high wind across the Cascade and Porter ranges at extraordinary speed until burning pieces and hot smoke filled the air at Keene Valley and St. Huberts seven miles away. Small new fires sprang up and were put out with difficulty. Many residents of both places buried their valuables and some fled to Elizabethtown. Both places seemed doomed, but

then, after midnight on June 8, rain began. The fires were subdued and then put out.

The fourth simultaneous fire destroyed more acres of forest than any of the others and burnt up a number of houses at Euba Mills. It swept over the south shoulder of Giant Mountain and all of Rocky Peak Ridge with flames two hundred feet high. It crossed the Port Henry road and joined the old fire on Round and Noonmark, forcing the pickets on the earlier fireline to flee for their lives. It was stopped not far from the Nubble on Giant and some one hundred yards from the Otis farm at the foot of Chapel Pond hill when the rains finally came. All told, the fires burnt six hundred thousand acres.

Forest fires can be of quite different natures. Sometimes lightning hitting a tree starts a fire, which may smolder along its roots deep in the duff for ten days or more before coming to the surface or giving any smoke signal. In the spring when new leaves have not yet come out, a fire may move slowly, staying mostly on the ground, because there is no foliage to generate a draft. When a fire gets off the ground, it becomes a "crown fire," flames leaping from tree to tree and whipping up a strong draft. The hotter the fire, the higher the wind. A slow ground fire is more apt to destroy centuries of accumulated vitality in the soil. A crown fire may pass by so rapidly it barely scorches the earth. Fir trees may be stripped of needles but left standing with unburned trunks and blackened limbs. The trunks of these dead but standing trees can be used to make pulpwood during a period of about four years. Also, the more dead wood removed, the less danger there will be of future fires.

After the 1903 fires there were some twenty-five thousand cords of pulpwood to take out. Lumberjacks were imported from Canada and established in a big lumber camp in the Dix valley, a smaller one near the Noonmark Notch, and another in Chapel Pond pass. The north side of Noonmark was almost completely burnt except for a small patch of spruce trees just below the top. Here it seemed the updraft from the fire on the south side was so great it pulled up with it a sufficiently strong suction of air on the north side so these trees did not catch fire. This group of trees subsequently provided a most valuable source of seeds for the mountainside below, eventually creating a patch of dark spruce near the top of Noonmark. From this high point on Noonmark just below the live trees, the lumberjacks constructed a wooden trough in which to slide the five-foot lengths of the dead tree trunks down to

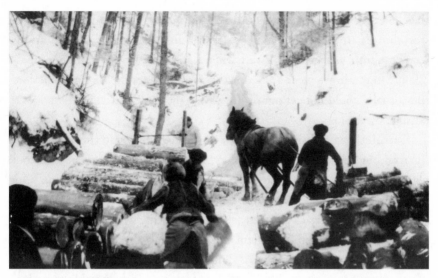

10. Logs for pulpwood that were skidded down in the summer and stacked by the edge of a lumber road are being loaded on sledges, which will transport them to the side of the river for the spring run to the paper mill. Photograph by Harold Weston, 1923. Courtesy of the Archives of American Art, Smithsonian Institution.

the notch. A trestle was built with strong slender timbers crossing at the top. These timbers were spaced some ten feet apart and crossed at a level (varying from three to twelve feet from the ground) to hold an evenly sloping trough made of saplings or tops of trees with all stubs removed on the upper side. It was not possible to have any abrupt turns on this sluiceway since its sides were not high and a log could easily get caught on the turn, causing a jam-up. Men patrolled the chute when it was being used, and this was a bit dangerous because every once in a while a log would get going too fast and jump the tracks. The peeled saplings of this log chute could be plainly seen from St. Huberts like a shining monorail zooming down the side of Noonmark to a point well below the notch.

These short timbers, cut pulpwood size, were piled up at the base of the chute, waiting to be taken on sledges during the first snow to a big field by the river below St. Huberts. Part of the descent from the notch was sufficiently steep that a heavy cable was attached to the sledge, the cable being braked around a high wheel-drum six feet in diameter. In the coldest weather or when the thermometer fell to twenty below zero or more,

the cable was not used. When a cable is put under strain in severe cold its steel threads are likely to snap. The driver riding the load of logs was always ready to jump, as Faith and I were when some years later at a lumber job on Giant Mountain we went along for the thrill of the ride. As for the horses, they usually could not get out of the way. If the cable broke, the horses were crushed by the logs.

I recall the impressively long rows of stacked timbers in the field close to the river but I did not see the running of the logs down the river. This took place after the ice went out and the water was still high in the spring. One place, just above Hull's Falls, the logs frequently jammed on some large boulders. Certain lumberjacks had great skill in knowing where to place a charge of dynamite to break up the logjam and also how to jump to safety once they set off the charge. Running logs is dangerous and exciting work, the climax of the salvage operations. The AMR was fortunate in being able to cash in on many thousands of dollars' worth of pulpwood from the devastating fire of 1903. But, although this covered deficits for several years, it did not begin to offset the irreparable loss of a vast tract of virgin forest.

The Beede House Burns

The original 1876 Beede House had been supplied with water from a spring on the side of Noonmark. The Adler deed of purchase attests that this water was brought down by hollowed logs used as pipes. The supply was ample for the winter needs of "100 horses and 50 men"—but there were no flush toilets, winter weather did not encourage tin tub baths, and anyway the men preferred other drink to water. After the fire of 1903, the flow of water from that spring during the summer barely existed. The enlargement of the Beede House in 1886 and the growing number of reserve cottages required a more ample water system. So a pipeline was laid to Gill Brook and has served well ever since.

The task of running such a large outfit was too heavy a burden for the Beede family. During the summer of 1889 a plan was devised to acquire the Beede House and surrounding six hundred acres and organize a Keene Heights Hotel Company. The property was to be purchased in the spring and arrangements were made for the installment of flush toilets and bathrooms now that an ample water system was available. Then, on March 3, 1890, before the transfer, the Beede House and most of its contents were

burnt—uninsured. The organizers of the Keene Heights Hotel Company decided to construct a new building at once. A noted Philadelphia architect, Wilson Brothers & Co., architects of The Sagamore in Lake George and "other well known Summer hotels," was engaged.[8] Most remarkable, it was possible to open the new inn, completely furnished, on July 15th, just four months and twelve days after the Beede House burned down. This huge structure, rather imposing in its Victorian style, and only slightly remodeled, is the present Ausable Clubhouse. This speed would not have been possible except that skilled workmen, carpenters, masons, plumbers, and some material had already been lined up for alterations on the original Beede House. Even at that, it was an amazing accomplishment.

St. Huberts Inn

Keene Heights Hotel Company was not a terribly alluring name. Charles Alderson asked his wife, Eleanor, who was traveling in Europe, to suggest a

11. Chorines of the 1911 Ausable Club musical comedy hit practicing by the casino. Note in the background to the right the extent of the 1903 fire around Giant Mountain's Nubble. Courtesy of the Archives of American Art, Smithsonian Institution.

better idea. She happened to visit the Benedictine Convent of Ardain in the Ardennes, France, where the body of Saint Hubert is enshrined. His legend seemed highly appropriate for the hamlet at the gateway of the reserve on which hunting was no longer allowed. It runs somewhat as follows: Hubert was a nobleman of Aquitaine in about the year 695. Passionately fond of hunting, he followed the pursuit even during the Holy Week, and was only turned aside from making it the end and aim of his existence by a startling apparition that came to him in the forest. While hunting on Good Friday, in the forest of Ardennes, a milk-white stag, with a crucifix between its horns, suddenly came into view. Filled with awe and astonishment, Hubert was then converted and lived as a hermit in the forest. There he became the friend and protector of the harmless forest animals. So the name St. Hubert's Inn was adopted, and later St. Huberts (without the apostrophe) became the name of the summer post office and of the vicinity, including the cluster of year-round homes at the foot of the hill.

Every effort was made to encourage more guests to come to the inn. The golf course was improved after all stumps had been removed from the Beedes' former potato and corn fields. Even though space permitted only six holes, the claim was made that it was "the best golf course in the Adirondacks." From the point of view of varied and stunning scenery to be enjoyed between shots, that claim was undoubtedly true and still is. A casino was built containing three bowling alleys. I can still remember the noise the balls made, like distant thunder reverberating, as they rolled down the wooden alleys. A second tennis court was built, made of wood with space between the narrow boards to allow drainage. In keeping with that Victorian time, however, neither bowling nor tennis was permitted Sunday mornings.

The inn continued an energetic struggle to make both ends meet. A four-piece hotel orchestra was employed, which gave concerts in the parlor on rainy afternoons as well as every evening before and after dinner. The bowling alleys had not proved profitable and the cacophony aroused complaints from guests, so the casino was converted into a hall where square dances could be held and plays performed on a mini-stage, which also served as a lecture platform. Every week some form of traveling entertainment was arranged—magicians, card tricksters, even, once a summer, pathetic dancing bears from Switzerland. A highlight in mid-August was a fancy dress ball in

which young and old enthusiastically took part. Rather ambitious musicals were staged in the casino, sometimes with original music or popular lyrics revised to fit the local scene. A memorable "happening" was pulled off during a fancy dress ball by George Bright, Sr., and the club manager Gus Coughlan. The casino had no ceiling. Coughlan had two stout ropes secured to the ridgepole and tied obscurely to side windows opposite each other. Just before the Grand March was to take place, Bright and Coughlan, both small men, suddenly appeared dressed as monkeys on the sills of the windows and with great yells and antics started swinging back and forth across the hall. They brought down the house.

Another attraction was added that was most popular from 1907 to 1917. Years before, Wesley Otis had cleared a flat acre below Roaring Brook Falls and built a farmhouse and barn. Otis hunted deer with hounds and became one of the most skillful builders of log cabins and stone chimneys. Beside the Otis farmhouse a reasonably good baseball diamond was fixed up on the flat cow pasture, and bleachers were built among the sugar maple trees at its edge. It was used constantly during summer months with big crowds cheering on the "cottage boy" who hit a home run or the "bus boy" who pitched a shut-out. In fact, it was said that Coughlan, who was team manager as well as club manager, took greater pains in recruiting his college stars than he did in selecting a chef or headwaiter. The St. Huberts ball team had a schedule of games with teams from much bigger resorts and, not so surprisingly, usually won to the joy of those club members who put money on the game. Baseball had its day at St. Huberts.

In spite of these efforts, the trend for long vacations was slowing down inexorably. Families wanted to spend some of their time at the shore and autos made an enormous difference in the ability to come for shorter periods. The inn faced increasing financial difficulties. The great fire in the spring of 1903 gave the coup de grâce. More than half of Noonmark, most of Round Mountain, and up to the Nubble on Giant were now visibly blackened areas, depressing to guests. The fire had torn off the thick forest blanket that had enveloped Round and revealed its succession of rocky ridges, projecting like stark skeletal ribs above the blackness of the mountain's prostrate form. After struggling through that summer, the St. Huberts Inn Association went bankrupt and the hotel remained closed during the summers of 1904 and 1905.

The Ausable Lake and Mountain Club

People discussed ways to meet the need for an inn or hotel run in conjunction with the reserve at its doorstep. S. Burns Weston and Dr. Theodore C. Janeway worked out a suggestion that an Ausable Lake and Mountain Club be created by the AMR to operate a clubhouse and activities at St. Huberts. Their proposal led to many group meetings, particularly with William A. White, his brother Alfred T. White, and their friend Robert W. deForest. The arrangements were strenuously opposed by William G. Neilson and a minority group of stockholders. Neilson did not want the reserve to become a private club. He had taken leadership in safeguarding the interests of the guides and was concerned that the termination of their "right" to have their own camps on the Upper Lake would be fairly handled. Neilson resigned in 1906 and Robert W. deForest was elected president. A couple of years later the name of this offspring of the AMR was abbreviated to Ausable Club. Since then, far-sighted individuals have worked together to preserve the unique character of this bit of wilderness with sophisticated accessories as a haven of peace in a disturbed world.

Obviously a park or a reserve to which the public has always been admitted freely under reasonable restrictions and which is subject to ever-rising taxes and maintenance costs can never be a paying proposition unless the land or the timber on it is exploited. The AMR has kept the central portion of the property—the watershed of the East Branch of the Ausable River above St. Huberts—largely free from commercial lumbering. For quite a period when the financial pressure was greatest, Robert W. deForest, William A. White, and Alfred T. White made up the deficit. DeForest, when he was president of the Metropolitan Museum of Art, once wrote: "And if it be an act of philanthropy to preserve the masterpieces of art for the public good, it is equally commendable to seek to preserve the masterpieces of nature."

Between 1921 and 1932, however, the AMR sold 18,215.32 acres to New York State to reduce its heavy tax burden. In 1978 it sold another 9,100 acres, reducing the total AMR acreage to about 7,000.[9] The sold tracts, which contained not only some of the most scenic portions of the High Peaks but also the much-coveted top of the highest mountain in the state, Mount Marcy, the heart of the Adirondack Park, became part of the Forest Preserve. In

12. *Beech Tree, Winter,* 1922, Harold Weston. From the collection of
Mrs. Lloyd T. Whitaker, Atlanta, Ga.

turn, the money paid by the state for those thousands of acres helped the
AMR continue to preserve the remaining property in a "forever wild" condi-
tion. The state should use any means it has to encourage large landholders to
keep their holdings together for the long-term benefit of the people of New
York State.

Changes in State Policies—Forever Wild

Until 1883 the state sold land from time to time, usually to lumber inter-
ests; once these purchasers had cut off the timber, they usually stopped
paying taxes, and the land was reacquired by the state for unpaid taxes.

The whole process was most inadequately supervised, and the state frequently did not know the location of the various lots of land it owned. To discourage timber thefts a new law was passed in 1883 that forbade any further sale of state-owned land in ten counties, including Essex, which contains almost all of the Adirondack High Peaks. The restricted area was extended to four more counties two years later when the New York State Forest Commission was established. The commission still could sell "separate small parcels or tracks wholly detached from the main portions of the Forest Preserve." Many such were sold, one of them consisting of 3,673 acres. Obviously this legislation was not adequately protecting sales of state land. This prompted quite a number of individuals to make great efforts to have the "forever wild" principle adopted within the Forest Preserve. It took some eleven years, but they were finally successful at the Constitutional Convention of New York State in 1894. This magna carta of New York conservationists became Section 1 of Article XIV of the state constitution. New York's is still the only wild land preserve in the country with state constitutional protection.[10]

It is interesting to note how New York State compares when looking at the dates of early major conservation measures in the country:

1864 Yosemite Park set aside as a national preserve.
1872 New York State Park Commission created and Colvin appointed to serve as its secretary.
1872 Yellowstone National Park established.
1885 Forest Preserve of New York State created.
1886 Audubon Society founded.
1886 Adirondack Mountain Reserve formed and initiated purchase of over twenty-eight thousand acres of Township 48, which later became the heart of the Adirondack State Park.
1891 Forest Reserve Act passed, allowing public-domain land to be set aside for national forests.
1892 Adirondack Park created.
1892 Sierra Club founded as a California-focused group.
1894 The "forever wild" principle added to the New York State Constitution.
1906 Theodore Roosevelt created eighteen national monuments under the Antiquities Act of 1906.

1909 The New York State Department of Conservation was established by combining the activities of several other state agencies.

1916 National Park Service founded, establishing a system of national parks.

The above list does not pretend to be comprehensive. Generally, however, New York State was at the forefront of the conservation movement.

13. *Inlet Pine Tree,* 1915, Harold Weston. Private Collection.

4

Youth in the Mountains

Trails and Mountain Heights

FROM THE TIME I was old enough to tag along with my father and older brother when some of the lower ATIS trails were being kept up by volunteers, I learned to help by dragging fallen limbs or cut branches out of the way. Even before that my brother and I marked our own secret "Indian trails" near Icy Brook, using jack knives to make obscure blazes on saplings. We built half a dozen "wigwams," which were simply sturdy branches propped against a big rock or small ledge with boughs laid across and sometimes covered with strips of birch bark for roofing. These usually were crushed by snow the next winter. We did not gather stones for fireplaces since we were not allowed to make any fires in the woods or to stay in these ramshackle shelters overnight.

The first night I spent in a lean-to high on a mountain was on the Marcy Trail from the Upper Ausable Lake, the first lean-to built on a major trail. My great uncle, Charles Alderson, had it built in 1889 soon after the AMR purchased Township 48. It was halfway up from Panther Gorge near the source of Marcy Brook and was then on AMR property. My father took my brother and me to climb Mount Marcy for the first time in 1903, when I was nine. We walked from St. Huberts, rowed up the Lower Ausable Lake, and left our packs at the Alderson Camp. We climbed to the top of Marcy to watch the sunset. Well do I remember the sound of the wind in the trees during that night, that sound peculiar to upper reaches of the timber line where strong currents of air strike against the twisted boughs of scrub mountaintop firs, without the muting of the soft leaves of deciduous trees or blurring vibrations echoing back from higher ridges or taller trees. The next morning we got up before dawn to watch the sunrise from Mount Skylight.

Other customary camping places existed along the trails, such as Slant Rock on the Marcy Trail via Johns Brook, but generally no permanent shelters

were erected. The second real lean-to was built just north of the top of Giant Mountain on the trail to Elizabethtown. This lean-to was frequently used even though no dependable source of water existed anywhere near the site. For some years the ATIS kept a box with blankets at the camp.

Giant, being set apart from the other high Adirondack peaks, is a fine place from which to watch sunsets, moonsets, and sunrises. At certain times of the year, if the weather is exceptionally clear, the rising sun silhouettes Mount Washington of the White Mountains in New Hampshire. Even on good days one normally cannot see beyond the Green Mountains in Vermont. I remember staying at that camp in the early twenties, when dew dripped through the roof and the blankets had disappeared from the box. By 1923, when I stayed there with my bride, the camp had been taken over as a summer resort by two obstinate, seemingly arthritic porcupines. No matter how often you drove them out, they would slowly and silently lumber back just as soon as they thought you were asleep and then try to curl up like affectionate kittens on part of your blanket. The forest fires of both 1903 and 1913 skirted around the top of Giant and did not touch this little camp, but the blanket box finally succumbed to porcupines in 1923.[1]

All traces of the Alderson and Giant lean-tos have long since disappeared.

Community Lean-to Parties

At Icy Brook we had an exceptionally large lean-to with log settees alongside for overflow crowds of forty or more. This lean-to was too large to keep supplied with fresh balsam boughs, so each summer it was carpeted by freshly mowed hay. We children rarely slept there. Usually it was used for community parties, singing, and often charades. (See part two, p. 143, "Letter written by Harold's mother 'exactly as dictated' by Harold, to Uncle Walter Percival, n.d., 'up in the Mtns.'") My grandfather and an uncle had brought nearly a hundred gay Japanese paper lanterns of all sizes and shapes from Japan. We children helped to supply them with new candles, to nail brackets on trees on which to hang lanterns, to make holes in the ground for slender poles with a forked branch notched for lanterns, and to light them after supper so their flickering light through the woods indicated different ways to reach the lean-to. We also helped to get wood for a big bonfire and to carry simple refreshments over to the lean-to. These

campfire parties to which young and old were invited were great fun. My sister led the singing with a large repertoire of then-popular songs, old English or Scotch ballads, Negro spirituals, and hymns. I often accompanied on the mandolin. The companionship generated at these community campfires was intensified by the tangy smell of balsam and wood smoke and the crackling and exotic fireworks of sparks against the night sky with a sense of the wilderness all around.

Camps on the Upper Lake

By 1906, eighteen years after the founding of the AMR, certain major stockholders wanted to build camps on the Ausable Lakes. My grandfather, Charles Hartshorne, a charter member of the AMR, had obtained a lease for a large camp on Sandy Point on the Lower Lake. Before he got around to building, two small landslides started simultaneously, high above on Sawteeth, joined forces, and swept over the proposed campsite. I remember this slide made the water of the Lower Lake a lighter brown than the usual dark obsidian for the rest of the summer. The landslide shook up my grandfather's good intentions. On the Upper Lake the AMR purchased those guides' camps that were still being used. A couple of guides' camps were remodeled or added to by the new owners, but most private camps were built on completely new sites. Strict regulations prevented the large clearing of trees, and all buildings were to be in keeping with their surroundings. The first private campsites on the Upper Lake went to W. A. White, A. T. White, Robert deForest, Henry deForest, and Hartshorne early in 1907.

In preparation for helping Hartshorne choose a campsite, my father, brother, and I spent some time in early September 1906 exploring all potential campsites on the Upper Lake. None had yet been assigned. The most alluring location was on a narrow point of land covered with stately white pines between Labrador Bay and the lily pads near the Inlet. Verde Beede's camp there offered a magnificent view of the Great Range. He claimed to have a well of never-failing spring water handily near the kitchen. My father was skeptical about this "spring" and told his sons to bail it out. We hauled up bucketful after bucketful by rope and dumped it out. The water lowered quite fast, and then up came old bones, rusted tin cans, and broken glass. Evidently the well served as a garbage dump at the end of the season. The

camp now on that site gets its water piped under the lake from Crystal Brook a good mile away. In 1906 such an engineering project for an Upper Lake camp was unthinkable. Rather than select and remodel one of the guides' camps, my father decided to build a new one. The site chosen for my grandfather has its own brook and a fine view of the Range.[2]

On the way up to the Adirondacks the following summer Father took it into his head to have the barber on the Hudson River Night Line shave off the beard he had always worn. He did not tell Mother he was going to do it, so when he walked into the state room, Mother uttered a shriek and fainted. When we got to St. Huberts, Mother commanded Father to go to the Upper Lake and stay there until he grew back his beard.[3] Father, Carl, and I were up there three weeks camping in a tent on the point with a large leaning pine. First a lean-to was built of cedar logs from trees growing along the banks of our stream, which we named Cedar Brook. Then on a knoll a dining room, kitchen, icehouse, outhouses, and woodsheds were built. It was great fun watching the horse we employed for the summer skidding the long straight spruce timbers down from the mountainside behind the camp and watching the skill of the axeman notching the ends of the logs so they would fit and hold, and hewing the sills so they would give even support. My brother and I were kept busy filling potato sacks with moss, gathered from the north side of trees, and wedging it into the cracks between the logs. These camps were put together by hand with the simplest tools, and some of them stand today almost as they were when first built.

The relationship between the craftsmen guides who built the camps and the proprietary AMR members may best be illustrated by an episode that took place a year or so later. Willis D. Wood had obtained a lease to a site and engaged Wesley Otis to build a camp for him. Otis recognized that Wood was to specify the size of the rooms desired and their arrangement. But Wood, who was accustomed to having his decisions carried out promptly and faithfully, told Otis that he wanted a low or fairly flat roof. Otis argued at length, insisting this was wrong and that it would not hold up under the depth of winter snows, soaked by a thaw or rain, and anyway, it would always leak. Wood finally got on his tin horse and told Otis to build as he was told with a low roof. Upon that, Otis lost his temper and shouted, "Who in hell is building this camp, me or you? Why, you're only payin' for it!" Upon which he drove the head of his axe up to the hilt into a stout spruce log and

stalked off as the shaft of his axe was still quivering. Wedges had to be used to retrieve the axe. Wood gave in.

Depending on Shanks' Mare

Two-horse carriages, used as buses, made regular trips to the Lower Lake from St. Huberts until the clubhouse closed for the season. After that, you engaged a team for your own party. Unless you had very heavy packs to take up, however, most people walked. Walking was considered the logical and surest method to get places if you were able-bodied and over six and under sixty-five. Generally the men and boys of a family packed in the household supplies on their backs. The supplies for building a camp, if bought at a lumberyard, were taken up on sledges in winter. If you had an exceptional amount of duffle to carry, a friend would take some in his carriage or you paid the driver a fee. As a bit of evidence about how strenuous walking was during that period—with no transportation aid of any kind from start to finish—I quote (with explanatory interpolations) from a letter my father wrote to an uncle on September 9, 1908.

> We returned yesterday from four days at camp [at the Upper Lake]. The boys [my brother, Carl, aged sixteen, and myself, fourteen] went over the Range Sunday, and Tuesday they went up Nippletop [at that time no trail]. They start on a trip this afternoon via Upper Ausable [spending the night at Hartshorne camp], White Lily Pond, Lake Henderson [bushwhacking almost all the way and spending the second night at the Tahawas Club], through Indian Pass to South Meadows, and home via Railroad Notch and Johns Brook with professors Dewey and James.

This last trip added up to about forty-five miles, though with very little climbing, in two and a half days. That is not bad for the middle-aged educator, John Dewey, and the slightly older philosopher, William James. When we parted at Keene Valley, the two professors trekking back to Glenmore on East Hill, my brother and I to Icy Brook, they insisted on giving us two dollars each "for acting as our guides." We tried not to take it because we had enjoyed the trip so much. But the hardest part, when the excitement was over, was that miserable three miles up the dusty dirt road back to St. Huberts.

My father's letter continues: "Last week the boys went to the Boreas [no trail] and also with me to Colden and up MacIntyre and Marcy." But Father left out the most exciting part of that trip. We bushwhacked from the top of Mount MacIntyre (now called Algonquin Peak), skirting over Wright Peak and down to a big lumber camp on South Meadows, spending the night there much impressed by the cordial hospitality of the French-Canadian lumberjacks. I remember most vividly my revulsion at having to swallow huge chunks of white, seemingly uncooked pork fat floating around in boiled but not baked beans, the main dish. Our long trip had made us almost as hungry as these woodsmen, and, anyway, it would have been a disgrace not to mop up the last drop on your plate with a hunk of delicious camp-made bread. That meal was my introduction to French coffee, made with chicory, of which the camp boss was inordinately proud. Following through the pass and down Johns Brook was uneventful. Father's idea was for us to scout it out so we could take the two professors through it the next week.

A few years later, in 1911, Carl and I, after visiting a friend at Indian Lake, walked back to St. Huberts via Boreas and the Upper Lake, some seventy miles in two days. That was no record; it was not even very unusual for one of the founding families of the ATIS. W. A. White, when coming by train from Brooklyn to Westport, not infrequently, if the weather was right, walked from Elizabethtown over Giant Mountain to his cottage at St. Huberts, while a carriage took his baggage and any other members of his family by way of Spruce Hill. His son Harold's favorite jaunt was to start early from their camp on the Upper Lake, have breakfast on Mount Haystack, lunch on Mount Marcy, with a leisurely return down the Marcy Brook Trail.

In such ways the children of the early summer residents of Keene Valley and St. Huberts got to know intimately the lay of the land, the feel of the mountains, the spots of rare beauty, and they became aware of the rich range of forest growth in an area kept forever wild. During a time when trails were not so numerous, usually poorly maintained, and rarely well marked, either by necessity or because it was so easy to get off a trail, hikers frequently bushwhacked. Such trips turned into voyages of discovery because you generally intentionally tried out new routes. Until after World War II, when the ATIS, the state, and the Adirondack Mountain Club refurbished their trails, hardly a summer passed without at least one night requiring a search party

of guides being sent out on a rescue mission. The ATIS and AMR now have more sophisticated technology to locate wandering trail buffs and to call off further searching by other parties when they have been found. Previously, communication was by a series of gunshot signals.

Shown Up

It is only fair to tell about the time when my brother and I got lost and then shown up for thinking we could travel in an unfamiliar area without the help of a compass. This was in the summer of 1911. Together with my Exeter classmate, Charles R. Walker, we went over Dix Mountain via the ATIS trail, not very well kept up but far better than the obscure track down to Elk Lake, where we spent the night at the Elk Lake Lodge. We planned to bushwhack the next day over Boreas Mountain to Boreas Ponds and then to the Upper Lake. In the morning the clouds hung thick and low. We decided to skip the top and go in a straight line over the Boreas Range. Finch Pruyn was lumbering at that time on the eastern slopes of Boreas. When you are not on a trail it is always a temptation to follow a lumber road or skidway where you do not have to push through the brush, provided it seems to be going more than less your way. These lumber tracks understandably have to follow contours, changing direction often and then changing back. This meandering, when you are up in the clouds and cannot see out, begins to dull your sense of direction. We finally struck out up the mountain and passed beyond the lumber area. After a while we came to what seemed to be the top of the ridge, crossed over, and started down.

We had not gone very far when we heard chopping. That surprised us because we were under the impression that no lumbering was being done at that time on the western slopes of Boreas. We headed for the sounds, soon coming down to where a husky young lumberjack was chopping. He greeted us with a big grin.

"How far is it to Boreas Ponds?" we asked hopefully.

"Boreas?" He paused and shrugged, "Way over mountain," gesturing up the hill we had just come down. "You boys want Elk Lake. Near. Jes' kep on downhill two mile."

Our French-Canadian friend quickly sized up the situation. In the clouds we had gone over a short spur at right angles to the main range,

and swung around down to the lumber job again. These pampered young-sters who thought they knew the woods were conceited about their ability to climb and did not bother with a compass. Here was a chance to teach them a lesson.

"I show you up," he announced unasked. Without another word, he took off at a fast pace straight up the mountain. Each time there seemed to be an alternate route, he chose the toughest and steepest way, increasing his pace. We had our tongues hanging out trying to keep up with him; after all, it was the second time that morning that we had thrashed through brush up that darned mountain. Soon our guide had completely disappeared up above us, but he kept egging us on with intermittent "Ha-a-al-l-o-o-os." When we did get to the top of the divide, there he was, lolling on a fallen log, complacently smoking a cigarette as if he had been there a long time. He did not give us time to catch our breath enough to say thanks but rose to his feet. With a touch of pride in his manner and a twinkle in his eye, he said, "You boys jes' kep down ze' hill an you won' git loss agin." With that parting shot he was gone. We looked at each other and then began to laugh. He had surely shown us up.

Bolt from the Blue

Ever since childhood I had been climbing mountains during summer months and the rest of the year taking a keen interest in track and tennis. Late in August 1911 infantile paralysis incapacitated my left leg, leaving me with no control over the ankle and very little over the hip and knee. I was supposed to wear a brace and use crutches the rest of my life. All the physical energy I had previously spread among several sports now had to be confined to swim-ming, canoeing, and walking. If I tried to get up any mountains, it would be strictly against doctor's orders. These physical limitations at the age of sev-enteen turned me all the more to communing with the woods and to paint-ing. It became characteristic of me to do things alone. In my painting I have preferred an independent course, have been a cat who walked by himself, making his own decisions. The first summer after polio, I started using easy trails and soon discarded the brace. By the second summer, I was climbing smaller mountains with crutches, for instance, going up Noonmark to pho-tograph the forest fire in the Bouquet Valley. The third summer, I depended

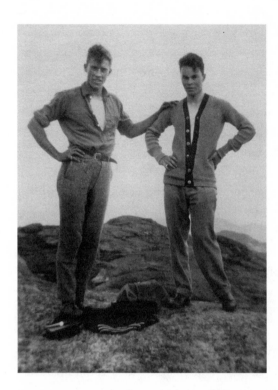

14. Harold Weston and
Charles Walker on top of
Mount Marcy in 1914, three
years after polio paralyzed
Weston's left leg. Harold
Weston Foundation.

only on a cane for smaller climbs but still used crutches for the highest, actu-
ally climbing Gothics from the Johns Brook side, hitching up the rockslide
with push-ups while a friend carried my crutches. By the fourth year, I found
it was far more efficient to climb with a six-foot yellow birch sapling—what
speed you could make with the pole-vault leaps when coming down.[4]

Forest Fire of 1913

Lightning struck the northern slope of Dix Mountain in September 1913
shortly after the clubhouse was closed for the season. At first the fire burnt
rather slowly because that area had been burnt in 1903. The Department
of Environmental Conservation had been created and plans were progress-
ing for the building of fire towers on strategic mountains—not the highest,
since the towers needed to be accessible to living quarters for the fire war-
dens, but those that commanded an extensive view, such as Hurricane and
Boreas Mountains.[5] A fire control system had not been completed yet, and
in this emergency there seemed almost no organization or direction of the

available human resources. Woodrow Wilson had spent a previous summer at St. Huberts, though not at the club. Now he was president. So an appeal was made to the White House for troops to help stop the fire. A regiment of regulars was sent down from Plattsburgh, New York. They pitched their tents on the ball field at the foot of Chapel Pond hill.

Our family became involved immediately. Before the troops arrived, my brother and I were sent up Noonmark to scout out the situation and take photos. It was a most dramatic sight, with smoke clouds billowing up from the Bouquet Valley like boiling thunderclouds well below. At that time it was not a crown fire, and there was too much smoke to see any flames. My father, who was secretary of the ATIS, and who probably knew more about the mountain trails than any other AMR member at the time, was asked to advise the colonel about where to start firelines. A fireline is a broad strip where all trees, brush, and burnable topsoil are removed, the trees being felled in the direction of the fire. A backfire is then started from the fireline to meet the oncoming fire in hopes that all flammable material will have been consumed. With nothing left to burn, the fire will be stopped. By this time, the fire was coming along the ridge of Noonmark. Father recommended a fireline from the Noonmark Notch along the edge where the 1903 fire had stopped and that backfires be started just as soon as possible. That evening, the colonel and Father were inspecting the fireline, which at this spot was a shallow trench cleared down to bedrock. Someone yelled "Timber!" warning that a burning tree was falling in their direction. The party ran down the trench in semidarkness. My father, aged fifty-eight, was following the man ahead so closely that he failed to see a small ledge, fell, and sprained his ankle badly.

The fireline held, diverted the direction of the fire, and saved the northern third of Round Mountain. But further south the flames swept on and the troops were ordered to new positions. Early next morning a few of us went with the colonel up the Chapel Pond road to inspect the progress of the fire, which by then was burning the entire side of Round across the pond. The heat was so great that we stopped in the shelter of a knoll before the dirt road dipped down near the pond, and even there we had to shelter our faces from the heat. Clouds of smoke darkened the sky, increasing the dramatic effect of the light from the flames on the cliffs above the pond. Some trees were breaking off and plummeting down into the water. Suddenly, sharp but deep

reverberations sounded above the crackling and roaring of the fire. They were explosions of rock, deprived of its water by crystallization on account of the intense heat. These explosions blew off small pieces of hot rock, which sent up little clouds of steam as they hit the water. It seemed like a scene from Dante's *Inferno.*

For a second time efforts to stop the fire along the road beyond Chapel Pond failed as dismally as in 1903, and the flames started burning on Rocky Peak Ridge and edging toward Giant. It was decided to send the troops up the Giant trail to dig a fireline and start backfires on the southwestern shoulder of Giant. Men and equipment were sent, telephone lines were strung for communication, and the men worked until exhausted.

When the fire passed Giant's Nubble and reached virgin timber at about noon on the third day it took on an explosive fury, as if vast quantities of kerosene had been dumped on it. The roar of the wind that its heat generated was trebled. If the prevalent wind from the southwest changed, the course of the greatly enlarged conflagration might swing around and engulf St. Huberts. Because of my father's sprained ankle, key community leaders crowded that evening into the small living room at Icy Brook for emergency decisions. Among those present were Robert W. deForest, president of the AMR-Ausable Club, William A. and Alfred T. White, Felix Adler, two of the Putnam Camp brothers, Scott Brown, Spen Nye, and the colonel. While they debated how to obtain enough horses and carriages to evacuate the residents of summer cottages and year-round homes at St. Huberts, and the logistics of supplying troops working on the upper shoulders of Giant, my mother was assembling a few cherished possessions in a small steamer trunk. My sister, who was fourteen, had been told to go to bed but was breathlessly listening at the crack of her bedroom door. My brother and I were allowed to be present silently. The conclusions were to get ready for evacuation but wait a day before starting, extend the fireline up over the southeastern shoulder of Giant, and pray for rain.

The fire raged on. We gathered that evening on the top of the hill near the dark and deserted clubhouse, grandstand seats for a great drama of nature. As we watched, the top of a burning tree, sucked up by the tremendous updraft of the fire, and pivoting with sparks flying like a slowed-down pinwheel, sailed through the air, high above the mountain shoulder, and then fell into Roaring Brook Valley a full half mile behind the line held by

the troops. We could see the woods starting to burn almost immediately in
this new place.[6] The men were told to retreat up the mountain and start a
line still higher up.

We were convinced that the heroic efforts of the soldiers were of no avail
and that all of Giant would be burnt. And then toward midnight, almost
miraculously, drops of rain started to fall. The rain increased and by morn-
ing the fire had abated. But the volume of smoke was so great that the odor
of burning wood spread through the back draft of upper air currents all the
way to New York City. A friend recently confirmed having smelled it there
when there were no nearer forest fires. It was not safe to consider the fire
out for at least another two weeks. The chances were that it would continue
smoldering deep in the duff and might break out again. So the regiment was
kept in camp on the ball field, much to their disgust. I belatedly hustled back
to college at Harvard.

Men serving at that time in the U.S. Army had to pay for their uniforms
and all other apparel. Fighting a forest fire is terribly tough on clothes and

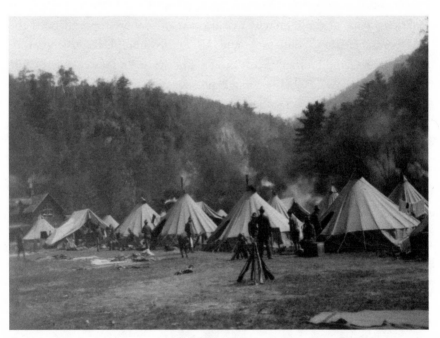

15. Army encampment at St. Huberts during the 1913 fire. Photograph by Mrs. G.
Notman. Courtesy of Archives, Keene Valley Library Association.

shoes, and the men got no extra pay for such duties. Aware of this, members of the Ausable Club raised six hundred dollars to help the soldiers buy new uniforms or at least have them repaired and cleaned. It was then discovered that army rules strictly forbade giving "gratuities of any kind" to men while on service. The money was deposited in a savings fund instead. Some thirty-five years later it was turned over to the ATIS and became the basis of the ATIS Fire Fund for the purchase of fire-fighting equipment and allowances for volunteer forest-fire fighters.

Nature's Cycles

In a climate such as ours, nature abhors a vacuum. The following observations about flora and fauna in the Adirondacks after a large scale forest fire are based on my own observations and do not pretend to be authoritative or comprehensive. The reported sequence of growth is subject to striking variations depending on the character of the fire, how much the vitality of the soil was depleted, the nature of the terrain, and many other factors.

The first massive growth along with grasses is of a rather coarse wildflower called "fireweed," which has tall spires of magenta-purple flowers. In a few years these are crowded out by berry-bearing bushes, raspberries and blackberries mainly, later blueberries, all of which like sun and open spaces. Before long, bushes, largely alders, then softwood trees such as white birch, "popple" (poplar or aspen), swamp maples and ash, for example, begin to take over. Their life span is not long unless they are in a sheltered spot, and when they die they enrich the fire-depleted soil. Usually hardwood trees, such as yellow birch, sugar maple, beech, oak, elm, and others, begin to appear only after an intervening stage of firs—cedar, spruce, balsam, hemlock, and various varieties of pines—has spread up the mountain sides and given shelter for the growth of ferns, mosses, and shade-loving plants. This whole process varies greatly in different areas and generally takes a couple of centuries. Naturally, at spots favorable to a particular type of tree, its species may hold possession for more than a century. The speed with which certain varieties begin regrowth also depends on availability of seeds, such as from the patch of spruce skipped by the fire of 1903 near the top of Noonmark.

Each of the periods of growth brings its special advantage to certain birds and animals of the region. Other species still get along, but the favored

16. *Grasses,* 1959, Harold Weston. Collection of Marion Sudduth Whitmore.

ones temporarily prosper. Early in the sequence rabbits and their larger cousins, North American hares (prevalent in early settlement days but rare now) flourish, and consequently also their predators, foxes and owls. Berry-eating birds and bear enjoy the next sequence. Deer appreciate expanded browsing areas provided by open woods, but they must be careful not to be caught among deciduous trees when the snows come—deer yards almost always are established where cedar, which deer eat, or at least other evergreens, provide protection from deep snow and winter storms.

The tree sequence and time span might be illustrated by the changes along the southeastern shore and mountainsides by the Lower Lake as a consequence of a mid-nineteenth-century fire. In my youth on that side of the

lake, contrasting with the hardwood trees on the north side and all the more noticeable in autumn when the latter turn brilliant reds and oranges, there were just a few fir trees growing under gracefully arching white birch. Sixty years later, only a few dying birch remained, the firs (mostly spruce) grew close together and tall with arborvitae and mountain ash, along the shore's edge. Near the top of Mount Colvin, where soil accumulation takes longer and the growing season is shorter, it has taken the dark evergreens longer to fully take over.

In contrast to this slow process, recovery can take place quickly in the area of destruction from a slide that is relatively superficial and not extensive. Going up the Wedge Brook Trail in the early 1920s, just below the Lower Wolf Jaw cliffs, I was immensely impressed by the beauty of a grove of white birches close together, tall and stately, which evidently had grown up where a slide possibly fifty years earlier had removed a bit of the forest cover. When I returned to the same spot some thirty years later, most of the birch were gone and a thick grove of balsam and spruce would soon become just as established as those on the surrounding mountain slopes. We tend to forget that irrespective of fire, slides, or blowdowns, the forest is constantly changing and that each sequence has its aura of fragrance; each makes its unique contribution to the ecology of that particular portion of the wilds. The wilderness is a living thing.

17. Harold Weston at the Upper Ausable Lake, 1921. Harold Weston Foundation.

5

Alone with Paint

Decision to Become a Painter

ON GRADUATING FROM HARVARD in 1916 I signed up with the International YMCA for war work attached to the British Army in the Near East and was out of the country for three and a half years. The only mountain I climbed was the Elwand Range (about thirteen thousand feet) in Persia. By the beginning of 1920 I had decided to devote the rest of my life to painting and with that in mind experimented with art school in New York City for a few months. To learn how to paint from objects or models that meant nothing to me seemed too external a process. I wanted to get down to what I thought were fundamentals alone with paint. I felt that if I lived at St. Huberts with the woods and mountains I had known so many summers, the techniques of how to paint would work out.

What is the lure of nature? What gives to persons attuned to it the ability of almost total recall of a trail followed even once, like the person musically gifted who hears a song or complex melody but once, and can go home and play it without any written notes? I can still wander over trails I climbed years ago, recall the changing conditions of the forest floor and how the character of the trees alters as you reach a higher altitude, the flowers, berries, ferns, mosses, and lichen, the quickening of breath as you reach a lookout or get beyond the timber line. I carry these trails with me. Many of the new trails cut out by the ATIS have followed routes that I had bushwhacked and suggested. I know the trails at least around St. Huberts in all seasons. At twenty-six years old I was convinced that this edge of the wilderness was where I belonged and that there I should make my home.

Studio Built at St. Huberts

With the help of a sailor-turned-carpenter I built a one-room summer studio. Very soon I announced, to my parents' dismay, that I intended to spend the winter in that summer shack. My mother, at the prospect of this isolation— no near neighbors and no telephone—insisted that I purchase a revolver with boxes of ammunition. Presumably, in an emergency, if I suddenly became ill or cut my good leg while splitting wood, the sound of shooting would bring help. I did not disillusion her by pointing out that such shots would only be heard on a quiet day with a breeze in the right direction.

The walls of my studio were made of rough native hemlock, the framework of spruce. Studding and rafters showed the line of the roof. Two layers of tar paper were held on the outside by spruce slabs, and there was no insulation. I kept the pot-bellied boxstove stoked with two-foot-length logs so the fire in it only went out once or twice during the winter months. I built an outhouse in the balsam grove in back of the house. Rugged simplicity was the basic characteristic of my life at that time and the place in which I lived.

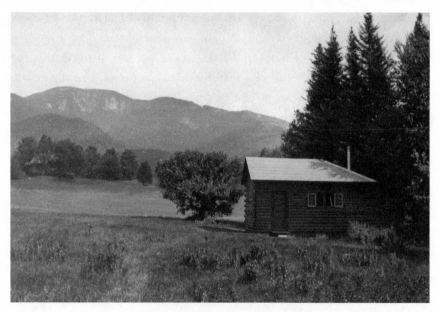

18. Weston's summer studio by a balsam grove looking up at Giant Mountain. Photograph by Harold Weston, 1920. Harold Weston Foundation.

I was as profligate with canvas and paint as I was frugal in living—spoon, fork, knife, frying pan, coffee pot, a few pans and a kettle, axe for wood, warm clothes, high lumbermen's boots and snowshoes, daily milk from a farmhouse down the hill, and monthly supplies from the village three miles away. These and my paints were the essentials.

I did a lot of wandering in the woods, up streams and climbing mountains, always with my sketch box. I painted a great many small oil sketches on cardboard on the spot. A semipantheism permeated my reactions: the tree, cloud, mountain—life and the eternal seen through the incandescence of the moment. The second year I started painting somewhat larger oils in the studio, not directly from nature, but based on my knowledge and love of nature and expressed in somewhat stylized forms.

Lumberjack's Sky Pilot

That first year my plumbing equipment consisted solely of an old iron sink, which came from David Hale's abandoned farmhouse. My water was piped from the Noonmark spring half a mile away, underground to prevent freezing, only a foot deep in the woods but down four feet in the open.[1] I tried snow baths—soaping down with a bit of cold water and then rolling naked in the snow when it was fluffy—far less of a shock than jumping into ice-cold water that engulfs belly and back simultaneously. But I did not become partial to this method of hygiene. I also found the use of an outhouse in twenty-below-zero weather tended to bring on constipation. My studio was far too hot near the stove while not much above freezing in the rest of the room. Later on, when spring came, I discovered the reason for this was that the hemlock boards had shrunk, leaving gaps above the roof plate that could not be seen but that effectively let out any accumulated heat. I dressed warmly, however, and got used to living in a sieve.

One midwinter evening after a rather heavy snowfall as I was reading by my kerosene lamp after supper, a knock on the door startled me. No one was expected. No one else lived "on the hill." The fresh snow had muffled any approaching steps. A tall gaunt man, whose dark clothes were powdered with snow, stood outside on peculiar ski-like snowshoes. In broken English he introduced himself as "Father Niccole, sky pilot for lumberjacks." He then asked if he might spend the night. Fortunately I had a second cot, though he

said he would be quite comfortable on the floor. He explained that he went from camp to camp throughout the Adirondacks all year round to bring spiritual comfort to the French-Canadian lumbermen.

The clergyman had come from Elk Lake and spent the night in Elk Pass, which is three thousand feet high between Nippletop and Mount Colvin. The snow there was "as usual at this time" twenty feet deep. He carried a small rucksack with dried foods, a tarpaulin, and two blankets. Attached to the rucksack was a very blackened, shallow covered aluminum pan with a long handle to hold over a fire and a half-sized double-bladed axe. I was fascinated to learn his technique. When stopping for a night in the woods he first looked for a small cliff or big rock and then for three trees, preferably balsam or spruce, of which about twenty feet ought to be above snow level, though this was not essential. He used some twelve feet of their trunks as rafters, leaning them against the rock. The larger branches became the roof and also closed up the ends of his "bough house"—the name given by the early Adirondack guides to this kind of shelter. He then crisscrossed the small boughs cut from the tops of the trees on the snow where he intended to sleep. He chopped four or five heavy chunks from the bottom of the trunks and stamped them down in the snow against the rock to form a hearth, which sank as he cooked, to keep his fire from being extinguished by snow melting from its heat. Finally, he looked around for some dead wood—not easy to find when the snow is really deep, as it was in Elk Pass. If he spotted some dead twigs above the snow, he would take off one of his snowshoes and use it as a snow shovel to locate a dead tree or to find out whether it was just a dead branch. Getting dryish wood was one of the worst problems, but his fire was not a campfire for warming his bough house; it was only for cooking supper and breakfast, which did not require much wood. After eating his dried food cooked in melted snow, he would wrap himself up in his blankets and crawl between two layers of his tarpaulin forming an improvised sleeping bag. He took these rigors in his stride and trusted in the Lord.

I asked him about his snowshoes, the likes of which I had never seen. Trappers generally prefer the "bear paw" kind, oval shaped and without tails, claiming that they are easier to manage in thick brush and to turn around on in a tight place. My snowshoes were the usual pattern, with fairly pointed toes, broad middles, and with the wooden framework extending beyond the heel of the snowshoe to form six-inch tails. Niccole's were over six feet long

and at no place wider than six inches. He was obviously very proud of them, and I gathered he had made them himself. He claimed they sank down less in powdery snow and accumulated far less snow on top with each step or glide. He pointed out the advantages they had over skis in mountain country—the crossed thongs gave desired traction when climbing and acted as brakes on descent. With them he would tackle almost any snow condition except a winter thaw that turned the surface of the snow into ice. He explained that he could have come down from Elk Pass much earlier but that the storm was wild up there and he waited too long for it to pass. He was looking for a place to stay when he saw my light.

Hermit of the Ausable Club

During that long winter I took many snowshoe trips alone. One memorable one was from our camp on the Upper Ausable Lake via Marcy Brook almost to Panther Gorge. Another trip was to the foot of Dix Mountain in the Bouquet Valley. The most exciting adventure was the return trip from Giant's Washbowl. The snow was deep and powdery in the woods, making progress tedious on account of the snow weighing down my snowshoes as each step sank down some eight inches or more. After having lunch in the old lean-to at the Washbowl, I decided to try a shortcut down the steep slopes of the Chapel Pond cliffs where the soft snow had been blown off and most of the surface was iced over or hardened. I could see the men cutting ice on the pond below and thought that if I got into trouble they would be able to hear my cries for help. Fastening my snowshoes together as a makeshift toboggan and using my long pole as a guide and brake, I slid from exposed rock to tree stump or rock, reasonably slowly and safely. Halfway down I stopped to take a photo of the men working by the black hole in the pond with a team of horses and sledge waiting to take the three-foot cakes of ice to the icehouses at St. Huberts (see ill. 19).

When I got safely down and crossed the snow-streaked ice of the pond to speak to the men, they told me that when they heard some ice or stones falling down up on the cliff and then saw a dark object slowly moving down, they thought it must be a bear that for some reason had come out from hibernation. That is the time when a bear is pretty hungry and better left alone. When it seemed to be heading for the pond toward them, they got a

bit excited, but even though the slight breeze was in the right direction their horses remained undisturbed. I have never heard of a bear attacking a horse, but instinctively horses get their wind up and become terribly restless if a bear comes anywhere near them. The ice cutters finally realized the moving object was a man. Actually, I was wearing my black corduroy fleece-lined jacket and a dark fur hat that I had made for myself from an old muff my mother had discarded. It was not so hard from a distance when your eyes were watering from the cold to mistake me for a good-sized bear. Anyway, the men simply could not imagine that anyone would be such a damn fool as to come down those cliffs in winter. This was long before winter climbing in the Adirondacks became commonplace. My reputation in the village as that "crazy artist" increased and the main local weekly, the *Adirondack Record*, called me the "'Hermit' of the AuSable Club."[2]

Ice Harvesting at St. Huberts

Until the Ausable Club generator was turned on in 1924, one of the major winter jobs at St. Huberts was to fill the icehouses. An average of fifty horses and thirty men were kept busy for about a month. In back of the clubhouse were two large icehouses that together held eight thousand cakes, more or less, depending on the thickness of the ice cut that year. The AMR had a smaller icehouse by the home of the superintendent that held around six hundred cakes. Each privately owned cottage, some twenty-five of them, and the ten year-round residences had their own icehouses averaging at least three hundred cakes apiece. The same was true for the camps at the Upper Lake. Thus the total number of cakes of ice to be harvested each winter was at least twenty-five-thousand cakes, ideally sixteen inches square and thirty-six inches thick. Some winters the average yield was nearer twenty-four inches thick, in which case the number of cakes had to be considerably increased. One year in the 1920s, the ice from the Lower Ausable Lake was forty-seven inches thick, but that was not desirable and much harder to handle.

The best source of ice was Chapel Pond, about two miles away from the Ausable Club. From there all travel was downhill, except the last bit up the hill by Icy Brook, where an extra team helped make the grade. Some years two crops could be harvested from Chapel Pond. At that time the northern

19. This photograph of Chapel Pond shows how little Round Mountain had recovered from the fire of 1913. Practically all of the trees that were killed by the fire but left standing, like those in the foreground, had fallen by 1970. This photograph won honorable mention in a *New York Evening Post* national competition and was reproduced in the paper's March 18, 1922, issue. Photograph by Harold Weston, 1921. Courtesy of the Archives of American Art, Smithsonian Institution.

end of the pond was AMR property, which was sold to the state in 1932 after the ice-harvesting days were over. Ice from the Lower Lake first had to be dragged up a steep moraine hill by a "short-haul team," which took small loads and stacked the cakes at the top of the hill for their subsequent ride on the big ice sleds downhill all the way to St. Huberts. Ice taken from the Upper Lake was exclusively for the camps there. The snow often got very deep at that higher altitude, and it took a lot of shoveling to make a road the horses could pull a sled through up to the camp icehouses. The lost art of ice harvesting in the Adirondacks, which required a lot of man and horse hours and which called for considerable judgment and special equipment that hardly exists today, is well worth recording here.

The initial problem was to determine just when to start cutting. It was essential that the ice be at least twenty-four inches thick, preferably thicker. Often there was a January thaw, and any thaws were to be avoided if possible. If the ice, after being laid out and plowed for cutting, is covered with water either from a thaw or rain, it is dangerous to continue working on that part of the pond. The blocks that had been ice-plowed were liable to crack off under the weight of a horse. If, as sometimes happened, a horse fell in, the seemingly cruel but most effective way to get it out alive was to "choke it up." A rope was hastily thrown around its neck and tightened until it could only breathe in, not out. Nature provides greater strength to suck air in than to exhale it, perhaps for just such emergencies. Whatever the reason for this phenomenon, the horse very soon would swell up and rapidly increase its buoyancy, stop struggling, and float to the top. Then a much longer rope was tied to the harness, and a group of men would gather on one side of the hole to depress the ice so it would not cut the horse when they pulled it out over the ice on its side or got another horse to do so from a safe distance. The unconscious horse would be dragged a fair number of yards from the hole before the rope around its neck was untied. A horse so dunked almost always recovered with remarkable speed, though it had to be taken at once back to the barn and out of the cold. But to a few of them it was a traumatic experience and for the rest of their lives they shied away from going out on the ice. They could still be used in the harvesting if not asked to confront the cause of their trauma. During the fifty years of ice harvesting at St. Huberts, although several horses and many men took a dunking that none of them will forget, none lost their lives.

The first step in the process of cutting took most of a day, but only one horse, a few men, and one piece of special equipment were required. On the surface of the pond a rectangular space was marked out, generally one hundred by two hundred feet. Then an old and steady horse, trained to walk a straight line, was hitched to an ice plow. This had a framework and handlebars like a farm plow, except attached to its base were five-eighths-inch steel blades with sharp pointed hook ends to cut or "plow" the ice. They were fixed, three in a line, one behind the other, with each one set to cut a little lower than the one preceding. Wood blocks rested on the base, which the plowman adjusted with thumbscrews so that the blades cut deeper down into the ice on successive rounds of plowing. The procedure was to start at one corner, the one nearest where the sleds would be loaded later, and plow lines

sixteen inches apart first north-south, then east-west, until the whole area marked for cutting was covered by plowed squares. The second time around the blades were lowered, and again each successive round until a depth of at least fifteen inches was reached. Here was a time of major risk. If the estimate of the thickness of the ice was far off, over rather than under, and the ice was only a few inches thicker than the plowed furrows, and you could not be sure of the thickness until the first cake had been hauled out and measured, then the ice cakes might break off with the horse's weight.

As the ice plowing was on its last round, other men gathered snow in a "scraper" to fill or "chink in" all ice-furrows that were not to be sawed or chiseled apart that day. The purpose of this was to reduce the chances of their freezing up after the first hole let in water when the grid work of the furrows would be filled. When water is snow-filled it freezes more slowly and even then not solidly. Under some conditions, if the first real freezing of a pond takes place when its water has recently absorbed a heavy snowfall, and subsequently more snow covers it when it only has a thin coating of ice on top, for the rest of the winter certain portions of that pond may remain insufficiently solid to support even a person on snowshoes, let alone a horse. Whenever a space has been plowed on a pond, its corners are marked with a small tree, often propped up by cakes of ice. This is to show very definitely where plowed furrows exist, which even a two-inch snowfall would completely obscure. Also, these markers warn anyone that this section of the pond has been cut and may have frozen over but not yet solidly enough to bear any weight.

By far the hardest task in ice harvesting was getting out that first cake of ice, actually the second square from the corner. Beginning again nearest the loading area, the men chopped up and shoveled out the first cake as low as convenient and then broke it into pieces with an ice chisel. These were four-inch blades on stout six-foot wooden poles. After the first small hole in the ice let water through, of course that square filled up with water, and floating ice chips made it difficult to see where to chisel next. All that was necessary, however, was to open a space big enough to get the ice saw through in two directions, and then the ice saws took over. An ice saw was very much like an overgrown crosscut saw, longer (six foot), with larger teeth more coarsely set. It had a peculiar wooden handle at only one end, fairly straight with the blade-length to which it was secured by a steel brace, but the wooden part

had a slight crook so a man could saw standing up and yet cut ice over thirty-six inches thick more or less right below him.

The two sides of the first furrow were then sawed as far as cutting was to be completed that day. After that, ice chisels were used to crack the furrowed squares apart. Other men pulled out the cakes as fast as they were freed, using large-sized ice tongs, two men to a cake. These cakes were not allowed to remain near the edge of the open water but were skidded back quite a piece to where the sleds were to be loaded. If these cakes were stacked too close to open water, their weight would gradually sink the ice in that area, and when the weather was good and cold, water from the hole would soon freeze the cakes solidly to the pond. The cakes were loaded onto special ice sleds, actually two sleds, each with steel-faced wooden runners, fastened together by an ice rack with high sideboards and chains to keep the cakes of ice from sliding when the framework was not on a level. These sleds drawn by two horses took as many as forty cakes at a time, if the ice was of average thickness. To slow down the sleds on the steepest down grades, sand or hay was spread on half of the road while the other half was not covered to make it easier for the horses to pull the empty ice sleds back uphill.

At the icehouses each layer or tier of ice was covered with snow, which the men stomped in but did not chink solidly, leaving enough snow between each layer so the cakes would not freeze together. Some of this work was done on stormy days or if the wind in subzero weather made ice cutting on the pond or lake just too punishing. When an icehouse was full, the top tier was covered with at least a foot of sawdust brought from the nearest sawmill in gunnysacks or burlap bags originally used for potatoes or apples. An important final step in preserving this source of summer refrigeration was the use, as spring came and thawing started, of ice chisels to press down the extra sawdust on top into all crevasses or cracks between ranks and to cover over carefully any exposed ice when taking cakes out during the summer.

Much of this information about ice harvesting was given to me by Hubert Nye, born at St. Huberts, son of Spencer Nye who was in charge of wood cutting and ice harvesting at St. Huberts for nearly fifty years.

Splitting Wood

In the winter the sun sets early at St. Huberts, probably an hour earlier than it would if the High Peaks were not clustered in the southwest. Having only a

kerosene lamp, I made no attempt to paint after dusk. A good-sized woodpile always stood in the snow outside my door along with blocks that needed to be quartered, at least, before they would fit into my stove. I would take my double-bladed axe, my six-pound splitting hammer (locally called a "peed-unk"), and a couple of wedges to split apart obstinate crotches and two-foot lengths of curly maple or yellow birch. When it became too dark to work on my winter wood, I would put on my heavy jacket, grab my fur-lined gloves, take my six-foot staff with a spike driven into the bottom to keep it from skidding on ice, and start down the hill to Spencer Nye's. I never used a lantern or flash when snow was on the ground. It is surprising how much light snow can reflect from the night sky.

Spen, with his snow-white short-cut hair and ruddy complexion, was quite a fellow. Though he had had little schooling, he had a keen mind and made good use of it. He was road commissioner for the township and owned the biggest livery stable in town, often with fifty horses in the barn. You could hire Spen to get to the train station or back. "The ride to [the] Westport [station] is not without its exhilaration," wrote Faith after a winter trip to the Adirondacks before we were married, "when Spen drives out into slithery drifts or bumps along seeming shell-holes of snow and ice."[3] He employed and boarded up to twenty husky men—a tough but good-natured crew. Spen's three-story house was a combination dormitory and home for his two children. His wife died in the flu epidemic of 1918, and his married daughter ran the establishment as well as taught at the one-room schoolhouse nearby.

Someone would pick up my mail along with Spen's on weekdays from the Keene Valley post office three miles away. I came down in the evenings to get it. The best time for that was after the men had eaten their hearty evening meal and had gathered with Spen in the back room around a box stove, the sides of which often glowed from the well-stoked fire. They chewed the fat as well as tobacco, spinning yarns, commenting on events of the day, or kidding each other. Lumbermen or ice-cutters, working all day in the cold, seemed to need to soak up the heat in the house in rooms that got hot as an oven and stuffy and blue with tobacco smoke. When the snow was right, I employed one of Spen's men, a horse, and a jumper to bring to the studio wood that I had sawed into lengths from big trees on the other side of the swamp. The men knew how cold I kept my studio—not at all to their liking. They seemed unconvinced when I insisted I got more work done when the place was cool. They figured I was just reducing the amount of wood I had to cut and split.

Spen had his favorite chair in the back room, which no one else dared to sit in. It was within good spitting distance from the ashes under the stove door. The whole top of the stove swung around to take big chunks of wood, as mine did, but not for getting rid of some extra tobacco juice. One evening, much to the men's delight, Spen started kidding me about my living alone up on the hill.

"You're not such a bad-lookin' feller that you couldn't get yourself a woman to keep you company up there. Why, she could do your cookin', darn your socks, keep the place clean, lots of things. It must get awful lonesome now and then."

"I don't want to get hooked up yet," I replied, "and, if I had a woman up there, you can bet your bottom dollar she would try to get her hooks in me."

Spen's retort to that was immediate. "All right, get yourself two women. Then you'll be safe. They say three's a crowd and you won't have to worry."

My parry to that was a bit feeble: "Women will want to keep the place a hell of a lot hotter than I like it, and think how much extra wood I would have to split."

Letting his tipped chair back onto the floor and slapping his spread thighs, Spen threw out as if calling a poker hand, "All right then. Here's a deal. Get those two women, boy, and by jeepers, I'll bring your mail up to you every night and help you split that wood!"

Sugaring Off

The snow came early and lasted long that first year living alone at St. Huberts. Ten inches had fallen by mid-October and snow remained in the woods until mid-April, until mid-May at higher levels. I kept track of the thermometer that year. Several times it dropped to more than thirty below zero; once to forty-five and one-half below. In my opinion, winters were colder then than now. During the first two weeks of March we had warmish days, but every night ten to fifteen below zero. This was ideal maple sugar weather—the sap drawn up during the sunny days was driven down again by the cold nights. One of the guides, who ran a sugar shanty near the spot where my father built his original cabin, invited me to a "sugaring off." When it is decided that the sap has been boiled down enough, taking longer when the end result is to be sugar rather than syrup, a ladleful is spread out on the snow. If it hardens fast and firmly enough, that vatful is "done" and may be put in

permanent containers. From time to time friends come to the sugar shanty and sample the snow-hardened syrup, which is called "sugar wax," and make predictions about the quality of that year's crop. The fires under the big vats must be kept going all night.

Making maple sugar requires a lot of time-consuming work: boring the holes in sugar maple trees; setting drip-pegs in those holes; hanging small buckets on each to catch the sap; gathering up the sap before the buckets get too full (which amount varies greatly according to the span of temperature between day and night); and taking the collected sap, usually in big tubs on small horse-drawn sledges, to the sugar shanty to be evaporated in large rectangular copper vats (originally in large iron cauldrons), as well as cutting and bringing to the shanty many cords of four-foot wood, most of which needs to be hardwood, to maintain continuous fires for a couple of weeks or more, depending on that year's weather. Few of the sugar shanties that used to be focal points of activity each year in the township of Keene are still operating today. Too many work hours are involved, even if nature provides the sap "for free."[4]

Harland's Hare and Flying Squirrels

The twelve-year-old son of a neighbor down the hill came up to the studio on most Saturdays to take the other end of the crosscut saw to keep my wood-pile replenished and to do the week's cleanup, dishes included.[5] One time he brought me a big hare that he had snared. The first several days I enjoyed eating it, but the bones made so much rabbit soup that by the time all was consumed, I told Harland Jaquish I never wanted to look another hare in the face.

One spring morning Harland and I cut down a big half-dead beech tree. As it hit the ground with a resounding thud, a flying squirrel darted out from a knothole some thirty feet up the trunk. Flying squirrels are mostly night animals, and it is a rare experience to see one in flight particularly in the daytime. This one ran up a big nearby tree and out on a limb. Then, spreading the thin web of skin that connects its forepaws with its hind ankles, it glided or "flew" through the air in most graceful arcs to land lower down on the limb of another tree. It kept on doing this, gradually coming nearer. We soon concluded it had babies in the rotting knothole enlarged no doubt by an obliging woodpecker. Harland suggested that we catch the mother in the large cloth cap he was wearing and then put her with the babies in a cage box I had fixed up earlier for two chipmunks, including a homemade squirrel wheel for their exercise.

I sat for quite a long time motionless, close to the knothole, with the cap in my upraised hand. The arcs of the mother from branch to branch came lower and closer. Finally she landed on the trunk near her hole. Then she made a series of cautious advances and precipitous retreats. Since I did not move, she finally darted down into her hole. We could hear the little chirps with which the youngsters greeted her. In a few moments she poked her head out, holding in her mouth one of her babies by the nape of its neck, as a cat would carry its kitten. We were startled to see that these babies had no hair and their eyes were not yet open. I could see the mother's whole position tense as she got ready to dash out, and when she did she was caught in the soft folds of Harland's cap. Then Harland, who had much smaller hands and wrists than I, reached into the nest and carefully brought out the other three babies. We could find no trace of the father of the family. We hurried home and put the family in the chipmunk box. We cut up an old pair of socks for their nest. As far as I could tell, the mother would not let her babies nurse her. The next day Harland brought a small bag of beechnuts for her, and one of the babies died. I felt very bad and opened the cage door. The mother went out alone. Maybe she thought the ordeal had been too much for the babies and that they would die anyway. I tried to feed them some warm milk with an eyedropper. They took a little at first, then refused it and soon the other three died. I have always felt ashamed of my spur of the moment attempt to bring up a family of flying squirrels and resolved never again to make captive a wild creature of the woods unless it clearly had no other means of survival.

Snowbow, Rainbow, and Range

One of the rewards of living in the wilderness and of many years of hiking, canoeing, and snowshoeing, has been the opportunity to experience rare moments of nature and to absorb its basic rhythms into my blood. I almost always had a paintbox of oils or, later, watercolors with me and frequently did on-the-spot paintings or made color notes. Nature in the Adirondacks with its fickle sunshine and ever fast-moving clouds does not remain the same for many minutes. Superficially, the changes may not be obvious, but that is the exception. Any genuine recording must be largely from the momentary impression retained and supplemented by past knowledge of its sequences. Mornings often start out with bright sunshine; usually it clouds up toward

noon; and frequently most of the clouds clear away without rainfall before sundown. "Red in the morning, sailor's warning; red at night, sailor's delight," an old Maine saying, applies pretty well to the High Peaks area. In the fall of my first year at St. Huberts I was planning a climb when I happened to run across LeGrand Hale. "You have lived here a long, long time, LeGrand," I said. "What is the weather going to be like tomorrow?" He looked up slowly at the sky, spat a bit of tobacco juice, and winked at me as he replied, "Young feller, I've lived here long enough not to tell."

Memories of special moments experienced on the lakes are so numerous it is hard to isolate them unless there was some special identifying feature. I will never forget the snowbow arched over Gothics when I was snowshoeing on the Upper Lake during a snow squall in 1920. (See part two, "November 5, 1920, St. Huberts.") I tried hastily to capture some of this dramatic moment in paint. The result looked far too contrived to be convincing and I have rarely shown it. Another rainbow moment was far too fleeting to record. This took place after a short heavy shower while on the top of Mount Haystack. The sun suddenly came out and two brilliant rainbows formed below us, toward the Upper Lake, one inside the other. Another mountaintop experience was on Gothics watching a silvery moon setting over Mount Skylight while the glow from the rising sun gradually spread down the dominating cone of Marcy, which rose from the blue shadows in which the Great Range still slept. My belief was that each instance of creative work springs from emotional reactions stimulated within the artist by anything, a pattern in the dust even, and not from recording visual observations. If the pictorial content of a painting has any significance, it will be because the essential qualities of the landscape, person, or object depicted is sensed or known by the artist, however patterned, simplified, or abstracted the final product may be. John Marin once said to me, "If a man wants to paint a mountain, let him fish its streams first." Of course, whether the result has any value depends upon that artist's creative gifts, whatever the approach.

Breaking Solitude

When spring came in 1921 I told my parents that I wanted very much to continue to live at St. Huberts but confessed that a few changes would make life there far more pleasant. My main concerns were bathroom and cooking facilities. So three rooms were added that spring: a kitchen, a bathroom,

and, at my father's urging, a living room with a fireplace. I was the architect and the second carpenter. When two carpenters were employed I was downgraded to carpenter's helper. The extra room allowed me to have guests and not be totally alone, which my parents did not favor. Indeed, that was the next step. A school classmate, Charles R. Walker, wanted a place to write his first book. He arrived late in the fall of 1921 and stayed nearly three months. By Christmas time we agreed that with all this space a winter party with some college women would indeed provide relief and recreation. My sister, who was at Vassar College, agreed to help. I did not realize how far that shot in the dark would go and how long-lasting its effects would be. Later, the woman who turned out to be the most important participant of that party, Faith Borton, wrote the following account of it:

> My first impression of the Adirondacks was when I dismounted from the [Pullman] sleeper in the bitter cold of a January dawn. A stable lantern supplied the only heat on our twenty-five-mile drive to a lumber camp. There we breakfasted by kerosene lamp on fried potatoes, sausage, and black coffee. Warmed and fed, we transferred to a haycovered sled for the remaining lap of our trip.

20. One of Spen Nye's teams at the Upper Ausable Lake. Faith Borton is the figure to the left. Photograph by Harold Weston, 1922. Harold Weston Foundation.

During the next three days, the placid suburban pattern of my life was completely shattered. We balanced perilously on a load of teetering logs, as charging horses dashed down hill, we watched the cutting by hand of three-foot cakes of pure aquamarine ice. My future husband and I cut down a hardwood tree seven feet in circumference where we used a crosscut saw [see ill. 46]. In the evenings we walked a mile for our can of milk. A sturdy team drove us, bundled to the ears in furs, for an overnight trip across frozen lakes at temperatures of ten degrees below zero to a camp seven miles from any other human beings. We became lost in a blinding snowstorm, on snowshoes, in the remote wilderness of Marcy Swamp. To everyone's astonishment, a year later, I "married into" this way of life, permanently.[6]

The one episode during that party that merits a bit more description is the humiliating trip in search of the deeryards at Marcy Swamp. When we got to the Upper Lake, the snow was some four feet deep. Since the current of the Inlet made the ice there treacherous in spots (even though the ice on the lake may have been a good three feet thick), I planned to approach the deeryards by way of the Marcy trail and then through the swamp.

As we left Inlet Camp that morning large flakes of snow started tumbling down, clouds were low on the Range, and the air had the ominous stillness of a heavy snowfall to come. The snow turned out to be some six feet deep in the sheltered area of the swamp with many small evergreens bowed over by its weight. It was almost impossible to follow a straight line even though we snowshoed over the tops of many of the bent trees. We had no compass. I was confident I knew the way. After walking a half hour or so we were surprised to come upon recent snowshoe tracks—evidently our own, for no one else was at the Upper Lake. We had made a big circle in the swamp to the right. The five of us then spread out to be able to sight back through the trees and fast falling snow. Another tedious hour passed, for the snow was getting deeper. Again we came upon snowshoe tracks, this time to the left in a much larger circle. The women were obviously alarmed. I had to confess failure and recommend starting back to camp. When we reached the lake, the deep impression our single-file snowshoeing had made that morning had been so covered up by the ten inches of snow that had fallen it was only a vague depression on the unblemished surface of the virgin snow.

21. The upper section of Stillwater, looking in the direction of Marcy Swamp where the Winter Party of 1922 got lost on snowshoes. With fine views of Marcy, Skylight, and Haystack, this seemed to be the most remote spot on the AMR. Photograph by Harold Weston, 1921. Harold Weston Foundation.

6

The Power of Nature

Lost and Found

DURING BLUEBERRY SEASON in the late summer of 1921, a young Swedish *au pair* for an Ausable Club family was given permission to climb Dix Mountain alone.[1] That was a mistake, even though Anna was a sturdy girl used to climbing mountains around her native village, because the trail was in poor condition. The ATIS had neglected it entirely during World War I and in 1920 started negotiating with the Department of Environmental Conservation to take over its maintenance. The following near-tragedy may have expedited a favorable decision.

Anna managed to follow the trail in spite of its being overgrown in many places and safely reached the summit. For more than a mile in the valley of the Bouquet River the trail followed one of the lumber roads made to take out pulpwood after the fire of 1903, the corduroy base of the road having been only singed by the fire ten years later. Anna confessed to me when I spoke with her after her adventure that her first mistake was in not breaking a number of branches to mark the turn-off spot through a thick growth of raspberry bushes. She had thought on the way up that this big clump would be enough of a signal but later discovered any number of similar clumps of raspberries along the road. On the way down she could not identify the turn-off even after searching for some time in rough terrain. Actually she had gone too far down the river valley.

Anna decided to head for Round Mountain, which she could see beyond a series of ridges, for the two forest fires had left no trees of any size in that area. She knew there was a road on the other side of Round, between it and Giant Mountain. If she got to the top of Round and then headed for Giant she could not miss the road. It just happened that she picked out a very tough way to get to Round over a series of ridges, and by the time she reached the

83

southern flank of Round she was getting very thirsty. The day had been fairly hot, walking without the shade of trees. Delighted to find lots of ripe blueberries on successive ledges, she stopped to eat some every now and then. The forest fires had made very favorable conditions for their growth.

From near the top of Round she could see the dirt of Chapel Pond road as it emerged beyond the pass. Much encouraged, Anna started straight down the mountain toward the pass. The descent soon became very steep. About halfway down she came to a place where the only way to continue seemed to be by sliding down a rather long strip of smooth rock to a fairly broad ledge visible below covered with blueberry bushes. Here she made her second mistake. When bushwhacking you should never slide or jump down before making fairly sure you can climb up again. Once on the blueberry ledge Anna discovered that this maybe hundred-foot-long sloping shelf on the mountain's side ended in a drop-off at least fifty feet into the black depths of Chapel Pond. According to Verplank Colvin, unexpectedly, the name for Chapel Pond "does not come from the imposing cliffs which plunge down into its black waters, but from an old hunter's name *Chapel,* one of the earliest explorers of this section." The hunter was actually a French Canadian named Chapelle. Anna had forgotten about that little body of water, which could not be seen from higher. She would have to go back up and try another way.

Abrupt little cliffs rose up on either side of the smooth rock funnel down which she had so easily come. Anna tried and tried to get back up, first with her shoes on, then in bare feet. There were no toeholes, no places for her fingers to cling to the rock, which got steeper as it rose. She would get a little way up only to slide back down, scraping the tips of her fingers until they bled. Then she heard a car going along the road. She called for help. The car did not stop. Anna then went down to the edge of her ledge and waited for the next car to come. Surely her cries would be heard. One, two, three cars passed during the next hour. Each time she tried to call louder and waved a strip of her shirtwaist, which she tore off to use as a flag. It made no difference. That side of Round was in shadow by late afternoon, so her frantic waving was not likely to be seen unless you were looking for it. Also, an evening breeze had sprung up coming from the north, and this threw the sound of her voice back up the mountain. When it turned darker, Anna gave up trying to attract attention; she had no flashlight and no matches. Being practical,

she had a good supper of blueberries and settled down for the night among the bushes, selecting a place against the wall of the northern barrier to shelter her from the now-chilly wind.

Toward dawn, scraping noises on the rocks above her roused her from a fitful sleep. Thinking it was rescuers coming down the slide, she stood up and called. Only then did she see the big black bear who had come skidding down the rock funnel to get its breakfast of blueberries. It seemed more startled than she, swung around, distended its sharp nails to get traction, and had no trouble scrambling up the steep granite slope with more speed than you would imagine possible. It did not take the bear long to decide that it preferred to eat breakfast in a more secluded spot.

When the morning sun rose above the Chapel Pond cliffs across the pass (the cliffs that I had come down on snowshoes when the men were cutting ice on the pond), Anna refreshed herself again with blueberries and confidently waited for cars to start coming up the road. There was no wind at all. "Surely someone will hear me," she thought. Actually that road was rough with sandy ruts up the two-mile hill from St. Huberts. Few people took it unless they had to go directly south. Cars were far noisier then than today and it was necessary to use a lower gear to make the hill. When they reached the top just before Chapel Pond, people shifted gear and stepped on the gas to pick up speed on that level part. Several cars passed during the early morning hours. Anna called as loudly as she could for help and waved frantically. None of the cars slowed down. She began to get desperate and made up her mind that, if the next car did not stop, she would jump down into the pond. She was a good swimmer and the water looked plenty deep. As a matter of fact, its depth is supposed to be 350 feet not far beyond that cliff. From her perch on that ledge, however, she could not see the narrow line of big boulders that ring Chapel Pond on the Round Mountain side. Had she jumped without a running start, an impossibility on that sloping blueberry-covered ledge, she never would have cleared those boulders.

The sun was now full upon her. Anna held in one hand that strip of white cloth to use as a flag and in the other hand her brightly patterned sweater, waiting for that crucial car to come along. A chauffeur was driving over to Westport in a new car to meet his boss at the station. In those days you had to go slowly with a new car to break it in. It was a lovely day; he had plenty of time; he decided to start extra early and go by way of Chapel Pond

to see the views that were said to be dramatic. So he was just moseying along when he heard Anna's desperate cries. Luck was with her at last. He honked his horn several times and called back. Then he caught a glimpse of her standing waving on a ledge halfway up the cliff, it seemed. Hardly believing his eyes, he got out to get a better look. How in the world did she get there? He hollered, "I'll go for help. Don't fall off." Anna waved back to show she understood his intent. With that he jumped into the car, turned around as fast as he could on that very narrow road, and started off down the hill to St. Huberts in a cloud of dust, forgetting entirely that you must not speed in a new car and just taking a chance that no car would be struggling up the hill without room for him to pass. The chauffeur had heard about a lost maid who had not been found by the night search parties. Now he could tell them where to look but not how the devil to get her down.

Anna told me about a week later that she had kept her emotions under control until after that man's car disappeared down the road and she knew she would somehow be saved. Then she sat down and quietly cried and thanked God for the blueberries that made her ordeal far easier to endure. It took the guides nearly two hours to locate the long ropes needed and to get up the mountain and down to her ledge, which could only be approached from above. This was fifteen years before I laid out the first trail up Round Mountain, and going up without a trail took longer. They did not know whether she had fallen onto the ledge or how much she was injured. They decided it would be best to let her down the cliff with ropes, taking up two in case one was not long enough. They also sent up a small flat-bottomed boat to meet her at the pond.

Quite a group of us walked up from St. Huberts to the pond to help if we could, but anyway to get front seats to watch the final act in this rescue drama. When Anna saw so many people gathering on the far shore and the boat being carried down the steep bank and put in the water, the plucky girl made up her mind to put on a good front whatever happened, and that she did. Since that whole side of Round had been laid bare by the two fires, we could see the four guides as they made their way from near the summit down to the rock funnel. Some of the rocks up there were those I heard exploding from the heat during the fire of 1913 and plunging down, sizzling and sending up little puffs of steam as they hit the pond. Most of the rock on Round is worn smooth, and the guides, as they feared, could find no place above the

slide to attach the rope. They drove a big spike into a fissure to act as a piton and tied one end of the rope to it. Not trusting its security, two of the guides stayed at the upper end of the funnel to anchor the rope down. The other two slid down to the girl on the ledge after splicing the two ropes together. She assured them she was not hurt and could climb either up or down a rope. They decided it would be best to lower her.

The end of the rope was thrown down over the cliff. Helped by his partner, one of the guides negotiated himself over the edge of the ledge clinging to the rope, and then hand-over-hand down to the boulders. His jobs were to select the best place for Anna to land among the big rocks, to hold that end of the rope steady as she came down, and to try to catch her if she did not have the strength to hold onto the rope all the way down. The fourth guide explained to Anna just how he would steady her over the edge of the ledge, by far the worst part of the descent, and keep a firm grip on a smaller rope, which he tied around her waist, until she had a good hold on the rope below the ledge.

Anna did exactly what she was told to do. She was not flustered. The guides were genuinely impressed. Soon they had her safely in the boat and were rowing across the little pond. I happened to be very close when they helped her ashore. She looked terribly tired and I could see she was trembling, but outwardly she was keeping her cool and smiled at the cheering group of spectators. Since this is the most dramatic rescue of a lost person I happened to witness in the Adirondacks, I would list the names of the rescue guides if I could remember them. They would say it was all in a summer's work and claim no personal credit.

Exhibition of My Adirondack Landscapes in New York City

The 1920s were a productive period for me as a painter. I was given my first solo show in New York City at the Montross Gallery in November 1922, less than three years after I devoted myself exclusively to painting. More than 180 paintings were shown, 63 oils on canvas, the rest oils on cardboard, sketchbox size. The vast majority were Adirondack landscapes with a few still lifes, and 20 landscapes done in Persia during my war service in 1918 and 1919 (ills. 9, 12, 33, 35, 47, 49, and plates 1–8). The show was exceptionally well received. The *New York World* ran a large reproduction and a full column

on its art page as well as an article with color reproductions in its magazine section. The critic Ralph Flint wrote in the *Christian Science Monitor:* "In his pictures [there is] something different, something stirring and magnificently bold, a proclamation of a bigger belief in beauty than is usually heard in the galleries . . . a perspective which is continually reaching out toward far horizons." Henry McBride in the *New York Herald* commented, "Most of our best artists, such as Homer, Eakins, Fuller and Blakelock, have been recluses. . . . Your true recluse is born not made. . . . Weston uses small sizes but aims at big things." I was enthused and all the more determined to go on with painting.[2]

A Companion for Life

In May 1923 Faith Borton and I married each other in a Quaker ceremony. We came to St. Huberts to live. In April I had added a bedroom to the studio. Marriage greatly enriched my life but did not radically alter the pattern of climbs and painting until after the summer was over and we were left alone for our first winter of marvelously concentrated isolation together, which changed the focus of my work for the next several years.

Spring sweeps over the Adirondacks irregularly, beginning as early as the third week of April or as late as the middle of May. This interlude between winter and summer is far briefer than the transition from summer to winter. Spring at St. Huberts is an ephemeral moment of delicate fleeting beauty. As the weather warms and the snow on the hillsides turns into rivulets, the millions of buds on the tips of the tree branches begin to swell and turn from their dull winter purples into vibrant reds, visibly moving up the mountain slopes day by day. Then these buds burst in the valleys and at warmer exposures. All gradations of evanescent light yellows to yellow greens begin to appear. These are the tree flowers with attached winged seedlings and are accompanied by the unfolding of embryonic leaves. Successive waves of sensitive color spread up the mountainsides. The new shoots on the evergreens lighten their dark masses, and for a short time there is less differentiation between the deciduous trees and the conifers than at any other time of year. Quite soon the overall lush green of June rides rampant in the full vigor of its coming of age.

The spring of 1923 was late, and that added appreciably to the pleasure of climbing together. The first mountain we tackled was Noonmark, when the trees were reaching the budding stage near the top. As usual I painted until after the sun had set. While coming down through the woods in the

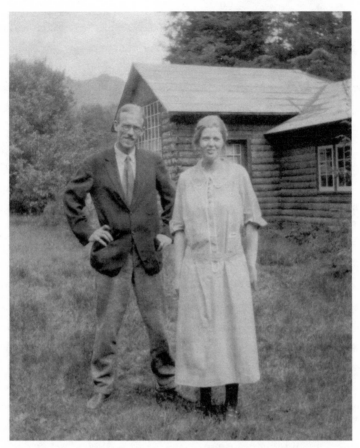

22. Harold and Faith Weston in front of the studio, with the living-room extension visible to the right, 1923. Harold Weston Foundation.

dusk below the first ledges, I started answering a fox who was courting a mate. As we walked along, he followed, getting nearer as it became darker, alarming more and more my bride, who was unused to animals in the forest. She would not entirely believe my assurances that a fox would not attack a human being. I stopped teasing the fox and he followed us no further, to Faith's profound relief.

Night of Misery, Morning of Glory

In the early 1920s the Department of Environmental Conservation had a very limited budget and welcomed outside help in the construction and

maintenance of lean-tos. A group at the Lake Placid Club, which was known during its short existence as the Sno Birds, offered to cover the costs of building a lean-to between Haystack and Basin Mountain on property owned by the AMR, if the AMR gave permission for state maintenance of a camp there. The lean-to was constructed in late September 1923. Faith and I were the first people to spend a night in Sno Bird Camp as it was named.

We planned to go from camp at the Upper Ausable Lake over Mount Haystack, spend the night at Sno Bird, and do the rest of the Great Range the next day. It was October 1, 1923. We reached the camp toward dusk because I stopped to paint on Haystack. I always have a hard time tearing myself away from a mountaintop, especially from this focal point among the High Peaks—the massive thrust of Mount Marcy looming up from the crevasses of Panther Gorge to tower above us, the impressive sequence of pyramids formed by the receding ridges of Basin, Saddleback, and Gothics, the rhythmic repetition of lateral mountain ranges of Sawteeth, Colvin, and Dix, one over the other, with the distant flatlands of the lower Champlain Valley as a backdrop, the pearl-like string of opal colors from the waters of the Upper Lake, the Inlet, Stillwater, and Boreas Ponds with lucid blues of successive low ranges fading away to the south. Any attempt to pin down these visual happenings realistically was all the more futile because the colors were fast losing their resiliency in the fading light of a sky becoming overcast. One had to absorb the essence of the moment and then transmute it into form and color later on.

We had been told that Sno Bird was "finished" and assumed that meant it was in condition for hikers to spend the night there. Upon reaching the lean-to we were dismayed to find the walls and roof of the lean-to were finished, but on the floor of the camp, where some day a springy depth of balsam boughs might be found, the tops of the trees cut for the logs that made the walls were nailed about five inches apart above some rocks and muddy ground. Unfortunately the person who lopped off the branches was in a hurry and left sharp stubs sticking out in all directions, composing a spurred corduroy bed for its first guests to repose upon. Hurriedly, because it was getting dark and about to rain, I gathered as many evergreen branches as I could to form a two-foot-wide base for a "mattress" of boughs at one end of the camp, adding boughs that I cut in short lengths and stuck into the "mattress" sharply to take advantage of the natural springiness of the curve of the branch. In the meantime, as rain began, Faith was cooking supper over a very smoky fire made from the countless green chips of all sizes from the camp logs, which of course had just been

cut. The bedding proved as dismal as the fire, which constantly threatened to go out. Soon after we lay down, the firm spikes of the corduroy began to assert their manhood. Then, after we got a real fire going because it was getting colder, the wind shifted, smoke filled our end of the lean-to, and we wished it would rain harder and put that damned fire out. Never on a mountain have I shivered and wept through a more miserable night.

Then, in the predawn light, we could see that every twig, every balsam needle, every fern and blade of grass was covered with a thick hoar frost. In some places between trees fantastic frost wreaths had formed, actually frost clinging to sturdy spider webs. Here and there on the ground lacelike accumulations of snow formed weird patterns by edging irregular patches of ice over black rocks. It would be madness to try to go on over the Range. Spots on Saddleback Mountain and Gothics would be impassable without special equipment. The clouds, scurrying past just overhead, seemed to be lifting. I predicted it would clear soon. After a leisurely breakfast, leaving our packs but taking my sketch box, we cautiously climbed the short distance to the top of Basin.

By now there were breaks in the clouds sweeping over us. As we reached the top and looked toward Johns Brook suddenly there was a glimpse of autumn trees blazing in sunlight in the valley below us. A bit later in almost the opposite direction the cold shoulder of Haystack emerged from the clouds and a moment later to the left of it Boreas Ponds silvery and shimmering. It was tantalizing because the vision was wiped away before you could grasp it all. The tempo of the moving clouds calmed down after a while and it cleared as we watched the movement of sun patches and shadows sweep up and over the bare glistening slides of the western ridge of Gothics, with Giant Mountain in the distance now benignly warming up in steady sunlight. I did four paintings in a frenzy. The wild exuberance of the day and its successive orgasms of wilderness beauty called for a shorthand method in paint to capture rapidly changing emotional reactions, methods that predated abstract expressionism. It was indeed a morning of glory.

Landscape Nudes

Marriage brought the nude into my life and pantheism disappeared. My wife had a beautiful body and I wanted to express in paint some of the deep emotions it aroused in me. When the winter snows set in and we were

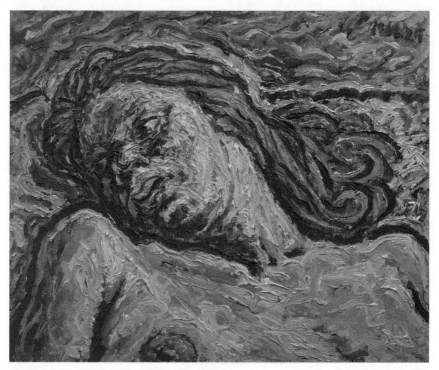

23. *Beast Head,* 1925, Harold Weston. Private Collection.

entirely alone at St. Huberts the first two years after we were married, I began doing a series of nudes and fragments of nudes, first many in charcoal on large sheets of paper, then in oil on canvas. I had plugged up all the hidden air holes in the studio and cut a lot of wood for the box stove so it was warm for posing and painting; there was no fear of interruption; we had no telephone. The companionship of working together under conditions of primitive living in almost complete isolation brought about an exceptional quality of togetherness that has endured through nearly fifty years.

In 1925 when I was showing a dozen of these nudes to the art dealer and photographer Alfred Stieglitz, a man came in whom I did not recognize. He looked with great intensity at my paintings spread around the floor of the gallery and then astonished me by asking Stieglitz: "I feel the woods and the mountains in these nudes—synthetic American landscapes—direct primitive quality—purely American stuff—who did them?" The question came from John Marin, whose watercolors I had long admired. Some years later a

Russian artist, who did not have any connection with Marin and knew nothing about my life, told me that he liked best of all in my exhibition of that year a winter landscape in the other room. I was not aware of having included such a painting and demurred. "I'll show you which," he said. It turned out to be a nude torso done in high-keyed light colors. It was a landscape nude.

In an article in the *New Republic* in 1930, Paul Rosenfeld wrote about my landscape nudes:

> Weston . . . figures as one of the relatively few moderns in whom the body's forms have roused an eloquence of color, line and shape. . . . Very few of his competitors parallel the fire and force of attack to which his moving torsos bear emphatic witness. . . . One of the best of his nudes is painted in a rhythm and structure of ardent color, of angry, vehement, wonderfully heavy and driving garnets and purples. Another has the more aerial, floating tone of mountains in blue October, and mingles with the sensations of flesh the cool mysteriousness of sharp aromatic air, golden crests and profound and lonely lakes. . . . Those rude, bare shapes of his, resembling the knotted contours of roots, hard, wrinkled peasant flesh, primitive materials and things worn by the elements, convey in a hundred degrees of intensity the quality of living stripped to the essentials; the acrid breath of the rough and solid earth beneath. . . . Besides, the spiritual implications of these paintings are important in a bourgeois America, dangerously removed from the simple realities and the struggle with nature by a thousand conventionalities and sentimentalities.[3]

The Great Flood of 1924

The storm that burst the dam at the Lower Lake took place on September 30, 1856. Curiously, the next serious flood also took place on September 30th, sixty-eight years later. Faith, my sister Esther, and I were caught in that flood and were lucky to escape with our lives.

Two days before, we had walked from Heart Lake, the gateway to the High Peaks from the north, to a little old lean-to near the outlet of Lake Colden, built long before the state took ownership of that area. We noticed that someone had tried to repair the torn and disintegrating tar paper roof

with a coffee lid, a pan, and an old undershirt stuffed in a hole. This was a bit ominous because the perfect morning had become an overcast day. My sister and I had expected to climb MacIntyre Mountain, now called Algonquin Peak, but rain started in the night and so did the drips. Rain came down steadily and by noon we could see that Lake Colden was rising fairly rapidly. Esther and I spent a couple of hours, I must confess futilely, trying to pull out a small section of a recently made beaver dam to lower the pond. The branches were woven together and their crotches kept catching; they could not be loosened by the hardest tugging but only by cutting with my small-sized axe. We cleared a patch but the water seemed to be rising even faster.

Thinking it would clear up, we stayed a second night. It poured. We could hardly find a place in the lean-to without drips falling on our faces or blankets. By the second morning Lake Colden had risen at least ten feet. We had little food left, since we had only planned to stay one night. We started immediately for the Adirondak Loj by Heart Lake. Lakes Colden and Avalanche are connected by a stream. These two ponds were originally one until separated centuries ago by a huge landslide that left a quarter of a mile strip between them and raised the level of Avalanche Lake about a hundred feet. Our first big obstacle was the single-log bridge with a flimsy railing that we had to use to cross over the stream that the flood had broadened to nearly double the length of the bridge. This essential link of our escape route was floating diagonally downstream, pushed by the current after breaking loose from its moorings on our side but still held on the other side, how firmly we could not tell. There was only one solution: We just had to retrieve that bridge.

A few four-inch spruce had fallen over on our side and were half floating on the flood water. We formed a chain. Faith held firmly to a spruce still standing on the bank. She held Esther's hand, who in turn held mine as I inched out along the trunk of the largest of the fallen trees. As it sank under my weight, Esther also inched out until she was in the water up to her thighs and I up to my waist. That far out, by leaning forward I could just hook the bridge-log with the crook of my cane and was able to draw it slowly back against the current and hold it there until Faith and Esther, one by one, going out on another fallen tree, were able to get across. However, I could not possibly step up onto the bridge with a large pack basket and two water-weighted blankets on my back, and, of course, as soon as I did the bridge would start floating downstream from our end. So my sister came back to lower the

bridge by her weight, and somehow I managed to make it. At any rate, we were safely across with our packs, which would not have been the case if we had tried to swim across, the only other alternative.

At Avalanche Lake in two spots where sheer cliffs drop into the water, the trail follows floats made of two logs fastened together. These are locally known as "Hitch-up Matildas."[4] At the first and longer one, when Faith stepped on the inner log holding onto the wobbly railing, the float, which was held in place by wires at each end but due to the flood was fully ten feet above its usual position, began to tip over. We were alarmed all the more because the railing might have pinned her under water. By steadying one end and distributing our weight carefully, we negotiated both of the Hitch-up Matildas without too much trouble.

During this storm Mount Colden, which rises abruptly from the black waters of Avalanche Lake in cliffs of rock worn smooth through the centuries, was a fantastic sight. Rain was still coming down but mingled now with flurries of snowflakes; it was near freezing. The copious rain on Colden formed a series of small waterfalls on the cliffs. Gusts of wind caught these rivulets and threw the water back up onto the mountain or into the swirling clouds. It was the wildest display of nature's waterworks I have ever seen, including monsoon rains in the foothills of the Himalayas. We were far too chilled to stop and admire this demonstration, but it left a lasting impression.

The next obstacle, after crossing Avalanche Pass to the headwaters of the West Branch of the Ausable River, was totally unexpected. On the way into Colden we scarcely noticed the wide but almost dry streambed of a tributary where the trail had no need of a bridge. This small brook had become a raging torrent, less than a couple of feet deep, but you could not tell exactly because it was muddy. You could plainly hear the "whrung-whrunging" of largish boulders hitting against each other as the fierce current swept them downstream. A person's ankle or leg would soon be broken by fording, and his body swept down into the nearby maelstrom of the main part of the river with no possibility of getting out alive. The only solution was to bushwhack upstream, hoping the tributary would soon divide, which it did after a half mile of tough going. Not too far beyond that, a big dead tree had fallen across the main branch of the stream. The roots of the tree had been undercut by the current. The question was, would the trunk drop down with the weight of a person so the log would be half under water rather than just above the

rushing current and, if so, could a person still cling onto the log and get across? To decrease the danger of losing our balance from looking at the foaming mass of brownish, soil-filled water that swirled under the log, each of us kept our eyes concentrated on the log as we hitched across astraddle. Faith, who had broken her leg in February and was only just getting back into trim after a long recovery, took some ammonia and went across with her eyes closed, terrified. We could ford two other smaller branches of the tributary; the current there, while swift, did not have volume enough to propel football-sized boulders. Finally, near exhaustion, we reached the newly built state lean-to by Marcy Dam. We debated staying there but found all our matches wet. For once I had carelessly not taken a supply of wax matches in a screw-top bottle. We were so chilled in spite of constant exercise that as soon as we stopped to rest our teeth began to chatter.

Marcy Dam was a log-cribbed structure, built to help float down logs cut after the big fire in 1903, similar to the operations getting pulpwood from Noonmark and the Bouquet Valley. My impression on going into Colden was that the sluiceway was about ten feet high and fourteen feet wide, and that a lazy inch of water was spilling over the bottom log of the open sluiceway. Now all that space was an awesome mass of coffee-colored liquid, arched up in the middle like huge biceps by the friction of the sides of the sluiceway, swooping down the spillway with accelerating speed and a sense of relentless power, sucked on by the twenty-foot drop of the riverbed below the dam, missing by a foot or two the single plank bridge with a railing by which the trail crossed. To our alarm, we saw that the earth on the far side between the crib logs was beginning to crack, crumble, and wash away. Would the dam collapse as we crossed? Would the fast-moving mass just below us make us fall from dizziness halfway across the bridge? That experience was relived by all three of us in nightmares.

It took us nine and a half hours to get from Lake Colden to the Adirondak Loj in water from ankle to waist, in contrast to a leisurely two hours going in on a dry trail. Once back to our car we assumed our troubles were over. Not so. Both roads to Keene Valley were impassable. The big iron bridge at Keene had been washed nearly a mile downstream (see ill. 24). The small iron bridge below St. Huberts had been swept away, and no traces remained of a hundred feet of the town road there, just the bare rock of the ledge. We stayed at Cascade Farm for three days until makeshift bridges and road repair enabled us to get back to St. Huberts.

This is the big steel suspension bridge at Keene Ctr., washed down the river nearly a mile, Keene Valley flood, Oct. 1st, 1924.

24. The steel suspension bridge from Keene that was washed down the river nearly a mile during the flood of October 1, 1924. Courtesy of Archives, Keene Valley Library Association.

I do not know how high the Upper Lake rose during that famous flood of 1924. I made a recording of the crest on our boathouse door, just short of eight feet, when another flood took place, curiously on almost the same date in 1932. Fields and roads in Keene Valley were flooded by the river deeper than in 1924, I was told later. Faith and I happened to be staying at our camp at the Upper Lake for a couple of nights, so we just stayed on, using old stocks of food kept there for emergencies. When it cleared, it turned colder as usual after an autumn storm—trees brilliant in color and the first snow of the year on the Great Range. We paddled our canoe in a furious wind down the lake, past the dock, and up the trail to the AMR Warden's Camp where we used the crank phone on the wall to report that we were all right and would stay one more day to let the water subside. Two guides had come through in hip boots to say that a bridge on the trail back had been moved out of place and to advise us to wait over.

On the way back to camp from telephoning, we paddled a quarter of a mile through the woods along the flat part of the Haystack Trail. Looking down from the canoe at ferns, bunchberries, moss, and bright autumn leaves, seen through a couple of feet of clear water, gave a most unusual sensation, as if we were gazing at coral and exotic fish through a glass-bottomed boat.

While cooped up at camp during the rain, I painted several watercolors of autumn leaves and mountain ash berries, which were exceptionally fine that year, and we thoroughly enjoyed the solitude of camp with the soft patter of rain on the shingle roofs. This flood provoked no nightmares.

Interfaith Religious Services

Interfaith services were held on Sunday mornings in July and August in the Ausable Club casino from 1922 to 1932. The two leaders of these innovative services were Felix Adler, founder of the Society for Ethical Culture, and Henry Sloane Coffin, pastor of the Madison Avenue Presbyterian Church for twenty-four years and then president of the Union Theological Seminary for nineteen years. They often explored the connections between nature, beauty, and spirituality in their talks. (See part two, "Harold to Faith, August 6, 1922, St. Huberts.") I had the privilege of painting portraits of both of them, Adler twice.

Coffin and his wife, Dorothy, were enthusiastic mountain climbers who loved wildflowers and established a striking rock garden below their summer home perched on a promontory. They were also generous, as proved by lending us an old car they intended to store at St. Huberts for the winter of 1924–25. It was the kind for which you had to button on the sidewalls when it turned sufficiently cold. In return for his kindness, I offered to do a portrait of Coffin in hiking clothes the next summer. When he started to pose for me at my studio, he first looked at photographs of other portraits I had painted. Taking off his silver rimmed spectacles, he happened to hold them with one side in each hand. "That's it," I exclaimed, for the gesture gave the impression of a moderator holding scales to weigh the pros and cons of a problem he had to decide. When the painting was done, both Coffin and I liked it. Dorothy Coffin insisted I made him look too old, that I should have waited to paint it later in the summer when he would have been more rested.

Adler was keen about trips to the Upper Lake, but he did not like the discomforts of camping out. After the Hartshorne camp was built in 1907, Father took Adler up for a day's trip each summer. Generally I went along to do some of the rowing. Even as young as eight I had "guided" the famous educator, John Dewey, with his family to the Upper Lake. The comments of such men, particularly about the lakes and mountains and philosophical aspects of natural beauty, made a lasting impression even though a lot was

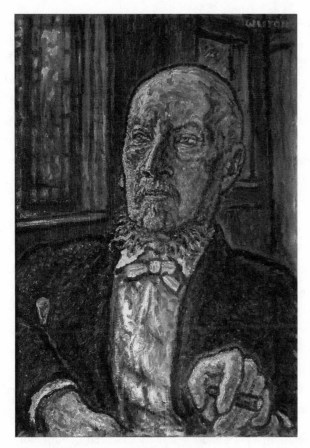

25. *Dr. Felix Adler,* 1930, Harold Weston. James and
Marcia Morley.

way over my head. As I grew older, Adler's freewheeling mind, alertness to
new ideas, and brilliance of expression fascinated me, though I also found
him stubbornly opinionated on certain subjects.

Toward the end of Adler's life, the summer of 1930, I finally got up the
nerve to ask him whether he would permit me to paint him in his study, the
retreat up the cliff behind his cottage. I knew he had a rigid rule that visitors
were not welcome there during his morning working hours, but it was precisely
when he was doing creative work, writing, or dictating lectures, articles, or let-
ters on a wide range of subjects, that I wanted to paint him. When he found
I was not asking him to pose as other artists had, he reluctantly agreed. For
a week or more I went by the back way to his studio, arriving before he did.
I tried to seem like a piece of furniture and after a first greeting Adler would

totally ignore me. He liked to smoke cigars. The first day he made some com-
ments about the cheap cigar I was smoking and offered me one of his hand-
some Coronas. Some people called Adler the Pope of the Ethical Movement
and in this painting Adler brandishes a cigar like a papal crosier while issuing
non-negotiable edicts. Adler was a man of many moods. He could be haughty
and caustic as well as a kindly seer with a keen sense of humor. He was the only
one in the Adler family who appreciated the painting. Shortly afterward it was
exhibited at the Pennsylvania Academy of Fine Arts as well as in one of my
solo exhibitions in New York City. The art critic of the *Cleveland Plain Dealer,*
when reviewing my show, included the following two paragraphs:

> The portraits in the exhibition are few in number but of especial impor-
> tance. That of Dr. Felix Adler of the Ethical Culture Society reaches a
> level seldom attained in contemporary portraiture. The animation of it
> overflows into the darting, scintillating streaks of pigment that seem to
> have fallen like sparks from some seething crucible onto the canvas.
>
> The nudes—painted with that same virile brushing seen in the
> portrait of Dr. Adler—are a challenge in the way that primitive things
> are challenging, old sagas, myths of the gods and heroes; but perhaps
> this is just another way of saying they reach fundamental wellsprings of
> life which few artists are able to tap.[5]

Columbia University had for some years been commissioning portraits
for its Butler Library of the six leaders of Columbia's philosophy department.
Adler was one of them, but the university and the family had never been able
to agree on the artist. Adler's wife, Helen, a sensitive woman who painted
a bit herself, claimed that none of the various portraits of her husband had
been at all satisfactory either in portraying the physical man himself or his
life objectives. This situation became all the more complicated when Adler
died in 1933. Because of my having done a painting of Adler during his
lifetime, my close observation of him in the Adirondacks since childhood,
and my assurance that it would not be a replica of the mood of my first Adler
portrait, Columbia finally offered the assignment to me on two very firm
stipulations: the result must first be approved by Helen Adler and then by a
special committee of Columbia's philosophy faculty.

I went to Adler's study and made preliminary sketches in watercolor of
the canvas-backed chair in which he usually sat when working, of the squat

little box stove that somehow echoed Adler's shape, and of the views from the long windows into the virgin hemlock at which Adler was prone to gaze when groping for a solution to his thoughts. This portrait had to be created from within and it was not an easy task.

Helen Adler agreed in advance to my request not to pass judgment the first time she saw the portrait. I also asked that only one daughter come to the first viewing at the studio. I had a cloth over it and unveiled it when Helen was ready. Within a minute after looking at the painting she began to sob. Adler had no hair above his ears, a comical "asparagus-gone-to-seed" thin grey beard, and a sparse Chinese moustache. I could not be sure whether she was overcome by the liberties I had taken, or what. After fifteen minutes of quiet sobbing, neither the daughter nor I could stand the suspense any longer. Her daughter said, "Mother, don't you think we should go?" "Yes," she sobbed as we helped her up from her chair.

We went out into the garden, radiant in the early September sunshine. After being visibly refreshed by the flowers, Helen Adler asked if she might go in alone, giving no reason. She stayed quite a while, longer than the first time. On coming out, she took my hand in both of hers. "Harold," she said, "I want to apologize for my unseemly behavior. As soon as I saw your portrait of Felix, I felt a sense of his presence more keenly than at any time since his death. I wanted to make sure why I had that reaction in contrast to other portraits done of my husband. Now I know. They tried to record the physical man and failed, stressing superficial things. You tried for the essence of the man himself. I only regret that it is going to Columbia so I cannot keep it during the rest of my life."

One member of the special faculty committee told me they thought it was not an appropriate portrayal of Adler for the place in which it was to be hung. Why was he not in academic robes like all the rest? Why the prominence of the background of his Adirondack study? Then they began to discuss the fact that for all of them, for reasons they could not explain, the portrait reflected or expressed "Adler's ethical philosophy of life." Since the portrait seemed to contain some of the essence of the man's teaching, they came to the conclusion that they could not turn it down. With reluctance, they gave approval, recommending that it might be hung apart from the others, perhaps given a niche of its own in another part of the Butler Library.[6]

26. *Figure Dancing,* 1927, Harold Weston. Private Collection.

7

The Bear and the Buck

Pyrenees, Paris, and Painting

OUR LIFE AT ST. HUBERTS was abruptly interrupted when I had a kidney removed in the summer of 1925. Because my method of working was so intense, doctors advised me not to paint for a while, so we went to Europe early in 1926, returning in 1930. The majority of that time we lived in a remote corner of the eastern Pyrenees in a mountain hamlet called San Martin. Our farmhouse had a chapel at the back where services were held in A.D. 1090. The house had been remodeled and modernized in 1732. Faith had to cook on the hearth because the kitchen had no stove, and a single hand pump provided water for the four families of San Martin. One year the well went dry and water was brought to us in goatskins slung in pairs over the backs of mules.

Catalan farmhouses were generally built on steep mountainsides with the ground hollowed out under the main part of the house. When cold weather arrived in late fall the peasants would herd a flock of sheep under the house. The hand-hewn floorboards were spaced a quarter of an inch apart so that heat from the sheep could radiate to the upper occupants of the house, and what they left behind at night continued to keep the people warm during the daytime. The owner of our house was utterly disgusted when he found we would not permit him to use this long-established central heating system. Instead, we bought a small box stove, putting the stovepipe through one of the windows because the walls of solid masonry were nearly two feet thick. I cut and split wood for the stove and for the hearth in the kitchen. It was even more primitive living than at St. Huberts.

We got to know the Spanish sculptor Manolo Hugué, who had discovered Pablo Picasso. Curious to find out how townspeople felt about us, he asked the proprietor of the local hotel about these Americans. He responded,

"Well, his wife's all right. She puts the neatest second patch on the seat of her husband's pants of any woman in town—*she's all right!*"[1]

This was a period of intensive painting and etching as well as much mountain climbing of nearby peaks up to nine thousand feet. About once a year we would find a cheap studio to rent in Paris for a few months and become part of the considerable group of American expatriots there. Our two oldest children were born in France. My paintings and graphic work of this period were a logical sequel to the landscape nudes. They aroused the interest of Duncan Phillips, who arranged a solo exhibition of my work while we were still in France. A few years later Phillips's book, *The Artist Sees Differently*, concluded with a chapter on my work. He wrote:

> It is something earthy and rugged and at the same time of a lyric poignancy, something unguardedly and tactlessly frank yet tenderly humane. . . . Weston's best asset is his life-communicating vitality. . . . There is a devout, an affirmative conscience in the man and in the artist. . . . Weston must *live* his pictures before he paints them. Unlike the French "wild men" of the early nineteen hundreds he must *feel* intensely about his subjects and let the means of expression follow rather than lead the emotion. . . . Rugged universality is all he wants for his art. It should be quite enough. He is austere in an early American—almost a puritan sense. His austerity consists in being more outspoken and more scornful of airs and graces than is either expedient or easy for us to enjoy. . . . He keeps before his mind's eye as he paints an ideal of expression which not only starts from nature as its source but returns to nature as its goal. It is the mystical feeling about nature which proclaims the romanticist of the Nordic race. . . . The fact that modernity, in spite of its concerns with engines, and complex organizations, and new theories of time, space and the atom, and the workings of the subconscious mind can still produce an artist who can see and feel so simply and tell what he sees with so little compromise and constraint, the fact that our standardized world can still boast of such *an individual* is news of the most cheering and vital consequence.[2]

Between 1930 and 1940 I had twenty-five solo shows in New York City, Philadelphia, Washington, D.C., and elsewhere. In 1935 Lewis Mumford, then art critic for *The New Yorker,* wrote:

Plate 1. *Push-Ti-Ku Range Near Mesopotamia,* 1918, Harold Weston. Atea P. Ring.

Plate 2. *Red Hill Near Hamadan,* 1918, Harold Weston. Private Collection.

Plate 3. *Autumn Storm,* 1920, Harold Weston. Private Collection.

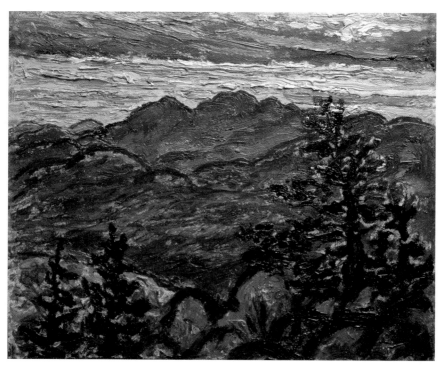

Plate 4. *Adirondack Wilderness,* 1922–24, Harold Weston. Collection of Francis Hart Burget-Foster.

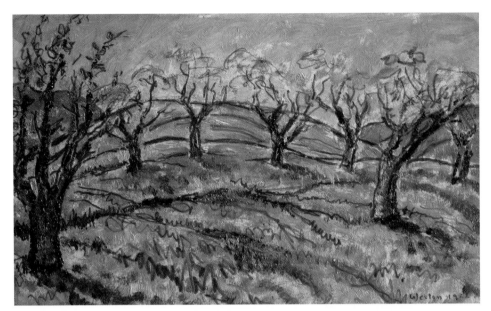

Plate 5. *Orchard Early Spring,* 1922, Harold Weston. Courtesy of Mary Buschman-Kelly.

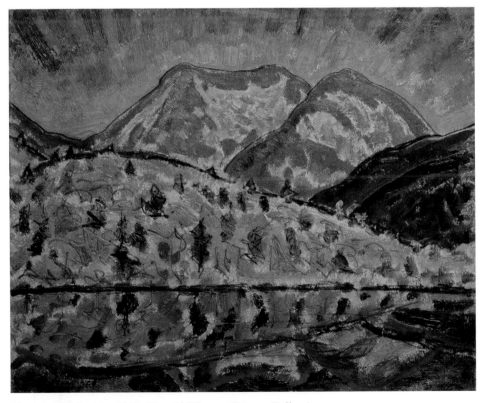

Plate 6. *Red Gothics,* 1920, Harold Weston. Private Collection.

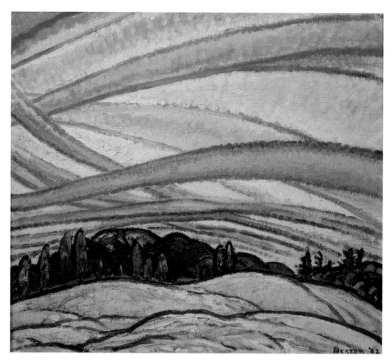

Plate 7. *Giant Mountain Sunrise,* 1922, Harold Weston. Private Collection.

Plate 8. *Basin,* 1922,
Harold Weston.
Collection of Jonathan
and Jennifer Ring.

Plate 9. *Fertility,* 1924, Harold Weston. Private Collection.

Plate 10. *Bending Nude,* 1925, Harold Weston. Private Collection.

Plate 11. *Pyrenees Fields,* c. 1928, Harold Weston. John and Diane Chachas.

Plate 12. *Fort above Prats de Mollo,* 1930, Harold Weston. Harold Weston Foundation.

Plate 13. *Mad Marja,* 1930, Harold Weston. Private Collection.

Plate 14. *Rhubarb in Bud,* 1931, Harold Weston. Sabele Foster.

Plate 15.
Wind-Swept, 1964,
Harold Weston.
Carolyn C. Galbraith.

Plate 16. *Rain Can Down (Stone Series #34),* 1968, Harold Weston. Harold
Weston Foundation.

27. *The Arena,* 1930, Harold Weston. The Phillips Collection, Washington, D.C.

Weston is the sort of man beloved by Whitman, who relishes well his sweetheart or his steak; he bites into a landscape, or an interior as if it were a russet apple. . . . Sometimes his intensity is inconvenient and awkward, like the fumbling gestures of a man overcome by emotion. . . . Shall we call Weston's combination of austerity and sensuality a saint's love of the flesh or a lover's desire for holiness? At all events, there is a touch of almost religious conviction in it, as in some of the best of D. H. Lawrence's prose and verse. . . . Weston's pressure, his violence, his rough exaggeration and his sudden sweetness of color, are not, perhaps, purely American traits, but they say something about life in America that has long waited to be said.[3]

Bait for an Elusive Friend

John Dos Passos was one of the few Harvard classmates with whom I kept in touch over the years and who visited us at St. Huberts several times.[4] An

amusing incident took place after Dos and his first wife Katy visited us one fall in the 1930s. Returning late from a climb, Dos got quite a kick from digging up some new potatoes out in my garden by moonlight for supper. Eating them he said, "Oh, these are such wonderful little fellows, I'd even dig them up by candlelight." I did not have potatoes to spare that year, but I had an exceptionally big crop of macombers, a kind of turnip without the strong turnip taste, which kept well and could be used as a staple vegetable all winter long. Unfortunately, other than boiling, there are few ways to vary the cooking of macombers. The children were delighted when Dos expressed special fondness for these humble macombers and I offered to give him a gunnysack full—so many less for the family to have to eat.

Dos put the gunnysack in the trunk of his little roadster and did not realize until the next morning that he had taken a timid little Adirondack mouse back with him to Provincetown, Massachusetts. He and Katy became quite fond of their Adirondack friend and used to take out special meals for it while it lived in the car for a few weeks. Alas, a Provincetown suitor discovered the lonely Adirondack girl and was sufficiently persuasive to get her to abandon her traveling home and go share his winter quarters.

In the early 1930s, when our children were too young to go to school, we spent two to three of the midwinter months in New York City. One winter when I had a studio off of Washington Square, Dos and Katy were living in an apartment nearby. I wanted very much to try a portrait of him. I had painted quite a few portraits, almost always of people with whom I had personal relationships, which gave me an interest in painting them. Dos was most reluctant to pose, claiming that the human face in general was hardly worth looking at and he did not relish having his own put under lengthy scrutiny. Nevertheless, out of friendship he did come one day, presumably to pose. I like to paint people in some pose that is completely natural to them. Dos asked if I minded his reading a book. The word *reading* was hardly appropriate. Perhaps due to his nervousness at even this degree of "posing," he seemed to devour the book a page a minute until it was finished. Then, he confessed, he just could not sit still. By then I had gotten a few things jotted down on a canvas in charcoal. Dos pleaded with me that I should go on with the painting alone, which I agreed to do.

Dos was partial to a special kind of black Cuban cigarette, smaller than cigarillos—I have forgotten what they are called. So I kept a pack or two of

28. *Dos Passos Reading,* 1933, Harold Weston. The Phillips Collection, Washington, D.C.

these in my studio by way of bait, and every few days for several weeks Dos would come along and smoke a cigarette and we would talk. He did not want me to paint while he was there. He did not know it, but in his absence I was doing two paintings of him at the same time. The one called *Dos Passos Reading* was purchased by the Phillips Collection in Washington, D.C., in 1933 (see ill. 28).

When I had the two portraits done I arranged to show them to Dos and Katy one day when Archibald MacLeish and Niles Spencer were also there. As soon as I put the first portrait on the easel, Katy started to laugh like the devil. I asked her what was quite so funny. She replied, "The damned thing looks more like Dos than he looks like himself!"

The Weasel and the Poker, or The Mouse Ran up the Clock

One of the swiftest animals in the woods over a short distance, in spite of its dachshundlike legs and low-slung body, is the weasel, a North American cousin of the ermine—to its misfortune. One of nature's devices for self-preservation is to turn the weasel's brownish fur into white in the winter. Evolution could not be expected to foresee that this safeguard would in time become a reason for risk of extinction of this species. The soft white fur of its aristocratic cousin, the ermine, has been much sought for ladies' coats and royal trimmings since feudal days. Therefore, after a few centuries ermine furs became difficult to get. The weasel's winter white coat could be palmed off as ermine almost as easily as muskrat for mink. By the second half of the nineteenth century weasels were hunted in the United States intensively.

The weasel's proclivity to suck eggs and to seize a chicken by the neck and drain it of all its blood, a dozen in succession, turned it into an arch enemy of farmers. Weasels were hard to keep out. They could burrow under or climb over chicken wire if the webbing was too small to go through. Their whiplike spurts of speed made them difficult targets to hit. They were also difficult to trap, not only because they were cunningly aware of any contrivances that had a human smell, but more so because of the difficulty of setting a trap with bait that would attract a weasel. Finally, they were known to suck the blood of very small mammals, such as young lambs, and were said to have attacked human babies.

The Adirondacks usually go through a period in late autumn when the weather becomes balmy and sunny, a prelude of calm before the winter storms. This lull of Indian summer, when the mountains are bare of leaves while patches of slightly faded gold and red cling still in the hollows, is a time of relaxation and peaceful beauty. During such a period in 1930 we used to put our eight-month-old son in a carriage and leave him to sleep out in the sun or on the back porch. Parenthetically, I did an oil painting of *Child Sleeping* that fall, which was shown at the Philadelphia Art Club. One day by chance I caught a glimpse of a weasel reconnoitering around the house. Faith and I became alarmed that it might be looking for a chance to get at the throat of our infant son. We put him inside any time we were not there to watch over him but, since the weather was warm, we left the doors open, not thinking for a moment that the weasel would dare come in the house.

The next afternoon I was painting in the studio and heard a slight rustle. It seemed an unusually early hour for any of the many deer mice and field mice that wintered with us to be scurrying about. Their habit was, come autumn, to select a cozy spot between floors or in the recesses of a closet and bring in their harvest of seeds from the extensive swamp behind our house. This was their insurance that they would be warmed and well-fed during the long winter months irrespective of what food they managed to scrounge from us. Out of curiosity I glanced around the studio, cluttered with canvases stacked against the walls and all sorts of other impedimenta, including the usual armfuls of wood ready for the box stove as soon as it turned cold. Suddenly, to my great surprise, I caught sight of the bushy black-tipped tail of a weasel. It was snooping behind a canvas and was not yet aware that I had seen it.

Quietly and quickly I got up and tightly closed all three doors and picked up from behind the stove the rather heavy iron poker, the short-angled blade of which I used to ease in or turn over in the stove the two-foot-long hunks of wood that I had cut the winter before and brought over from across the swamp. I was prepared to give battle, but then, before starting to remove the canvases from the floor and putting them on the cross-pieces of the studding, leaving a few to screen a corner closet, the door of which I left ajar, I got two buckskin thongs, the kind I used for fastening my snowshoes, which happened to be handier than looking for string, and I carefully tied up both of my trouser legs. Come on, man, what are you scared of?

When my father was about twelve years old he was given his first pair of long pants for dress-up occasions. He had them on for the first time on a Sunday evening at a family gathering in the Skowhegan, Maine, farmhouse where the Weston family lived. Someone spotted a mouse in the kitchen and chased it into the living room. All the children were making a great clamor, and the frantic mouse was at its wits' end to know how to escape. In every direction there seemed to be enemies making bloodcurdling noises. My father, known then as Sammy, was less boisterous than the rest. He was very conscious that he must not do anything that would spoil his best new pants. The mouse, seeking a haven in all this turbulence, headed for the spot that seemed the quietest, where perhaps he could hide. He dashed up one of Sammy's legs under his well-pressed trousers, all the way to the crotch and clung there trembling. By that time it would have been hard to say who was

more terrified, little Sammy or the mouse. There is no debating who was given the longest lasting shock. To the end of his life my father never fully got over the memory of those little claws clinging where least welcome.

When we children were growing up, S. Burns Weston habitually wore knickerbockers or knee pants, which buttoned just below the knee, the calves being covered by heavy woolen "golf stockings" (see ill. 2). My father claimed this tight protection of his lower limbs was to avoid, when walking in the woods or on poorly cleared trails, scratches from briars and brambles and the stinging itch caused by brushing against nettles. I accepted that explanation until I heard the story of the fleeing mouse that ran up where the clock strikes one.

Safely tied up, I could go ahead with my plan. I knew the weasel's movements would be far too swift for me to hit it with the poker out in the room. I slowly encouraged it to retreat into the closet. When this was accomplished, I took my position slightly around the corner of the closet, motionless, with poker poised. A half-hour passed. Then the weasel's head appeared for a second to scout out the chances of escape from this dead-end closet. In some ten minutes its head reappeared. I remember noticing the inquisitive protrusion of its sparse, long whiskers, like multiple feelers of a snail on the upper lip, and the buttonlike eyes triggered with alarm. Several more minutes passed. The muscles in my right arm were almost getting a cramp from the wait. At last the weasel cautiously came forward a bit to try to look around the edge of the closet toward the outside door through which it had entered the studio. That was enough. One lightning-swift blow broke its neck. But Faith insisted the doors of the house be kept closed for fear of another weasel invasion.

Indeed, another weasel did figure in a very different way in our son's life, but that was about eighteen years later, when Bruce was clearing trails for the ATIS. One day while working on the West River Trail, he heard repeated high-pitched cries or bleatings giving the impression of an animal in terror. Bruce pushed through the brush to get nearer and very soon saw a spotted fawn jumping frantically up and down and uttering pathetic sounds. It was then he saw a slim dark form hanging from the fawn's neck, but, before he could get close enough to see it clearly, it dropped down and was gone in a flash. Instead of running, the fawn staggered away. At first Bruce thought it might be a snake, but it had disappeared too fast. Unquestionably it was a weasel, and the fawn's life was saved just before too much blood was lost. A

slightly older fawn would have known to use its hind feet to strike off the weasel from its throat.

Red Hot Stove

When our daughter, Barbara, started school at Keene Valley, we got a Scotch collie to be a companion for her younger brother. The isolation of life at St. Huberts, except in summer, was undoubtedly a bit hard on our children. From an early age they enjoyed skiing and tobogganing on the golf links. We had fun as a family cutting and bringing in our own Christmas tree. Our youngest daughter, Haroldine, was born in the Keene Valley Neighborhood House and Hospital in 1936.

The children had few chores to do but their steady exercise was the daily walk down the hill a half mile to the school bus stop and back up again in

29. Faith, Bruce, and Barbara Weston in front of the studio in the mid-thirties. Note more extensions on the back of the house. Photograph by Harold Weston. Harold Weston Foundation.

almost all weathers. That "almost" is where I came in. I had to drive them in hard rains, heavy snows, big wind blowing deep snowdrifts near the top of the hill, or well-below-zero weather. Even with an early start sometimes there was too much shoveling to do near the top of the hill to get to the bus stop in time, so I drove on to the village. Cars of the 1930s did not have strong enough batteries to start easily in unheated garages during subzero weather. I was offered a discarded laundry stove that had survived the 1890 fire at the Beede House. It was about four feet tall, decagonal-bellied, with two rows of shelves or grooves on which to heat up twenty-two flatirons simultaneously. It was equipped for burning coal. I welcomed this strange-looking stove to warm our garage and help to start the Dodge on exceptionally cold mornings.

One well-below-zero morning I went out to the garage before breakfast, put on some more coal, and opened the draft. I did not take into account how much stronger this severe cold would make the draft. After breakfast as I started from our house to the garage to get the car, I saw to my horror thick smoke coming out from under the garage door. As soon as I opened the door the wall back of the stove burst into flame. I tried to get the car out, but it only rolled as far as the ice ruts in the road. By the time the Keene Valley Volunteer Fire Department's fire truck arrived there was little to be done. Someone suggested the car's gas tank might explode, so my revolver was used to puncture a hole in it. Soon flaming gasoline was running down the ice ruts for some fifty feet. In the meantime the heat melted the glass in the car windows and soon nothing remained on the cement floor of the garage except a red hot stove, a mound of winter coal gaily burning, and the charred embers of the roof and walls.

The Horse's Day Is Done

Spen Nye's livery stable in St. Huberts kept up to fifty horses in winter for hauling wood and ice. In the spring some of the horses were hired out to do farm work in the valley. Spen also had a goodly supply of carriages, most of them surreys—with a fringe on top. Behind that fringe, rolled up and attached to the roof, were oilcloth curtains that were let down and hooked when it rained. These four-wheeled carriages had steel springs to absorb some of the roughness of the gravel road. They were drawn by a team.

Their stuffed leather seats held three adults and were known as "two-seaters" or "three-seaters." Spen also had sulkies and buckboards, with a rig on back to hold pack baskets. He let certain customers drive these single-seaters if he knew them well enough and had a docile horse to spare—an early example of "drive-it-yourself"—but even with this special privilege these small vehicles were not much in demand. He kept a few riding horses but that also did not pay.

During the time of the Beede House and then the St. Huberts Inn, there was a stage to the Lower Ausable Lake, one round trip in the morning, one at night, always a three-seater holding eight people in addition to the driver and a kid or two tucked in. For a large party, it was customary to hire a surrey. In either case, able-bodied men and boys were expected to get out at the watering trough, a moss-covered hollowed-out log, and walk up the Flume hill.

Simple primitive methods not infrequently become a luxury. After the installation of electricity at St. Huberts in 1924 and the consequent end of ice harvesting, there was less for horses to do to pay for their winterlong board. Electric heaters, toasters, and the like cut down the amount of wood used. Horses were no longer used to mow the golf links. Fewer farms were cultivated and more trucks and tractors were used. Meanwhile, the surreys were getting old and dilapidated and were hard to repair or replace. By that time more people, lazier about walking, wanted a ride to the Lower Lake without having to hire a surrey or sulky on their own. There was strong demand for a bus that could take quite a lot of people on many round trips a day without sweating and at low cost. The club authorities gave in and in 1934 purchased a converted station wagon for use on the Lake Road. The day of the horse was done.

Educational Program of the ATIS

In the mid-1920s, Henry Goddard Leach, editor, scholar, writer, naturelover, and inveterate bushwhacker, took over the presidency of the ATIS from William A. White. In 1929 Leach brought to St. Huberts a young Canadian botanist, Alice "Jo" Johannsen, who undertook an intensive study and then wrote *Flora and Fauna of Noonmark,* which Leach published for the ATIS. The next summer Leach invited Jo Johannsen to initiate daily trips for the ATIS, acting as hiking leader and nature counselor.

The program met with such enthusiasm that the following year Jo's sister, Peggy, came to help expand the program, and together they laid out the "Speaking Trail" up Noonmark. This consisted of some forty small signs on short stakes that were stuck in the ground beside trees, flowers, and ferns along the trail, naming each variety. Such nature trails have become commonplace, but in 1930 this was quite a novelty. For the next ten years the Johannsen sisters ran the ATIS educational program, which became enormously popular with the kids. Keeping up the Speaking Trail required more botanical knowledge than their successors possessed, and by the time World War II began it was abandoned.

In fact, the whole ATIS program bogged down for a few years but was reinvigorated in the 1950s with young, "gung ho" counselors who had natural leadership, sensitivity to children, and bursting enthusiasm about this unique region of rugged mountains, unspoiled lakes, and virgin forests. These young counselors have planted at least a rudimentary understanding and appreciation of the lore of the wilds in the hearts of hundreds of eager children. As these ATIS boys and girls grow older they become all the more receptive to the lure of the wilderness. These early encounters often lead to a lifetime love affair with nature. Last summer an eight-year-old girl returning from her first ATIS night-trip exclaimed, "You don't realize how beautiful it is out there—how much you miss when you're asleep." Such experiences are not soon forgotten.

Trail maintenance, too, was largely suspended during World War II. The older guides were dying off; the younger guides were given year-round employment by private camp owners; those of draft age were taken off by the war or left for work in war industries and, anyway, they had no interest in trail clearing. In 1948 we tried a new system, engaging two college boys to begin to open up our trails again. It took several seasons to recondition all ninety miles. I was asked to supervise ATIS trail work for several years. This meant selecting the crew, planning the work, and, from time to time, taking part in building bridges or other special chores, such as deciding whether to cut through a slash or cut a detour around it. When the Korean War came along we could not even get college boys and had to employ teenagers and, on account of their inexperience, increase the crew to four. To tell the truth, toward the end of each working day I held my breath until the crew returned safely. We were lucky in having no serious accidents.

This responsibility brought with it indirect rewards of close association with a group of youngsters keen about the woods, and also a few amusing adventures.[5]

The trail crew and I were staying at my camp on the Upper Lake for several days while clearing trails near there. I was camp cook. The third day the boys insisted that I make a double quantity of flapjack batter, boasting that they could eat any amount. In the end they bogged down when there was a bit of batter left. A young racoon, friendly but scared by these big noisy boys, had been coming part way in the kitchen door begging for scraps. On a fast-cooling griddle the boys cooked two oversized, thick, tough pancakes. The first one was broken into pieces thrown on the floor further and further in from the door. As soon as Mr. Racoon timidly got hold of a piece while we watched, he would scamper out to eat it. While he was out downing the biggest piece, the whole second pancake was tacked firmly to the floor. The racoon's expression of surprise and annoyance when he could not pick it up was so comical that we all burst out laughing. I could see that our practical joke and particularly our crude laughter when it succeeded had hurt his feelings. Somehow he was going to get even. The next party to go to my camp a week or so later reported a two-foot hole ripped through the shingles right over the stove where rainfall would cause the most damage. Mr. Racoon had his revenge.

The ATIS over the years had placed a great many signs on its trails. Up until 1948 no clear record was kept as to just where they were located. On certain sections of our trails the bear seemed to resent any signs and to take pleasure year after year in ripping them down with their teeth or tearing them off the trees with their claws. We tried the ruse of nailing the signs much higher on the trees so the bear would not notice them—neither did the hikers. The absence of a sign only came to our attention after some hiker made a wrong turn and then reported it to us. During the summer of 1948, with the help of the counselors and the trail crew, I collected accurate information and made a chart showing the exact position and wording of over four hundred ATIS trail signs. We set up a workshop and replaced many rotting or missing signs and those split into pieces by the bears. We carved and painted many new ones. Also in 1948, several of us combined to gather material about all trails of the region for an ATIS map printed on a U.S. topographical map.

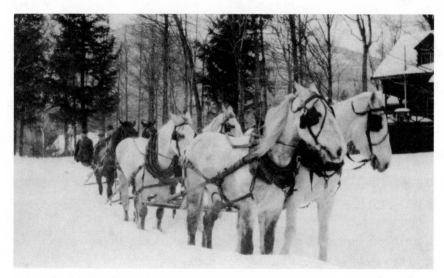

30. Back when God provided more snow and it took six horses to keep the road open with a wooden snowplow. Photograph by Harold Weston, 1920. Harold Weston Foundation.

Ski Trails and God's Message

Constant attempts have been made to gnaw away at the Forest Preserve and the "forever wild" principle. Amendments to the state constitution have been introduced over the years sometimes for very plausible reasons but more often for thinly disguised commercial purposes. Through the years, the Association for the Protection of the Adirondacks, founded in 1901, in a quiet way but sometimes by threatening court action, has been a stalwart defender of the "forever wild" principle and conservation policies. Since its founding in 1922, the robust Adirondack Mountain Club, better known as the ADK, with an extensive membership and educational programs, also has been very active in support of legislation and state policies to protect the Adirondack State Park and the "forever wild" principle.

One of the more comical assaults on the Forest Preserve took place in the mid-1930s. Harry Hicks, manager of the Lake Placid Club, spearheaded a big campaign to permit cutting of a professional ski trail on Wright Peak near Lake Placid and further ski developments on Whiteface Mountain. Encouraged by this drive, a group from Schenectady began pressuring for

a ski run on the southwest shoulder of Giant Mountain. This was not to be a racing trail but, even so, a great many big trees had been marked with red paint for cutting, and the trail would have left a very noticeable scar. I was asked to represent the AMR and the ATIS in opposition to this Giant ski trail at the hearings in Albany.

Hicks made a long-winded and fulsome speech ending up with a declaration that God favored these ski projects or otherwise he would not have provided the beautiful snow. When Hicks sat down, an earnest young man, whom God must have tipped off in advance to have done the necessary research, asked for the floor. He proceeded to read into the record of the hearing the exact amount of snowfall in the High Peaks area during the previous twenty years. The record indisputably showed a steady decline in the amount of snow that had fallen. This opponent of the ski trails concluded his remarks imitating the stentorian tones used by Hicks: "So you see clearly, gentlemen, the will of the Lord. Almighty God, in His infinite wisdom, is against these ski developments spoiling the beauty of His wilderness and has been sending you this message by withholding snow." This evidence and the manner in which it was presented "snowed under" the Giant trail, but the Wright Peak and Whiteface projects were carried out. It might be added that subsequently the Whiteface development almost invariably suffered from lack of snow in contrast to ski resorts in neighboring Vermont until artificial snow permitted them to disregard God's wishes.

The Bear and the Buck

In the autumn of 1940, when the foliage at St. Huberts was at a spectacular peak, two inches of snow produced a rare and weirdly surrealistic effect. The light snow was sufficiently translucent that the brilliance of the leaves and the dark greens of the firs were scarcely muted, and the color of the leaves seen from below was highlighted by the delicate white lacing of snow on top accentuating the patterns formed by the darkly wet branches and tree trunks. At St. Huberts the snow was melting fast and the ground was soon bare. After a morning of painting I decided to go alone to the Upper Ausable Lake for a few days where at that higher altitude the snow would be deeper and last longer. The Great Range was indeed almost as white as in midwinter and the ground well covered by a four-inch blanket of snow.

I stayed alone at camp for three days, more snow falling the last two nights, the temperature dropping to twenty degrees each time. The edges of the lake started to freeze a bit, and ice formed on the docks wherever splashed or dripped on when taking my canoe out of the water. A crew of workmen had been staying at the Warden's Camp for a week cutting wood. Walter Beede, the AMR superintendent, tried his best to persuade me to go down with them on Saturday. He was concerned that I should not remain the only person at the Upper Lake. He was afraid I might fall with my paralyzed leg by slipping on an icy dock or fallen leaves under fresh snow, or even get caught by the lake freezing over if it turned any colder. If a boat cannot be used and the ice is unsafe to walk on, it takes a guide a good four hours to "shore" the Lower Ausable Lake, and under such conditions it would have taken me twice as long. When I refused to give up spending another day trying to record the beauty of this white-decked wilderness caught by winter before autumn was over, he firmly stated that he would drive his pickup to the Lower Lake the next day and, if he could not see me rounding the turn of the lake by four o'clock, he would hurry back to the village, get a rescue squad, and help carry me out. I assured Walter that I did not want that disgrace.

The final morning was cold and brilliant after another couple of inches of snow in the night. I left camp soon after lunch to be sure to meet Walter's deadline. Early in the fall deer normally browse on the higher slopes, not to get out of reach of hunters, but instinctively to save up the browsing potentials of lower levels, which can be reached after heavier snowfall and are nearer those protected areas where the deer yard for winter. Consequently, during the week the men were working at the Upper Lake they saw no deer. The first thing I noticed on reaching the trail between the Upper and Lower Lakes, which is called the Carry, was a stately buck and four does. The depth of snow on the ridges had driven them down. I had heard that bucks can be dangerous during mating season, which was then in full heat. The woods on that part of the Carry were quite open, however, having been thinned out years before for the sawmill at the Lower Lake. The herd saw me first or heard me putting my canoe in the boathouse, and the does were ambling away while the buck guarded their retreat. Altogether while walking the mile of the Carry I counted eleven deer.

Near the Lower Lake, where the Carry trail joins a tote road, I came upon the largest bear tracks I have ever seen. They measured eleven and a

half inches tip of toe to heel, though in the soft snow it was hard to be exact. They looked as if just made. A bit of sunlight fell on them and I regretted I had no film left in my camera. What a chance to follow and perhaps catch sight of such a brute. In this snow I should be able to walk as silently as a fox stalking a rabbit. I started at once, but quite soon, to my surprise, instead of following the tote road, the tracks went down a short steep bank through a thick grove of alders and headed diagonally for the Carry River. Crossing the river there would have meant fording in that icy water while further down there were nice boulders on which to cross. Remembering the footbridge of the Colvin trail near there, and not wanting to press confrontation too hard, I decided to play it cool and go down the tote road to that bridge, hoping to catch sight of him crossing.

With quickened but cautious steps for silence, I rounded the turn of the tote road keeping my eyes and ears cocked to the right in the direction of the river and Mr. Bear. Suddenly I heard snapping branches somewhat behind me to the left. My first thought was that the bear had swung around, perhaps not wanting to get into the cold water, and was coming back. To my relieved surprise I saw it was not the bear but a big handsome buck breaking branches as he bounded over some bushes. "Oh, it's only you," I said out loud. Curiously he seemed to be coming obliquely toward me. I wondered why. Then it dawned on me that he was heading for the height of ground on the turn I had just passed. I knew that when bucks fight each other they try to get the advantage of a downhill charge. In a few seconds he was in the clear on the tote road about twenty feet from where I stood. At once he wheeled and rose on his hind legs to his full seven feet, snorting and shaking his antlers furiously.

None of the thoughts that raced through my mind were about momentous times in my life or anything other than how to get out of this crisis. In addition to a stout hickory stick in my right hand, I held in my left a boat seat, which I was bringing down from the Upper Lake for recaning. No substantial trees were near at hand to get behind or to climb. With my paralyzed leg I could make a jump or two but could not run. By that time the buck began his next demonstration of force to get me properly conditioned. With every hair on his back and neck standing up, as well as his white tail, he gave the impression of a far heavier and huskier animal than the three hundred pounds a male deer can reach. While still shaking his antlers and snorting,

he brought his right foreleg down with a pistonlike thrust to thud into the snow, then his left foreleg, to show off the power with which they could cut a hound from stem to stern. The front hoofs of a buck are pointed like an inverted V, providing a cutting edge, while those of a doe are cleft like an upright V. The buck's forelegs are more formidable weapons than his antlers when he does not have much room to charge, as in this instance. It looked as though he had decided that was the best way to finish me off.

I raised my cane over my shoulder ready to strike, hoping to break, if my timing was right, whichever foreleg he thrust at me. At the same time, I raised waist high and grasped firmly the boat seat in my left hand hoping to lock it onto his horns if he charged and with that movement to push my body and leap out of his line of attack. However, I realized that any step forward, any move of aggression on my part, or indeed any backward step or sign of fear would probably trigger him into action. Was there some other means of defense? Yes, willpower. We were staring each other in the eye. I started saying silently over and over with as much concentration of intensity as I could muster, "You can't do it! You can't start! You can't charge!"

Now the buck dug his hind legs through the snow into the ground, like a runner bracing his feet for the starting gun, and crouched to charge, snorting and swaying perhaps only for a second or two, but it seemed to me several minutes, while I kept repeating, "You can't do it! You can't charge!"

My opponent seemed to have decided I was not softened up enough, not sufficiently impressed by his superior strength, so he rose again to full height, which on that higher ground was mighty impressive. I in turn was determined not to relax a bit on asserting my superiority of willpower. This time he snorted a little less ferociously, shook his antlers less vigorously, and pounded with his forelegs less violently. He was beginning to run out of steam, but his crouch continued to show aggressive intent. I confess I was still thoroughly scared but I was determined not to show it.

The third time he rose again, but giving to his actions an air of pantomime, I could not say just how. I knew I would win if I made no false move. He knew he would not charge, but there had to be some face-saving gesture that showed he was not defeated before this confrontation could be broken off with the honor of both parties intact. His gestures became a sort of ritualistic dance. Quite gradually the hairs on his back and neck relaxed and, with tail still rigidly up, he rose from his last crouch to stand motionless, straight

and proud, staring me in the eye and saying, "I'm lord of this forest; you leave me and my harem alone or else!" My eyes accepted his nonnegotiable conditions, recognized his sovereignty over this wilderness domain. I began silently saying, "You're right. I have no business to interrupt your mating; I will go away if you let me."

We stood looking at each other quite a while as the tensions subsided. Then, indescribably slowly, he brought his left foot up and moved it some five inches to the right, brought his right foot up and over to join the left, the same with his back legs, so that gradually his body pivoted away from me, with his neck arched around and his eyes staring into mine repeating his victory message. With the trembling sensitivity of a cat stalking a grasshopper in a field, raising high one foot at a time and with a conscious sense of great dignity, he started up the tote road down which I had come stalking the bear—it seemed hours ago. The last I saw of him was as he passed behind a small hemlock bent over with snow. His head was still turned toward me and he was still saying as clearly as if in words, "I'm master here. Get the hell out and don't ever disturb me again when I am topping my does."

Pressure off, it was simple to dope out what happened. During mating season bear will avoid deer if a buck is around, as he usually is. Not that a buck could kill a bear, far from it. But he could cause the bear a lot of discomfort and drive him off. The bear, whose tracks I was following, became aware of the buck cavorting with his does, decided to avoid trouble, and left the tote road to cross the river further up. The buck probably smelled the bear, heard me, and came out to give battle. He soon realized I was not the bear but, having started to attack an intruder, felt he had to go through with it or lose prestige with his does. This encounter drained from me any desire to try to snoop up on that bear.

I went on to the boat shed at the upper end of the Lower Lake and saw with considerable concern that the little bay, which has no current and is sheltered from the wind, had completely frozen over, but not enough to walk on. In such cases, you are supposed to break the ice with a stick ahead of the boat, which is very simple with two people. I soon found how hard, if not impossible, it was to do this alone. It was easy to break the ice alongside but not ahead of the boat. To break a sidewise path for my boat would require more time than my rendezvous with Walter permitted. I tried getting the prow up on the quarter-inch-thick ice with the idea of breaking it off with

my weight as I moved forward in the boat. Nothing doing, the darned boat simply slipped backwards off the ice. Only one way seemed possible—to ram a passageway through the thirty feet of thin ice that separated me from the running water of the inlet to the Lower Lake.

This was soon done. However, I had not gone far downstream when I saw the boat was starting to fill up with water far faster than I could bail it out. The razor-sharp ice had cut two neat grooves a quarter of an inch wide and six inches long on both sides of the prow just at the waterline. I rowed as hard as I could to get to Sand Point, the nearest place to dump the water out and figure out a way to proceed. The icy water was just lapping at my rear on the middle seat when I landed soaked to the waist. I placed a couple of heavy stones in the stern, raising the prow well out of water. That solved the leak but made it almost impossible to row in a straight line. Time was running out, but I got to the bend of the lake just in time. Walter's truck was by the boathouse poised to leave.

Walter told me later that when he saw my boat weaving in semicircles he said to himself, "Looks like Harold was drunk or rowing like a city feller. That ain't like him." He soon figured that the ice had cut holes in my boat. He also told me, after hearing about my adventure, that once he, too, had been attacked by a buck on the Carry in mating season. He dodged behind a big tree and kept shouting as he circled the tree whichever way the buck came after him. The does had run off scared by the shouting, and the buck soon got tired of this game and went off to join his does.

Faith greeted me at the door of our home with a curious expression on her face.

"What happened at ten minutes after three this afternoon?" she asked.

"Why at that exact time?" I replied.

"Because for the first time in seventeen years when thee has been out alone on a mountain or at the lakes I suddenly felt thee was in mortal danger and that I should pray for thee." I had not consciously sent any appeal for help or even thought of anything except how to combat or ward off that buck. Some sort of message unknown to me had crossed those seven miles, however, a fact I can scarcely understand even though Faith and I have been exceptionally attuned to each other for a great many years. Somehow, she knew my life was at stake at the precise moment that it may have been more seriously threatened than I realized at the time.

31. Chapel Pond with ice at its edges in 1920, similar to the conditions in the Bear and the Buck. The photograph's composition illustrates Weston's early interest in the abstract patterning of natural forms. Photograph by Harold Weston, 1920. Harold Weston Foundation.

Forest Fire of 1955

One midsummer evening in 1955 my family sat on the dock at our Upper Lake camp and watched with fascination one of the most spectacular displays of chain lightning combined with sheet lightning we had ever seen. Long, angular, zigzag shafts of light streaked across the top of the Great Range, often with pronged forks that seemed to leap from cloud to cloud or shoot down behind the dark mountains, intermittently diffused by a bright overall pinkish glow from more distant sheet lightning—all of this reflected in the calm water of the lake and accompanied by almost continuous rumbles of thunder punctuated by a few startling thunderclaps. We wondered whether this electrical display would start any forest fires, but the lightning seemed mostly high up between clouds, and we were not unduly worried.

Ten days later Emily Lanier, who was trolling toward evening at the westernmost bay of the Upper Lake, casually remarked to the guide, Halsey Chase, who was rowing her, "It's curious that mist would be rising from the Lower this early in the evening."[6] The guide glanced over his shoulder and exclaimed, "That ain't no mist, Lady. By God, that's smoke!" He dropped

her at the nearest dock and rowed as fast as he could down the lake; rushed to the Warden's Camp where he could phone the club; trotted across the mile of the Carry; got his boat out as fast as he could; and by the time he reached the upper end of the Lower Lake, maybe fifteen minutes after he phoned, he saw the observation plane belonging to the Department of Environmental Conservation coming over to circle and pinpoint the location and report the extent of the fire. Men and equipment were already being organized to take to the Lower Lake.

The location of the fire was very hard to reach. Evidently lightning had struck a tree on a crag more than halfway up the Colvin edge of the ravine between Colvin and Blake mountains. Fortunately, for years the ATIS had maintained a trail from the Carry up that ravine to the notch where this trail joins the Colvin-Blake-Pinnacle Trail. A heavy pump was brought down from the Upper Lake to pump water from the Carry River as far as this pump could raise it to a small pool in the little brook that trickles down the ravine. A second, smaller pump and one from the Department of Environmental Conservation hoisted the water that much further up the brook in stages. That high up, the brook's pools were too small, and a canvas tank was set up from which the water had to be carried the last steep quarter of a mile in Indian packs on men's backs.

More important than water for this fire was the work of making a fireline. The area burning at this stage was not large enough for back firing. Axes, hoes, rakes, and shovels were more valuable than a few gallons of water spread thin. The terrain was rough, roots and outcroppings of rocks alternating with deep pits of centuries' old duff. It was in just such a pit that the fire had incubated for ten days or until it got the strength to emerge and send up a smoke signal, "Have fire, will travel." All able-bodied men at St. Huberts volunteered, from the bellboys to the president of the club; shifts of workers were selected and assigned tasks; women prepared sandwiches, doughnuts, and coffee, sent in cauldrons to the Carry. It was feverish, backbreaking work that first night. One of the bellboys fell off a little ledge in the dark and sprained his ankle. Somewhat later a club member, a theological professor, had a worse fall and strained his back. When the anticipated early dawn wind sprang up and fanned the fire, it was touch and go. The frenetic work to the point of exhaustion of a few men such as Paul Lewis, then the superintendent of the AMR, held the line. After two days and nights the danger was over.

Almost as lucky as the fact that the fire was detected the first evening, a friend of a St. Huberts resident had stopped for the night and had a motorboat with him on a trailer. The boat was rushed to the Lower Lake, the first time a motorboat had been permitted. Through the night it sped men and equipment up the lake. The district director of conservation, William E. Petty, arrived from Ray Brook and asked me to go up the lake with him on one of the early trips of the motorboat. A red glow lit up the clouds of smoke in the night sky halfway up the western ridge of Colvin. You could not see any flames until you reached the very upper end of the lake because the fire was slightly around the rim of the ridge. Petty said the lightning storm ten days earlier had started over a dozen forest fires just in his district, some that same night, some later; most were accessible places, none of the others serious as long as spotted and attended to. But this one could be serious if it was not held to the initial acre or two. Updrafts could sweep it up the steep wooded ridge. Prevalent winds were heading it directly toward the largest and finest tract of virgin timber east of the Rockies, the valley between Colvin and Nippletop, which, as far as is known, neither forest fires nor axes have ever damaged.

Dick's Clearing

Richard Norris Williams, II, won his first national singles tennis championship of the United States in 1914, his sophomore year at Harvard. I was one of his roommates during his junior and senior years and often enthused to Dick about St. Huberts and urged it as a place to spend his summer vacations after he retired from the rounds of tennis tournaments and Davis Cup matches. In 1939 he delighted me by suddenly appearing at St. Huberts with his family, and he rarely missed a summer after that. Because of Dick, his doubles partner Charles S. Garland also adopted St. Huberts as his family's summer home. Dick and Chuck had won the Wimbledon international tennis doubles championship in 1920, the first time for Americans. Several other top tennis players were also attracted to St. Huberts. For a number of years at eleven o'clock on weekdays in August the court by the clubhouse would be preempted for exhibition tennis, Williams and Garland taking on all comers. The club porch was crowded with people thrilled to watch the grace and excellence of the play.

32. *Forever Wild,* 1960, Harold Weston. James Mossman.

Dick had a warm and outgoing personality, and the ties of friendship between us were exceptionally strong. Dick and I shared a special bond that few people knew about. On rainy days, when tennis was out, Dick loved to walk in the woods; he rarely climbed mountains. He felt a deep affinity toward all the things that richly carpeted the forest floor—ground pine, partridge berries, ground cedar (known as umbrella plant), witch hobble or moose maple, and thick clutches of balsam or spruce seedlings pressed shoulder to shoulder trying to gain possession of a place in the sun or shade. Across the river in back of the club, actually within less than a half mile, during his wandering through dripping trees, one day Dick discovered an isolated knoll where all of his favorite participants combined to create the rare beauty of

a totally wild botanical garden and arboretum. He jokingly named this bit of untouched woods "Dick's Clearing" with allusions to Maghee's Clearing further up on the mountainside. Dick kept the way to it secret except to his closest friends.

Dick, the director of the Historical Society of Pennsylvania for over twenty years, was basically conservative. Early in his time at St. Huberts, he bought from me an "identifiable" watercolor of Giant Mountain and later one of Noonmark Mountain. He neither liked nor understood the semi-abstract work I began doing in the 1950s, taking rhythms or sequences of forms from some relic of the wilds—a stone with unusual patterns, the worm paths made under the bark of a spruce—which led to paintings that suggested coral under the sea or seemed related to the sixth day of creation, when islands rose from the oceans. However, Dick did buy a painting of grasses against blue sky that was oriental in feeling but not abstract—it was partly painted while lying on my back after a picnic in the fields of Samuel Thorn's dairy farm in Jay, New York, called Upland Meadows. The more imaginative or less realistic ones bothered him; in fact, he told me several times that he kept thinking about them during the winters. This finally convinced him that they must have some merit.

The next summer on his strolls through the woods he began looking for instances or trivia of nature that demonstrated interrelationships of form or color that might stimulate a painting. He started bringing me the best of his findings—a fungus ripped off an old stump that revealed on the back side an intricate lacework of fibers or veins that composed the inside of that fungus. My oil painting from this find is owned by St. Lawrence University (*Fungus,* 1965). Another example was a piece of curly maple split for burning, which Dick found in the wood box at his cottage. The ascending ripples of wood sinews on this stick of firewood when put on canvas turned into a series of forms spiraling up somewhat like flames. None of the forms were identifiable human figures, yet one woman exclaimed, "This picture should be titled *Nudes on Fire!*" In his last years Dick's attitude toward my late paintings changed from doubt to enthusiasm. Our friendship was enriched through sharing simple wonders of the woods that stimulated almost totally unrealistic creations.

33. *Rain Clouds,* 1921, Harold Weston. Bill Sudduth.

8

Forever Wild

Nocturne

DURING MY BRIEF SPAN as the Hermit of the Ausable Club, I took moonlit walks fairly often on the golf links encircled by the silent black masses of the mountains, on the lake road, or on familiar nearby trails. In the darkness I had to be cautious about unexpected holes or obstructions, since I had no control over my left ankle and could not stand on my left leg if the knee was bent. It is surprising, once you become aware of it, how quickly in the darkness your feet feel the difference and let you know if you step off a trail and onto the soft duff of the woods, provided that trail has been well used even in the fairly distant past. In any case, there was no hurry on these night excursions, no desire for speed—quite the contrary. I went along like those big fat "night crawler" worms with which we preferred to bait our hooks when we were children. When pursuing this unhurried tempo one could hear the familiar night woods noises, the drip of dew from the leaves or their rustling in a momentary breeze, and the scurrying of the Lilliputians of the night woods. One had time to note and remember the shafts of moonlight piercing through the trees and the weird combinations of complex shadow forms in the forest canopy. One had time to absorb not only the faint fragrance of the aromas from balsam, hemlock, and cedar but also to store up in one's memory the aggregate of varied sensations and impressions, which has always seemed to me an essential element in enjoying to the full nature, or love—in fact, life. My temperament is to work under pressure but not at such times as these. When I get to a mountaintop I want to stay there long enough to enjoy and record the passing moods. One of the most alluring features of walking in the woods alone at night when the leaves are off is the companionship of the stars in the immensity of the silence, and the sense of timelessness of which one is much more conscious at night and which helps to give a new perspective on life.

After I got married, except for going down the hill to fetch the evening milk and mail, I rarely walked at night. My sense of values had changed appreciably and, as the companionship of a love life absorbed my energies, intimacies with nature began to withdraw. One well-below-zero and crystal-clear night in January 1924, however, Faith and I went out for a walk on snowshoes from our home at St. Huberts. We were standing on the golf hill, awed by the dark majesty of the mountains in the frozen stillness, when suddenly the silence was broken by the eerie, mournful ululation of a timber wolf over by the river. Chills went down our spines, though it sounded lonely rather than threatening. Needless to say, we made rapid tracks back to the fireside in the studio. Although wolves were exterminated by poison and traps by 1870, lone wolves and Canadian lynx were known to slip down from Canada when winters were exceptionally hard.

I know of only one other person in our immediate High Peaks area during the time I was here who made a habit, far more regular than mine ever was, of following the trails alone at night, and actually climbing several of the nearby mountains. For about ten years or more in the 1950s, Hermann Saurstein, the bartender at the Ausable Club, who happened to be a Bavarian of mountain stock, did just that during his time off at night. I was secretary of the ATIS during the years of his night-prowling and part of the time was responsible for supervising the trails. He would report to me any recent blowdowns or dead trees that had simply fallen of old age. He did a major mountain trip only when the moon was bright, and then he would scarcely use his flashlight. He told me about experiences of special interest. Once, he climbed up Mount Colvin, one of his favorite trails because of its steady, even ascent and not-seriously-eroded condition. He walked through a stretch of cloud forest where the virgin firs were dripping and glistening in the paled-down moonlight, to the higher level of the mountain, which stood in the clear above a cloud bank that completely covered all valleys below. When the days have been warm, raising the surface temperature of ponds, and the nights cool, mist habitually begins to rise from the water and collects over the pond and adjacent areas so that sometimes from a higher mountain you look down on a sea of clouds with abrupt dark peaks popping up like the Greek Islands jumping up out of the Aegean Sea.

It seemed to me that this man's love of the trails and the mountains should be recognized in some way. I suggested that the ATIS might make

Saurstein an honorary member and wrote out a statement including the fact that he had been helpful in reporting on our trails. He considered the document a diploma. When the bartender returned from a visit to his native Bavarian village the year before he retired, he told me that one of the most treasured possessions he took to show his relatives and friends was his ATIS diploma.[1]

Cloudbursts and Hurricanes

A natural phenomenon that occurs in the Adirondacks from time to time is a cloudburst. Two have been seen in the vicinity of St. Huberts during the past hundred years. Both did considerable damage. The first took place around noon on July 17, 1901. The Weston family was having lunch on the porch of the dining room at Icy Brook Camp. Within a few minutes the uneven sloping ground was covered by a solid sheet of water that seemed about two inches deep. I was only seven but I can still see that sheet of water moving toward the brook. This cloudburst centered around Chapel Pond and the

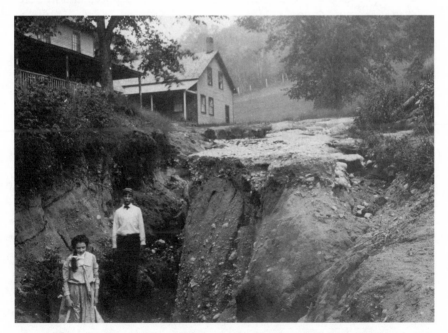

34. After the cloudburst, July 17, 1901. Courtesy of Archives, Keene Valley Library Association.

foot of the hill at St. Huberts. The dirt road was washed out seven feet deep on the Chapel Pond hill, which shut the road for the rest of the summer. The old road down the hill from the inn toward Keene Valley was gutted so much that a whole surrey could fit in some of the crevasses. That road was never opened again, but a new one was built with an easier grade. Because this deluge was so short and was not up on the mountains, it caused no floods or landslides, except two small ones on the Chapel Pond road.

The second cloudburst took place at the end of June 1963 and was even more dramatic. Two thunder heads met over Giant Mountain and dumped all of their water in a limited area. A rainfall indicator at Putnam Camp registered six inches of water in less than half an hour, and that was on the edge of the storm. Simultaneously numerous slides started down both the east and west faces of Giant. At dozens of places on both sides of the mountain trees lost their precarious hold on the smooth rock slopes—generally where slides had previously taken place, but also in some new places—taking along with them boulders, earth, and vegetation, scouring clean the granite base. On our side of Giant, six or eight slides converged at the narrow-necked valley of Roaring Brook and tore a path through the forest, in spots a hundred feet wide, churning the trees as in a meat grinder, ripping off branches and bark, twisting the trunks, leaving a three-ton boulder near the center poised to fall. The combined slides plunged down Roaring Brook Falls with such force that most of the ledge halfway up was broken off. All this produced a noise like muffled thunder, and the ground shook as from an earth tremor. A thirty-foot section of the road below was ripped out five feet deep; several cars were swept away or buried in debris, but, astonishingly, no lives were lost. It was all over in less than an hour. Over two dozen people were stranded three days until the road was reopened. The startlingly white slides that scarred the face of Giant have over time taken on that grey-blue-violet tone of weathered Adirondack rock.

The erratic violence of nature's power to alter the surface of an area by wind alone, revealed in the Adirondacks perhaps once a century, comes as a shock in the peaceful cycles of the forest's development. In the autumn of 1950, the tail end of a hurricane hit the North Woods. Literally millions of trees were blown over. In the High Peaks area, where the furious gale was deflected irregularly by mountain ranges, it left capricious streaks of devastation. The next summer, looking from Mount Haystack at the sides of Mount

Skylight, the forest there had been knocked down as if Paul Bunyan had taken a gigantic scythe and cut eccentric paths in a field of grain, leaving strips standing between the mowed-down lanes. On the Great Range the blowdowns bred quite a few small slides. On the northern slope of Colvin the trees were blown sideways to the course of the hurricane by winds bounced off the Range. The ATIS crew had to cut and remove 408 trees on the trail between the Lake Road and the top of Colvin; most of these were "hung" trees, more dangerous to fell.

One of the places hardest hit was a good portion of the state-maintained trail from Elk Lake to Marcy in the Marcy Brook Valley. Five layers of trees crisscrossed each other so that in spots the highest tree was some twenty feet from the ground. A large proportion of the trees blown over by this hurricane were not flat on the ground. Usually they were leaning against other trees, similarly leaning with their roots sufficiently torn off or upended so the tree would die after a year or so. The state opened up the forests, including the Adirondack State Park, for salvage operations for four reasons: the "hung" trees would take years to rot; their wood was good for lumber or pulpwood for about five years; such a large amount of dead or dying trees would be a terrible fire hazard for a decade; and removal of their trunks and cutting flat the branches would expedite their decay as well as encourage new growth.

It is tough to scramble through a heavily blown-down section, even many years later. When bushwhacking from Bear Run to the top of Lower Wolf Jaw Mountain several years ago, I came across an old blowdown, rather extensive, where young twenty-foot spruce had grown up between criss-crossed old trunks. For a hundred yards or more I had to clamber over different levels of these old trunks without setting foot to ground, and many of them threatened to break under my weight. Had these trunks been on the ground, they would have long since disintegrated.

Nature's Minor Mysteries

The relationship of all aspects of the environment to all living things is a complex subject, for brevity called the ecosystem, and I do not pretend to know much about the whys and wherefores. Not only does the ecosystem include air, water, soil, food, and habitat for each species native to that area, but also such potential dangers to existence as may be caused by epidemics or

predators, the most destructive of which are humans. Furthermore, ecological problems do not stand alone. They are intertwined with biological patterns, whether prompted by necessity, habit, or instinct, such as the instinct of the birds that makes them still migrate over the Himalayas. Nature's minor mysteries, generally considered inappropriate subjects for scientific research, are nevertheless interesting.

During World War I a shrew was caught at Icy Brook. The shrew is about a third of the size of a mouse, has a longer nose or snout, and lives on insects and worms. This specimen was identified as an arctic shrew, so called because it is rarely found below the Arctic Circle. Actually, they are a "relict" mammal from preglacial days. This one may have descended from a shrew family that got left in the Adirondacks when the ice cap melted. Ice and snow would have remained on these mountains long after it had melted in the St. Lawrence River Valley. Somewhat like the preglacial fern I saw on one of the High Peaks with a noted botanist in 1937 (I had to swear to secrecy about the exact location before he would show me this living link with prehistoric ages), the shrew is most diminutive, a shy little creature rarely seen. I have had a cousin of the Icy Brook shrew living for several years under the firewood stacked under a wing of my house at St. Huberts. How do the shrews adjust to the warmer climate we seem to be getting, and are they really another living link to prehistoric ages?[2]

A mammal related to the mouse and rat families but distinct from both is locally called a "meadow moe," a corruption of meadow vole. During the years that I raised most of the year-round vegetables for our family in our garden at St. Huberts, I trapped scores of these clever little beasties, far harder to catch than mice. When my beets, their favorite delicacy, began to get well filled out, these consarned critters would go down the row, selecting only the best, chew out all of the inside except a thin reinforcement under the skin, just enough to keep the tops green to camouflage their depredations. What instinct taught them to shelter their deviltry like that when their ancestors up until the first white settlers at St. Huberts had no experience with cultivated crops?[3]

I must mention the frequently observed phenomenon of periodic "hootouts" by owls to which the owls of the neighborhood come from some distances. These caucuses may consist of a dozen owls, more or less, customarily of the same species, though, judging solely from the sounds, sometimes out-

siders stir up the caucus by trying to get into the hooting competition. Every owl is master of its own kingdom; the word "ward" would seem more appropriate in this situation. Maybe these gatherings have to do with the division of territory or the spoils therefrom. Or maybe the owls get together just to have a neighborly "hoot-out." Only the hooters know.[4] (See part two, "Harold to Faith, October 14, 1922, St. Huberts.")

In 1920, when I first started to live at St. Huberts year-round, fine specimens of the Adirondack red fox were frequently trapped for furs, then at a good price. One day when Faith and I were climbing Hopkins, I stopped at a lookout just off the trail to paint a small oil. A superb fox came sauntering down the trail with his tail on high, like a waving flag that bespoke both dignity and pride. I have cherished his rapid unhurried movement as symbolic of the unfettered life of animals in the wilderness. In recent years fewer fox have been seen in our area, including the lakes where there was no spraying of pesticides that might have poisoned mice. Those that are seen seem to be the runts of the litters, small and scrawny, like the couple that used to pounce around on the golf links toward evening catching grasshoppers. It is known that a bad epidemic of rabies spread down from Canada and decimated the fox population in the North Country and Adirondacks. But why would the weaklings and not the sturdy ones survive?

In the spring the surface water of a comparatively small pond such as the Upper Ausable Lake is colder than down lower until the ice goes out. Fairly soon after it does, the warmer water rises from below and a fairly complete turnover of the water then takes place. While that is happening, the fish, who are accustomed to the temperature of the bottom water through the winter, often rise with it to near the surface only to seek the cooler lower depths again when the surface gets warmed up by early summer sun. Verified and personally witnessed instances of a mass of fish surfacing and bubbling have so far elicited no adequate explanation. This phenomenon has taken place at the Upper Lake twice to my knowledge; how many other times I would not hazard a guess. Both times were under an August full moon—the first when I was out in a canoe alone in 1921, the second when out with a friend in 1930.

Both experiences were eerie and gave me a disturbing feeling of insecurity, of being balanced on the shifting base of boiling bubbles, so many thousands of them that one became aware of a perceptible muted hissing.

Both nights were without wind and consequently without waves. The surface of the lake was a mass of bubbles with myriads of ripples made by many hundreds of fish, what kinds I could not tell, blowing bubbles through their gills. You could see the darkish heads of the larger fish just on the surface with their fins on their backs protruding. They were not moving about, but remained stationary, blowing bubbles in the moonlit air. These bubbles did not rise; they floated around on the surface, sometimes amalgamating with smaller bubbles, reflecting the moon. Was this a bubble festival, and what sort of a big bang did the fish get out of this communal bubbling? What instinct led them to do it? What prompted such a remarkable demonstration of united action? I have a sneaking feeling that, although I am sure this great gathering had nothing to do with the love life of the fish, they were just taking the night off to bay at the moon. I anxiously wait for a more sober and scientific explanation.[5]

The last example of lesser instances of animal behavior patterns of which I know neither the significance nor the motivation, frankly, scarcely seems believable. Unfortunately, I cannot personally vouch for this extraordinary episode. The event was described to me in detail by Walter Beede with an expression of his own incredulity that he had ever witnessed anything so bizarre. Walter, grandson of one of the Beedes who ran the Beede House, was a supervisor and warden of the AMR-Ausable Club for several years. He was not a drinking man. He was very serious in manner and well-informed about the forests and the creatures that dwell therein. This happening took place between 1926 and 1930 when Faith and I were temporary expatriates in Europe. I have no knowledge that such an incident has ever occurred again. What took place, one might say, was a mass gathering of toads and frogs in which, according to Walter, toads predominated. It occurred in the spring, and the gathering place was that flat bit of ground, maybe a dozen acres, near the Warden's Camp, where David Hale had thinned the woods by some lumbering prior to 1886. Walter was alone on his way to the Upper Lake. As soon as he started to cross the Carry he noticed large numbers of toads and frogs all jumping irregularly but consistently in the direction in which he was going. They were to be seen all through the woods along the Carry River, though of course they were closer together on the trail where their progress was less impeded. Soon it became almost impossible to put his foot down without stepping on a toad or frog, so Walter got a longish stick

and tried to shoo them off the trail ahead with it—no use. They seemed to be caught in a kind of mass frenzy and would pay little attention to any proddings. At the Warden's Camp a screen door kept them out, and in that vicinity they had ceased to move forward, although you could not see that there was any precise center of activity—no major croaker. Walter was kept awake most of the night by the amalgam of peeping, chirping, and trilling with a chorus of bullfrog bass notes. This cacophony began to slow down at dawn. By the time Walter started back to St. Huberts the next afternoon, the majority of the toads and frogs were disappearing. Walter had no more idea where they went to than where they had come from. All through the area around the Warden's Camp most of the fragile plants, such as ferns, were trampled down, but there was no evidence of suffocation from mass congestion or injuries from unpeaceful acts at the convocation. When I got back from Europe, Walter asked me to explain this event, since he knew I would not laugh at him. I had no answer then and I still have none now. Was it just an instance of spring madness? A toad and frog rock festival? I wonder.

Forever Wild

> "The lands of the state, now owned or hereafter acquired, constituting the forest preserve as now fixed by law, shall be forever kept as wild forest lands. They shall not be leased, sold or exchanged, or be taken by any corporation, public or private, nor shall the timber thereon be sold, removed or destroyed."
>
> —Article XIV, Section 1, New York State Constitution

These simple, sober words have a wider, longer-range significance than may superficially seem to be the case. Clearly this edict gives priority within the areas specified to values other than commercial returns. Who can weigh in board-feet-value of timber the peace-giving attributes of a wilderness area in a troubled world? Another implication of this constitutional provision is far more relevant today than when it was first adopted in 1894. An essential difference between a forever-wild forest tract and either state or privately owned land that is "husbanded" or under management for forest products, is that in the wild area nature is not tampered with or placed under any management or control. So much of life in the United States has become regimented—fixed patterns of education, established potentials of employ-

35. *Giant from Windy Brow,* 1922, Harold Weston. Robert O. Preyer.

ment, set standards of living and behavior. Life has been crowding in upon us all. The pressures for conformity have increased unrest on the part of youth. They fear that the wilderness areas of their lives, those areas where they are free from institutionalization and remote-control planning, are falling prey to exploitations, however well-intentioned and benevolent. Individuals should fight to retain elbowroom for their spirit, their inner sanctuary of unregulated freedom—provided they respect the rights of others.

The forever-wild area within us, of which I speak, serves as a link to ages past and to other spheres. Creative people in whatever field go beyond the known that they or anyone else has heretofore experienced or achieved. The inspiration for this send-off may stem from a multitude of sources. For those who are sensitive to nature, it is not necessary that there be more than a symbolic presence. The poet, composer, visual artist, and all those who are creative by instinct, even if their experiences are never objectified, can sense

from a single fern frond, a leaf, a stone, or the song of a bird, the quintessence of the kind of freedom a wilderness tract can convey, and by this they may break loose and be propelled into an orbit beyond their present world.

One acutely memorable experience of my youth took place during an annual family climb up Giant Mountain. I was probably about ten at the time. This glimpse into the free life of the wilderness opened a door to my reactions toward nature, established as it were a touchstone for freedom in the wilds. We were eating lunch on top when a bald eagle suddenly appeared from the direction of Lake Champlain and flew over the summit not more than fifteen feet above us. At no other time have I seen an eagle in the Adirondacks that close. When just about over our heads, it wheeled casually, and its eight-foot wingspan caught the updraft from the slide-scarred western face of Giant. It paused suspended, almost stationary, for some time with far fewer fluctuations than a kite tethered in a steady breeze. It was looking us over as we were examining it. Then, with no flapping at all, but a subtle adjustment of the angle of its wings to the air current, it gradually rose higher and higher until it reached the upper limits of the breeze. What a sense of strength and mastery over the environment. What a demonstration of freedom of will. Soon it started to toboggan down the updraft until it was only visible against the trees in the valley below, when the sun glistened now and then on its wings or back. For a while we lost sight of it entirely, only seeing later a tiny dark spot in the sky moving toward the westerly range.

Be similarly free to let your spirit take wing upon the updrafts of your mind. Trust it to keep you on your chosen course through the turbulences of our times. Encourage it to soar to distant ranges in whatever realms not yet explored.

PART TWO

Letters and Diaries

The writings in this section compose a narrative of the first twenty-nine years of Harold's Weston's life. To sustain the flow of the narrative, letter and diary excerpts are differentiated only as follows: diary excerpts are specified by date and place, while letter excerpts are specified by author, recipient, date, and place. Most are drawn from Weston's letters and diaries, although correspondence by a few other people of critical importance is included. Editorial intervention has been limited to the insertion of an occasional comma or period for clarity, and because the text is understood to consist of excerpts, no ellipses have been used. Weston's terrible spelling has been retained without editorial comment or use of [sic], whose frequency would be tedious. Enjoy the insight to Weston's youthful mind and be assured that everything has been proofread carefully. In deference to his youth and to the intimate relationships in these writings, Weston is referred to as Harold. Please see the introduction for a discussion of the content of this section.

36. Harold and Carl Weston, 1902. Harold Weston Foundation.

Mary Hartshorne Weston (Harold's mother), *The Story of a Child:*
Harold Francis Weston, entries from April to June 1899, when
Harold was five years old and living in Merion, Pennsylvania[1]

Harold takes the greatest interest in [his and his brother Carl's] garden and now
they have a second crop of peas and beans and some corn and tomatoes. He
dug up a fern in the woods with his hands and planted it in a pot. He amuses
himself out of doors for hours and he frequently suggests plays to Carl.

This morning the canary got out of his cage and flew out the window
and we heard him singing in one of the little trees. The boys were much
excited and Harold climbed the tree and shook the branch where he was sit-
ting; but unfortunately he flew still further away and we thought we would
never see him again. We left the cage, with water and seed and the door open,
on the porch, however. Just before dinner he flew up on the porch and Har-
old caught him in his hands (no one knows exactly how) and put him in the
cage in triumph. Yesterday I heard [Harold] calling on the lawn and I looked
and found that he was within two feet of the top of a little tree in front of the
house. I had never seen him up there at all before, but it seems he had shown
Carl [who was one and a half years older] how to climb the upper branches!

He is most energetic and out of doors all day. His latest accomplishment
is to catch butterflies, which he does with the greatest ease, holding them
in his two hands. He caught 8 or 10 one day and he generally lets them out
again, after having them in the nursery for a while.

Harold will always be a tease and inclined to play practical jokes. For-
tunately Carl is learning to take the teasing in a right spirit and is not so
resentful of it.

Letter written by Harold's mother, "exactly as dictated" by Harold,
to Uncle Walter Percival, n.d., "up in the Mtns"[2]

Say to Uncle Walter that I love him very well, and tell him 'at the kite flied
higher 'an Noonmark. Me and Carl each got a trowel and we planted ferns. I
gave Carl a slate to draw six pictures on. I was awake at half past eight o'clock
and saw the Camp Fire. I saw the lanterns hanged up and Papa lighting them
and all the people I saw. I was in my bed looking out the window. I heard the
people sing and it was not very pretty, but a little.

The first diary Harold ever kept, excerpts of which follow, starts with a review of his life up until 1906. The review is structured around the Adirondacks; if only one thing is mentioned for a year it is that he went to the Adirondacks for the summer. The first day-by-day entries begin with his trip to the Adirondacks in June 1906 at age twelve.[3]

1894

I was born a twin but my twin brother Edward died, only six months old. After I was born I got boils and was very ill, and might not have lived if I had not been taken down to Cape May by my Aunt Amy and Uncle Edward.

[1906]

July 7. Carl and I went up to end of Panarama Bluff trail at night. Carl and I carried 3 bords across the Carry. I ran home from the lakes $3^1/_2$ mi. in 26 min. and got stiff.

Aug. 15. Went up Giant with Mother, Carl, and bugged mother nearly all way. I came down slides with Carl.

Sept. 14. Went up to lakes and had dinner at Legrand Hale's. Went to Panarama Bluffs. Stayed over night at Verd Beede's without guide.

Sept. 15. Carl and I went up Inlet and cut logs beyond end of Panarama Bluff Inlet. I got wet above my waste. Saw ducks 8 which had grown and flown to Upper Lake.

Sept. 16. Was about 42° in morning. Help! Only 3 more days [until I leave the Adirondacks]!

[1907]

April 4. Painted in morn. and made kite in aft.

April 6. Went to painting class and did a little picture of no account; and finished moddeling the ear I had done before, and did a beet. Came home on the elevated and subway. Went to Alan's in aft. and played baseball.

April 10. Went to sch. painted a little, snowed a little.

April 11. Gave Grandpa the sea picture I had done and intended to give to Mother for her birthday present on the 29. Hurry up get to work [on another picture]!

Harold and his family lived and traveled in Europe from June 1909 to September 1910, Harold attending school in Lausanne, Switzerland, and Hannover, Germany.

June 18, 1910, Belluno, Italy

As it had stopped raining, Miss Zietz, Carl and I went out and went through the church in which were some paintings by Titian, who was born here. Then we took a lovely walk going on a little path through the woods of larches. The wild flowers in the fields are of all colors and most abundant. After supper we all went for a short walk. The valley to the north was most beautiful with the small white veil-like clouds that rise from the woods after a rain; and in the distance is a long chain of blue hazy mountains the peaks of which just kiss the clouds. Later in the evening I went out alone in the wonderful moonlight. I sketched three or four skribbles, the first I had [ever] done in moonlight. All reminded me of the Adirondacks.

September 27, 1910, Philips Exeter Academy, Exeter, New Hampshire

Carl left early in the morning, I said "Good Bye" to him last night, he starts in at Harvard tomorrow. It seemes very funney to not be with him or where I can see him every day. This is almost our first separation since over a year ago. I shall of course miss him very much. Much to my surprise and joy, Father turned up. He had just arrived from the Adirondacks and Boston and could only stay over night. He told me many interesting things of his trip to the Adirondacks, with fine weather, and we had a most interesting talk up to about 10 o'c and then we walked around in Exeter talking and finally had to say "goodbye" about 11 o'c. It certainly was a short but most interesting stay, and I am sure I profited by it, for who has more influence on a boy than his father, and especially one such as I have.

September 30, 1910, Exeter

It was an ideal afternoon and we could not have had a finer example of the great wonders of the colors in nature. Think what a bliss it is to be alive and able to see such things! What heaven could be better than parts of this life, if one could but seize the reality of the beauty of nature and preserve it longer. That is the object of painting to take the most beautiful things of this world, and surely there can be none more beautiful, and preserve them in their true forms and colors for those who cannot see the more beautiful nature itself. In

such a way painting creates as it were a poor imitation [of] heaven showing those who are ignorant what wonders we have on this earth and how could heaven be more beautiful only a more wonderful, grander, finer succession of such scenes.

What is the aim of life, if it is not to be active, to do something in this world, and if every thing was easy to do, what would be the joy in having done it? If we want to stay in this world longer than our lifetime we should do something that will make the world recognise us as one of its benefactors, great or small. Also in composing a picture you compose a world of your idea, therefore if a person can become a great painter one adds to the beauty of this world making scenes that were never seen before. A great source of joy to a person is his imagination and also a source of joy to others if he can but express it. I spent so much time over and enjoyed so much the *modern* and ancient paintings that I saw in Europe, for each picture was a world crying out for admittance in my mind, the more or less interesting the more or less emphatically.

I have written a lot of nonsense, I hope no one will read this but myself; these thoughts have been roaring around in my mind and needed an outlet. What one lives inside one's head is more than what one lives in the world. Although I am only 16 years old I have already had a wonderful life, and most of my trials and temptations are yet to come.

October 2, 1910, Exeter

I went to the Christian Fraternity meeting and heard Rev. Albert Parker Fitch, president of Andover Theological Seminary, of Cambridge, now a part of Harvard. He is a wonderful speaker. He spoke on the duty of the boy of the present day to mankind. How everything had been payed for them by the lives of others. His duty to his body, his mind, his soul and to the world. To see his opportunities, to think of and better the world for the future generations. His speech appealed to me strikingly, I hope I will not forget it!

October 23, 1910, Exeter

Got E in English comp on Venise, had comp read in class and Mr. Webber said it was a good A comp but the 5 misspelled words flunked it.

37. *Winter-Brook,* 1910, Harold Weston. Harold Weston Foundation.

February 14, 1911, Exeter

I am now seventeen, ugly (or not a bit good looking) thin, lanky, tall enough, rather pale, not exceedingly strong, but fairly healthy. I study or sit up too late, eat often too much, am troubled with coulds often, wear glasses. My maine ideal for the future has been to be a successful or good artist, mainly a nature composer. I doubt if I ever will be it but I will have, as far as I know, taken the most of my opportunities and, in a slight way, have succeeded in my small attempts. But it is quite different to be a great artist and one who can support himself (and others perhaps) by painting.

April 10, 1911, Exeter

I was elected 1912 class Tennis Captain and I wone the class tournament. [The class of] 1912 wone the championship over all the classes. I played the best fellow in each class. Was elected Art Editor of 1912 *Pean* [the yearbook].

August 1, 1911, Upper Ausable Lake, St. Huberts, New York

After supper Mother, Esther and I went in canoe along Western shore. Moonlight perfectly wonderful calm no breeze, pines water reflection golden silvery moon. Later Mr. Groble and I went out in canoe, paddle softly—talking (Art—Spiritual Energy—body-forms Eugenics truth—Socrates Hindu philosophy—Pantheism Stars.) Wonderful and impressive night.

August 2, 1911, St. Huberts

Rowed down with Father. Hard and steady [wind] on Lower Lake. Walked down talking [with Father] no ideas future existance, almost Pantheist, animals, occupation art worthy but??

August 20, 1911, St. Huberts

Walked out of village [Newcomb] then got 6 mi auto lift. Walked 6 mi Boreas Pond. 6 mi on to brook for lunch then Inlet—Upper Lake met Father at boathouse. I rowed down, then walked and ran down to toll gate. Walked 30 mi that day.

August 24, 1911, St. Huberts

Raining. Played Bridge almost all morning [at camp on Upper Lake]. Rowed down in rain. Went to Openheim's for sup. (Pig) Pains begin. August 25th Sickness begins, cousin Anna H & V. pain head ach, lay *around all day.* Bad night. Aug. 26th Doctor bed. Father's room. Foot boil lanced. Aug 27 Worse paralasis in left leg. Miss Paterson (Norwegan) Aug 28th Miss Schaeble (Neighborhood House, Albany)—August 29-30-31-Sept-1-2 all in bed flat on back—pains leg & back Dr. Miller every day Dr. Adler once. Sept 3rd. Mr. Byron (Philadel-45-daughter Irish) cousin An & V left. Sept 4-5-6-7 slightly better Father left for Glenmore. Sept 8-9—rainy and cold past week. Electrical treatments. Read. [This is the last diary entry until June 23, 1912.]

The polio in Harold's left leg prevented him from returning to Exeter in September. For a year he lived with his family in Merion, keeping

up with his studies and learning eventually to walk on crutches. In the
fall of 1912 he entered Harvard College.

June 28, 1912, Nantucket, Massachusetts

Took a walk with Brownie (2 miles?) around town, could not find pictur-
esque houses. Went in swim with the rest—High tide water cool but fine.
The blue sea against white rocks and golden tinged sand is just great. Hard
walking in sand to and from bath house.

July 3, 1912, Nantucket

Played mandolin on porch while Ruth and Brownie played tennis.

July 21, 1912, St. Huberts

Father and I made a very light and good easel. 22nd—All the others went to
camp. I painted some.

September 10 and 14, 1912, St. Huberts

Saw [Robert Ward Van] Boskerck—the painter—working by the Gill Brook
trail on a *large* canvas. He is certainly a great draftsman—but is somewhat
too photographical.

April 26, 1915, Harvard College, Cambridge, Massachusetts

I must write, yes I must write. Let me some day solve this at least, is there not
something underneath prettiness, underneath physical beauty that exists,
and will exist forever. Expression, what is it. You feel. You think. Is it all a
sentimental dream. What good does painting do. Study, study life, study
nature. All is in the point of view. Love for a mother, love for life. Work.
See both sides and then judge. Judge and be true. Live, work and be true.
True—how little is your truth outside your own mind. It is too easy to lie
back and let things pass. Be true *to your self.*

Write what you feel on the relation of message in art, to beauty. Is not art a higher thing if it is as a language used for real expression and not merely for beauty of or in expression?

October 24, 1915, Harvard College

Fate, immortality, waves beating blindly upon the headland shore. Mountains, clouds, the distant thunder, earth beneath the arching heavens—deep, so deep and blue.

November 24, 1915, Harvard College

Give me faith, give me hope, give me courage, give me strength. I render thanks for all adversity, all disappointments, all evils that I have met and known to conquer to overcome.

Harold to his parents, May 27, 1916, Harvard College, a few weeks before graduating magna cum laude

This letter marks one of the turning points, perhaps, in my whole career. I ask your approval of my decision which has been reached only after much thought and discussion.

You may have seen that in painting, as in my work here, I have come to consider more and more the spiritual side of things and the human aspects of life as the most essential. The futurism of my work is an attempt to get hold of the spiritual reality of things in their abstract beauty rather than their superficial appearance.

The YMCA in this country is often almost bigoted, almost narrow minded, and frequently distinctly second rate in the character of their workers and members. The work they have been doing—in the fighting nations—with the armies, in the concentration camps, and at the vast army prisons—is nothing short of magnificent. The need is immediate and urgent for workers of the greatest ability, solidity, and character of leadership, that can be obtained. The call comes not so much to me or to the others as a duty but as a stupendous opportunity. The opportunity of approximating the greatest good with the most personal benefit and enduring result for untold people. The

work is not evangelistic saving of souls or conversion from the heathen faiths to the teachings of Christ. It is for the Indian Sepoy as well as the Jew, the Catholic or Protestant. It is the waving of minds from insanity, of characters from the debasing forces of compulsory idleness whether due to sickness or to the barbed wires of the prison encampments. The responsibilities are almost too great to face—caring for the educational and ethical welfare of from one to 10,000 men, and one can only hope to do a little good here and there.

The leaders of these "Huts," as you have probably heard them called, are the American Y.M.C.A. secretaries. They have to be brother counselor, and teacher in all respects to the hundreds of men with whom their work happens to fall. They are dealing with human material—with an unfortunately segregated and incapacitated but fully developed section of humanity. The great world crisis which is bound to be followed—if not accompanied, by a vast spiritual regeneration is taking place. A man to be prophet or spokesman of any sort to coming generations cannot *afford* from his own selfish point of view to miss this opportunity to literally see the heart of humanity laid bare. Consequently I ask your permission to go—for probably over a year (14 months is the minimum) to work in the prison camps of Germany or wherever they have most need of my services. [He served in India and Mesopotamia.]

This step—so completely affecting my immediate and future plans and yours—does not mean that I have given up the idea of art. It means that I have seen beyond the need of a technique or mere skill of manipulation, in order to become comparatively better than the other man, to the bigger things in life; that I have recognized the necessity of training the heart as well as the hand and mind; that I recognize this fortunate coincidence of opportunity to apply my best efforts most effectively, and at once to reap the most good.

Your sacrifice will be one of absence, probably few letters and some natural feeling of risk. Do you not both feel that the price is worth paying? Life is a precarious affair anyway and we might as well accomplish some good when we can. Think of what uncalculably greater sacrifice a son going to war means.

September 7, 1916, Bombay, India

Sunset red and gray brown of utmost delicacy. Clouds on hill tops again, green fields in patches and dark trees. On plain glorious sunset best we have

seen. Most remarkable effect. First effect dark mts to left (we had come up by) red touched cloud. Nearer above in center a great gray cloud, behind, a low range of mts, blue, violet, a band of clouds gold silver tipped, blue sky with gold bars, arched. Then, better still, to the east, overhead a marvelous display of *yellow green* quite clearly "vibrated" with orange, and below great violet shadows. To the south, a stupendous array of color, so vivid as to take one's breath away. Fields over hills dotted with dark green trees, but fields of a green such as I have never seen, pure emerald only more vigorous and substantial, and on the slope abut riches (yellower), while above great violet blue shadows under a huge white, absolutely neutral cloud, above strays of gold, behind over the horizon traces of pink. And the moon, green! blue green!! among pink clouds against an ultramarine sky. But it is all quite beyond any description I can attempt.

September 30, 1916, Jutogh, Punjab

Notes on Coomarasawmy, "The Message of the East," Ganesh & Co., Madras. The artist needs to train and develop the one great distinctive power of the true artist, visual imagination, metaphysics and romance as well as technique. Must be intimately familiar with nature and human life. No new birth of art while life itself is mean (social problems, rhythm, discipline, and love in life). Beauty of art and life must stand and fall together, none may gather grapes of thorns nor figs of thistles.

March 13, 1917, Mesopotamia

Recapitulation. Many thoughts. Photos of Jutogh, of Monhegan [Maine], of the mountains. Compare them to here—or rather the life there to here. Trenches on Haystack, shells and burning forest. The Persian hills and Stillwater. The lesson is observe, sense fully the present, not only half, completely fully, absorb the meaning of the Wianno pines [on Cape Cod], the Monhegan harbor. Realize the fundamentals, feel the right selection of objects and lines and colors. Draw more. Be less superficial. Leave other jobs, family, friends, give all, all to absorption and expression. "Realize," conquer reality and then what? Homer Boss's Monhegan rocks, Whitehead, sun and sea—Mary Floyd O'Neal's "Despair." India and Stillwater. What a contrast.

Know intimately first. Hear the sound of men, energy, struggle, nationalism and empire, in contrast to Woodbridge summer school of painting. Grow first in soul. The present, the now, sense it, go out and watch the night. Hear it, see the stars, and listen to the brave Tommie at the piano playing "I want to go back." Do your job. Observe and note. Then to the hills of India, Japan, Siberia, Germany England, home.

Harold to Dorothy Stuart, April 19, 1917, Mespotamia

As months pass I begin to look towards the day when I can be alone to paint again. Art and paint—in the overwhelming horror of human deadliness, sacrifice, of war—may seem to become trivial considerations. The outlook one has on the world is changed. At all events, it impresses one with the earthly, hard facts of life, realism that can not be overlooked. And yet there is also an impression of the fleetness of life that the soul or the spiritual must and does matter. Show or sham is soon laid bare and the common place is the heroic. Here I get little time for thought of painting, except in the back compartments of my brain. I rather wish I could get the time for painting—and perhaps I could if I just took it, but, for some reason I do not want to paint now and here. Nothing, except in this indirect way, has clarified my ideas about art due to this experience in the East and this close contact with life in the trenches.

Harold's mother to Harold, October 11, 1917, Philadelphia, Pennsylvania

My dear, dear Boy,
You cannot know how thankful I am to have had your cable saying you were "well," since we got your two letters this morning of July 29th and Aug. 8th. I am sure you made light of your malaria; but I am more than ever anxious that you should leave Mesopotamia and not think for a minute of staying longer than your cable implied—December. You will have rounded out more than a year of hard work, under most trying conditions and your health may never recover from a prolonged stay. You know that, from the first, I have tried not to hamper you in any way in your decisions, but to be unselfish

about you and your work; so please plan to leave that terrible land, when you get this letter, if you have not done so already.

October 23, 1917, Mesopotamia

The October moon. Sounds of the night gulls, dogs and roosters. The night birds' Phee-tuc, turc. The half moon graceful crescent and the sparkle of its wake. Night lights and stars beyond from the far beyond. Palms and gaunt branches of dead dried trees—scorched. The river luminous, splash of fish and thumping plunge of oars a lantern lit boat and officers returning. Coughs and varieties of barks. Home, life, war, God, and self—miserable self. To be a man, to have lived and accomplished what. What a child you yet are. How small, and incapable of significance.

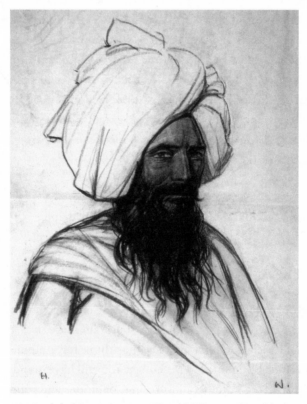

38. *Baghdad Portrait,* 1919, Harold Weston. Harold Weston Foundation.

November 26, 1917, Mesopotamia

I cannot but fear for art, draughtsmanship, will be lost. Too late to repair. Color will stay, but is that sufficient alone?

February 23, 1918, Mesopotamia

Tents pure white on the distant river bank, black lines, slowly moving of cavalry, a blue violet bit of river, and red violet mud banks tinged here and there with green. Squads of khaki figures on the parade ground whence come sounds of camels' rancorous gurgles (as if their bellies were full of the east wind of raw and undigested philosophy). And what at hand, a tent in which I live dug in on a little knoll, a baby tent of forty pounds, just big enough for a bed and biscuit box toilet stand and room to stand and dress. Comfortable withal and livable, which is the point.

39. Exhibition of the Baghdad Art Club, which was founded by Weston for the British soldiers stationed in Baghdad. *Baghdad Portrait* (ill. 38) can be seen at the center top on the back wall. Photograph by Harold Weston, 1919. Courtesy of the Archives of American Art, Smithsonian Institution.

Harold's mother to Harold, December 14, 1918, Philadelphia

I can sympathize with your desire to get back to painting. It was easier per-
haps to forget, when you had been cut off so completely from it for so long.
I was most curious to know how you would feel about taking it up again,
after you had had such varied and absolutely unrelated experiences. There is
no doubt in your mind, apparently, and I want you to take advantage of any
opportunities that offer, as I am sure you will. It is fine that you have started
an Art Club and that there are some congenial spirits out there. We will anx-
iously await news of your pictures for the War Museum.

May 11, 1919, Baghdad

I am to leave for Persia, after thirty odd months to shake the accumulated
dust of old Mespot from the very fossilizing recesses of my soul, with flying
banners of new hopes to start on the highroad to the Persian plateau, there
to revive, relive, rejuvenate and retrieve that neglected artistic communion
with All-Being Nature, which, in the flurrying storms of crowded days of
petty responsibilities, pressing tasks, one loses sight of. There to breathe like
a captive free. There to soar and sing like a bird escaped from its cage. I am
not too candid about my own abilities and prospects. The energy is surely
still as uncontrollable as ever. Is the gift, the vision, the spirit there? Let the
Persian hills echo "Amen."

May 30, 1919, on road from Hamadan to Kazuin, Persia

Snow on a green veiled mountain range, not far above us. The colours
absolutely opalescent in subtle variations of soft hues of green blue violet
pink. Beyond blue violet range. Then a turn brought to view a great moun-
tain of golden lights and pink to violet shades, with a white clay town on a
distant slope and a blue range beyond. The ground here is red yellow white
and in places even bluish. I longed to paint. Then another turn and again
an amazing view. Three ranges of hills red, violet, yellow, and deep blue
violet all with infinite variations and shades. Silhouetted against those a
group of slender poplars and the descending hillside streaked with flow-
ers and bits of green fields, dissected by the white rocked road. This will I

think always remain an impression which signally embodies that amazing startling and yet subtle colour charm that is to me one of the chief appeals of Persia.

May 31, 1919, on road to Kazuin

Here passed many camel caravans with Arab drivers, whom I was surprised to see. The Persian camel has its hair done up a different way from the Arab camel which gives it a very droll cockish look, a tuft like a roosters comb sprouts on the top of its head in wild confusion.

June 2, 1919, on road from Kazuin to Baku

Up at 6:30 to see about passage by Persian Post. Found chap who could speak French and said Post from Recht in today [that] would go to Teheran. I must pause to describe the post wagon. An old form of wagon, with big 5 foot wheels in back, four horses in front all abreast and with baggage piled up overlapping the high frame sides, seven Persians and myself, rocking about on top, hanging on for dear life as we sway down a *mulla* or jolt over a rock. Alternately half frozen and blistering in the sun, with bags of mail which seem to contain boxes of many angles and get packed harder and harder as the hours slowly bump by, for there are no springs and one drives at a trott along the ill fashioned road across the prairie in the night without other light than the stars. Every stone in creation seems to be strewn along the way. Sleep was out of the question, one was too cramped to stretch out and one moved as certain depressions made in ones anatomy became too disturbing, only to shift back as the next position proved a little worse. One was thankful the journey was only for 24 hours.

June 3, 1919, on road from Baku to Kazuin

About 10:30 A.M. we passed an auto which stopped and someone called. Who should get out but [Donald] Watt![4] He had seen a topee on the top of the Post, been so surprised looked again, saw two great glasses and knew it was the Honorable H. F. W. He was on his way to Recht with a rich Persian who was going to America.

June 7, 1919, Caspian Sea (continuing travels with Watt)

Heard car fired at on Recht-Mangil road, driver hit in head, other man wounded but did not rob nor rape the two women in the car. We will probably not be allowed to go back unescorted. Must clean up my revolver and prepare for action!!

June 25, 1919, Isphahan, Persia

While [in Isphahan] some 100 white fur capped police with a bugle at head marched by with one of the robbers (a tall black bearded man) in their center going to the central square to be hung. Seven were hung today, and nearly 200 were to be disposed of that way, one leader a boy of 15 who had killed innumerable people was to have the distinction of being blown from a cannon. About 100 robbers had been already killed in the fighting and over 200 were captured. For ten years they have terrorized the roads here abouts and countless wealth has been robbed from the caravans.

July 6, 1919, on road from Isphahan to Marg

Then the moon which was just half full and starting to sink westward, began to cast shadows as the twilight faded. Soon the sandy track of the caravan route shows ghostly white. Our mounted guards, ahead, on either side looked quite romantic in their black flowing robes, white hats and rifles catching a gleam of the moonlight every now and again.

July 10, 1919, Yezdikhast, Persia

Yezdikhast, which means in old Persian "God willed It" is the most extraordinary town perhaps in all Persia. The old town has often been compared to a petrified ship left stranded on one side of a deep river valley. We saw the way the houses were burrowed into the cliff so that there are some four storeys high, and are now inhabited here and there by the poorest of the village who could not build themselves hovels in the new town, a veritable Manhattan tenement district one would say. We climbed out on a roof and cautiously leaned over to see where in the great famine of last year a boy had let himself down by a rope, hanging over the precipice to get in a small hole

and steal grain from a storage room. It seemed to me he deserved all he got for his daring.

July 13, 1919, Surmaz, Persia

Had a short nights sleep disturbed by a thieving cat who stole our bread (one got away with our meat at Kirmanshah), and by the *sheluke* (fracas) of some arguing horsemen. Got away about 6:30 A.M. Walked ahead, with two young *toffangshi* as our guard. It was by now pretty hot and I was about to stop a few miles further on rather footsore hot and weary, to wait for the mules to catch up and get a drink, when four horsemen appeared and made known that they were sent out by the Khan of Surmay to meet us. They asked me to ride and as the mules were a good half mile behind I decided to do so. Got on a fine looking white stallion, that they did not seem anxious for me to ride, because he had the best saddle. Started my horse galloping and soon I found I was on a rather high spirited steed for he tore across the rough ground, leaving the other three far behind. I did not mind at first but soon my nether parts began to feel the strain and I found I could not fully pull him in (wore off a bit of my hand trying to do so), so headed for a small steep gravel hill, and perforce he had to stop. Rejoining my roadguards after they caught up I said *Khib giid asp* (good fast horse). Had walked from 6:30 to nearly 11 A.M. without a single rest fully 13 miles. Rode the last three miles in record time, so soon entered the very green little town of Surmaz very thirsty and tired. Winding through a narrow street came to the house of the Khan, Aga Duvan where he welcomed me in a very pretty garden and led me to a sort of summer house.

We were given a nice little carpeted room facing the garden below with a running stream and brilliant alfalfa to the north. Stained glass windows in the doors and in the arches above with very typical Persian design of the puttah shape and scrolls.

Had a sumptuous repast of Persian dishes, vegetables cooked in mast (and one lot in boot grease I fear) dough and sherbet, with the fat brother of the Khan. We found it better talking in our few words of Persian and sign language. It is quite remarkable how well one can converse with only a few words, varied intonation and the use of ingenious signs. Thus I told of America's mandatory power over internationalized Constantinople, by using my hands!

Nice breeze slept soundly outside under the rustling branches of the trees, the brilliant moonlight and the stars.

July 14, 1919, Surmaz

Khan Duvan is an uneducated man, a hunter, a tribesman but he is an excellent overlord in many ways. During the famine period over a year ago he controlled prices and by supervising the distribution of grain, actually was able to send some to those starving at Abadel. He himself fed 130 children who were orphans or whose families could not look after them. 3 loaves of bread a day. None died from famine but influenza here was terrific, out of a population then of 5,000, 1,600 died. One day 75 died in the village of Surmek alone. Of his guards out of 130, sixty died. At that time he had family trouble and shot himself at Dehbid. The bullet (we were shown the scars) entered his left heart and came out his back just grazing his spine, a remarkable escape.

He is a tremendously hardy specimen who would take a good deal to kill. He has a school for which from every guest he entertains he asks two krons. He was amusing in insisting Watt should hand him the money himself, when I put down Krs 4 on the table, saying that if he gave to Allah through someone else, the giver and not he was rewarded. The school before influenza last year had 42 pupils of which only 19 remain! He also has a most unusual thing for Persia, a group of adequate public latrines which actually did not emit the least odor when riding close by. There are also many mulberry trees in the fields of this valley which mark the sites of old gardens now without walls and turned into wheat fields. No one is allowed to cut these trees which are kept as food for the poor, especially in case of famine. Anyone may go and eat all he can but dare not carry away the fruit uneaten.

The guards which had escorted [me yesterday] thought the horse, which was a particularly bad one, was running away with me and they agreed together that they would flee to the mountains for they surely felt I would be thrown and if any harm happened to me they knew they would be killed for it by the Khan. Then they saw that the *sahib* was making the horse go and was in control of it, and they were indeed vastly relieved. Today I have a bandaged hand, a bandaged back side (which bled through my breeches), and very stiff arm and back muscles from pulling that stallion in but I am

exceedingly pleased to get this entirely unbiased evidence that although perhaps the horse tried and started to run away, I got him in hand and made the three guards (galloping behind) actually think he had not run away at all. I had of course started him off, as with only one leg to brace adequately I hate trotting. I do not think I will ride again for a few days.

July 15, 1919, nearing Khan-i-Koreh, Persia

[Harold had been riding on mules since 11 P.M. the night before.] What there is romantic and mysterious in moonlight, what there is ineffably inspiring in the first trembling glow of dawn, blended and overwhelmed the heightened imagination of ones half sleeping half waking mind. Not a touch of harsh color, an all pervading softness fading to imperceptibly varied hues of gray. The rose violet of the moonlit eastern mountainside which under the dark colorful colorless depths of the night star specked sky had just passed the marginal limit of ones color perception so that one fully sensed the charm of its delicacy, now became cold and gray, dark against the soft rosy shafts that thrust themselves low and quivering out from the east an hour or more before the rising sun. The foreglow of dawn that *dämmerung* that contains almost if not all of dawn's beauty more subtle and furtive than the brilliant afterglow one so often gets on a cold winters night, which has in itself a searching seeking hopefulness a persistent if subtle and veiled declaration of vigor and growing glowing life. The reign of our slightly wilting moon was robbed of her glory, and our guiding light became but a paltry silver disc slowly setting down behind the distant high western peaks. A few bands of cloud caught for one brief moment a rich golden orange from the sun.

We asked the Khan by the way, when the last robbery in this neighborhood had occurred. Oh, a long time ago, nearly two months! But it did not seem so very long ago to us. However with ten footmen and two suwars we should be fairly well protected, or at least put up a good fight.

July 19, 1919, from Kawamabad to Persepolis, Persia

The range to the east was broken by projecting spurs, starting forth to cut the valley, hesitating, losing all in a plunge beneath the gravel slope that swept up from the river bank. These irregularities cast great streaks of shadow across

40. Hoji, perched on his tiny gray donkey, who consistently set the pace for Weston's caravan. Kawamabad, Persia, 1919. Harold Weston Foundation.

the narrow valley, still about a mile broad and yet once or twice, where the mountain receded the sun had conquered to the very edge of the hill and we felt its strength in suddenly crossing a hundred yard stretch to enter the welcomed cool of the shadow again. I remember our passing a small caravan with fully ten women all assiduously veiled, one thought of the traffic in slaves, or wives that goes on still and wondered how long before that veil would be lifted and women classed as equals or partners of men and not as goods, chattels without a soul. Twenty years will no doubt see a great change in cities but I doubt if the bigoted Mohammedan is going to alter his ways without considerable strife.

July 20, 1919, Persepolis

On amidst swirling gusts of wind and dust, dust sweeping up from behind us swirling around around and above us until all was blinded but the sense of the hot roadway below the scorching sun through the dust above the lurching of the mule's steady quick walk and her great flapping ears. Dust devils indeed and dust devils there were so dark that one thought of pictures of young cyclones, from northeast to southwest, exactly our direction now, they raced and I only wished Maude's ears could expand as in a fairy tale and

become sails or wings and we would then go whirling swirling across that interminable hot plain to lie down in utter exotic exhaustion, as seemed the dust, on the cool mountain's side far away.

An inclination to swim was readily converted into a sponge bath on the appearance of several long water snakes and a couple of good sized crabs.

July 22, 1919, Shiraz, Persia

Up early to see Hafiz Tomb [Hafiz was a fourteenth-century mystical poet of great importance to Persian literature]. Inside one could see a varied collection of paltry offerings, fake flowers, some chap's photo in an inlaid wooden frame, vases etc. The main feature of the court was a fine pine that seemed in defiance of the paltry things man had placed in tribute to the poet of Shiraz, seemed to bear witness to the master's love of beauty of nature, life, air. Without it his final resting place had little of art or beauty.

Weston visited the town Dehbid on July 17 in which "many recently died of what seemed to be malignant malaria." On July 26 in Mian Kutal he had a high fever and bad headache. He tried to keep going, on mule, to keep to the schedule he had set, but clearly he was not well enough to travel. Impeded by malaria he stayed in the Kazarun hospital from July 27 to August 3. Then, against the doctor's recommendation, he went on to Bushire, Persia, to try to catch the ship to India, ending up in worse condition.

August 17, 1919, Bushire General Hospital

I have just received my "ticket," the Field Medical Card, and the hospital ship is to go tomorrow. I copy the card, after other details: "on the morning of 8.6.19 (the patient) had an attack of spasmodic contractions of both extremities with retraction of head resembling tetany under ample nitrite inhalation the spasm was relieved, the temperature has come down with Quinine. He is much debilitated." These few words cover a crisis the seriousness of which I did not fully realize until afterwards. Early on the 6th I went to take a bath. With my boil, which had not been improved by the long journey it

was somewhat a strain as I could not well sit down and I felt very weak. Felt breath a bit short but not worried. Got to bed and the Major Peoples came around saying he would see me later. In a few minutes I felt I would have to breathe hard to get enough air. Next I knew an orderly had hold of my wrist asking what was the matter. I was breathing as if running up hill. The two Indian doctors were there and more orderlies. I could hardly speak, but could hear their remarks. Right leg contracted hands clenched, numb and cold, no feeling could not bend neck, face contorted, could just move chin and cheeks enough to utter words slowly as one very drunk. The doctors were very worried and I was amused at one looking hastily at my card to see if details were in and then insisting on knowing my church. I realized what was in his mind, and I felt very far away, although my head was clear and I could hear them perfectly. Did *not* think seriously I would *not* pull through. Could not discuss religious status in that condition so I said "Presbyterian" to give him something to put down and in mind of the respect I had for the Persia missionaries. They had by that time got some capsules which popped as they were broken in a cloth, which was then held over my mouth, for I was gasping desperately for breath. One of the doctors kept saying "Don't worry it's all right" I did not worry but I knew by his tone (confirmed afterwards) that he did not really expect me to pull through. Soon after the nitrite I got a little better and they began rubbing my hands and feet to get out the contractions. In an hour I was over the attack but very exhausted all day, little twitches in my stomach or chest were very annoying as one of these started the heart contraction but I did not realize what was coming then now I felt it might come back but concentrated all my will power to avoid it if possible. By then I was a bit worried, for I feared the results of a second spell in my rather exhausted state. Many times on the journey down I had to say "stick it" and now again. In the afternoon I slept and was much better by night. Fever only 102 ½° but they were so excited pulling me through during the attack they forgot to take it then. In two days I was well enough to read a bit. In three I could get out of bed in a chair a few minutes. In four I actually walked to the mess room for two meals. In five I was at the table for all meals, still feeling pretty weak and with two more boils starting (on the left side). Not yet able to go far and have wash down in bed. Boils now better but very sore one on spine. Very bad prickly heat almost all over, now better. Doctor advised stimulant so take 2 oz of Port or Sherry at dinner. This rest good but

annoying when one realizes the date. Just think I hoped to be home by Sept! I left Kazarun too soon, should have waited another three days or even a week, but thought might be missing a boat. Did just miss one, as luck would have it and due to my set back feel far weaker now than when left Kazarun. I only hope the sea trip will recuperate me enough so I don't get retained in hospital at Bombay. Doctor says 32 officers in for boils at one time last year. The climate here during this month seems to produce boils. I have had five so far and one starting on left hand.

August 22, 1919, on hospital ship from Bushire to Bombay, India

Borrowed Royal Academy 1919 *Illustrated,* very discouraging mostly resemble pre-war pot boilers. Where is our great artistic revival. Perhaps it is too soon to expect to see its influence in the Academy. Then too, what is one looking for. There are good portraits, the venal landscapes, picture stories, genre, etc. I look back with greater appreciation in [John Daniel] Revel's work.[5] I hope he comes to the fore some day. My work this year in Persia is worth nothing. That of last year at least had some hopes. God give us light to learn and see more the essentials of life and art.

September 15, 1919, aboard *The Dilwara* traveling from Singapore to Hong Kong

Mr. Woods, a 7th Day Adventist, has written book on "Fruits from the Indian Jungle," a man of great enthusiasm, paints *horribly* (flowers etc), not very deep in thought, firm believer that all reasoning must be based on Bible, but in spite of this not narrow minded. Enjoyed watching waves. Finished "Joan & Peter" of H. G. Wells. Have been giving a good deal of time to thinking about my future plans. Wells's conception of God just leaves out that emotional faith which in so many lines seems to be the most vital factor.

September 17, 1919, Canton, China

Back to the YMCA where we ate with the head secy, Lockwood, a Chinese luncheon, with chop sticks and a shell spoon. After lunch Lockwood called up Woo Ting Fang and said I would like to see him if car available.[6] He

sent car and we had a very nice ride out by fields and tiny eel ponds where a man was solemnly fishing in a 10 x 20 ft pond!! Over some small hills to the residences of the leaders of the southern republic. I should mention their capital building, a small, domed affair, as it were a miniature Washington. Past guards to the flowered courtyard of a quite sumptuous residence. Here in a glassed reception room with a fine huge table green velvet covered we awaited W. T. Fang. In a few minutes he was ushered in, a small man in a plain gray gowned robe. Hair gray and close clipped gray, white moustache. Pleasant smile and animated expression of hands and face when talking. He pretended to but obviously did not *distinctly* remember "Merion" or "Weston" or Ethical Society. Talked a minute or so of Mesopotamia then of religion. He a *theosophist* (à la [British social reformer and theosophist Annie] Besant.) Talked of the seven bodies of which the 3 main are physical, mental, astral, this last occult. He had secret of the astral body and nightly talked with departed friends. Told of things they said (mostly seemed trivial). Obviously the poor man's mind is going. He is now 77. Talked with great enthusiasm but not too connected in ideas. Several times said how happy [he was] in America. A vegetarian. Going to live to be 200. Took his photo, and hurried in his car back to catch train [to Hong Kong], with just 6 minutes to spare. [After twenty-nine densely written pages in his journal, Harold concludes, "Trip to Canton well worthwhile, very briefly described."]

Walked to ship [in Hong Kong] getting Chinese cookies and peanuts for supper. Watt not well, but we went by rickshaw to call on the Woods family. They took us to call on their mission workers there, who has been in Japan for years. He from New York State, knew Keene Valley etc. Nice looking man. Told of Woo Ting Fang's help to get a hospital for them in Shanghai. Had remarkably interesting Java painted cloth. Curious long armed figures (Gods) very "modern" and decorative.

October 28, 1919, on ship nearing San Francisco

From a letter to J. B. Munn—"Have had a wonderful opportunity to see China and Korea and Japan which has been particularly interesting at this time. The world situation is one that calls for much thought and more action. I am not too confident of our present situation in America. Whether Fate will countenance the egoist who lies back spinning his idle tapestry of

beauty, love, life, art—in any case, it is great to be alive, to feel with the chill of these windy days the blood restirring in ones veins."

The long sea voyage is just about over. In less than 48 hours I will step once more on American soil. I have changed probably, much. The country too has changed. The world is not the same contented place. Social wrongs are imperious in their call. International prides and prejudices breed misunderstanding and eventually bitter wars. America, Japan, have discretion. Will my ambition to paint ever thus be unfulfilled?

January 1, 1920, Philadelphia

I look forward with much more apprehension than almost any time before. I stand on the threshold of a new era. I step into the arena of art of paint, what do I expect to do? And never before have I so much felt the need of support. In the rash egoism of youth one dares face the world uncouncilled—alone. I would that there were someone with whom I more intimately shared in all things.

From a letter to J.R. 1-1-20 "I am one who likes to think one is at work *worthwhile*. One reason why I enjoy your letters, they sing of the wind, church bells, the surf, sun or showers, without that infernal restlessness to "Accomplish Something" which is an American curse. It would do me good to be a gipsie for a while, for the hours to pass, clouds drifting by lying under a tree among the grass, absorbing enjoying life without rushing to "Accomplish Something," no matter what. I wish I could be more child-like in my attitude towards things, less analytic, calculating, self-conscious more directly responsive. I often feel that if fate intended me to be a painter it has made it a hard proposition with my own temperament to be mastered first of all."

March 15, 1920, The Annex, Spring Street Neighborhood House,
New York City, where Harold lived from January to May 1920

Looking back over paintings of Adirondacks. And I know how much I loved them! Oh could the hand only do what the heart feels, words, could the mind only organize and crystallize feeling into facts. I waste time and what is time. The greatest joy in life is in anticipation, so they say. If so I have known all the joys of life.

March 26, 1920, The Annex

The Penn Club dance. "Slimmie" dancing and the boy drummer of the Jazz band. Agnes, Waldo, Charlie. How I wish I could dance. Hell again.

March 30, 1920, The Annex

To several exhibits, Walt Khun, Marin, Degas and Gaugin. Great day. God give me faith.

April 8, 1920, The Annex

Damn! Where getting to. Money how?

April 15, 1920, Poughkeepsie, N.Y.

Took noon train for Poughkeepsie [Vassar College, where Harold's sister Esther was a sophomore]. Beautiful along Hudson River. Saw very startling poster of 3 harem ladies done for my talk [on Persia], in Main Hall. Had dinner in the main dining hall, about 200 girls, or less. The one male! To chapel 7 P.M. Very impressive when crowded. President announced my lecture again. To Taylor Hall. Room seating 500 well filled, over 400 (due to poster). Fine crowd to talk to, get jokes easily and very responsive. Rambled but made it informal. Embarrassed by lengthy clapping afterwards.[7]

April 26, 1920, Philadelphia

To [Pennsylvania] Academy [of the Fine Arts] Exhibit of Modern Masters— Great!! Organized by McCarthy and [Arthur B.] Carles loaned from various sources. Cezanne esp fine. Matisse, Gaugin, Picasso, Renoir, etc.[8]

May 5, 1920, The Annex

Painted best still life at Schumacher's, not yet finished.[9] [Brother] Carl said envy you going to Adirondacks. Think how much that means. Responsibility to show some sort of return, not just enjoyment. Hate idea but should

make money or at least satisfy yourself honestly, you are really getting ahead, and have something to say.

May 19, 1920, on board the Hudson River night boat to Albany

So New York fades into the distance and the life with "The Family" at Spring Street becomes a memory. I have wasted time. Am I getting anywhere. Are you fitted for a real job in the world? I fear not. Egoist, painter without real vision. Sentimentalist and think you are analytical. Read some of Henry Adams' *Education,* the Harvard attitude is well expressed, too negative. Can you be a real Positive. What power have you? This summer will be the test artistically, humanely, with brush and child. [Harold took with him a seven-year-old boy, Jimmy Bradley, from the Settlement House to the Adirondacks for two months (ill. 41).]

41. Harold Weston and Jimmy Bradley, 1920. Harold Weston Foundation.

May 26, 1920, St. Huberts

Woods glorious woods where one smells the pines and balsam, flowers among the moss, ferns and witch hobble (moose maple) that looks like Dogwood. A sense of the wilderness and wildlife, deer. My being thrilled to the woods as fully sensed for the first time since I have been back. How to express in paint? The complexity of life, our joys and longings. I felt lonely and weak and powerless before it, nature, God, almost more than ever before. Oh Lord give me power to see and interpret in paint, deeply. Energy I need vision, power, love of nature, God.

June 2, 1920, St. Huberts

Energy comes anew. To do. To express. Yes, children I would love, but as yet more than all there is, art.

June 3, 1920, St. Huberts

Dug up turf on site for studio. Trees now in full leaf but still a touch of gray mauve near the mountain tops. More impressed, after the rich purples of Persia, with the blueness and greenness of these hills. Tonight the gray opal tinged clouds over Giant are gloriously delicate. More strongly than before I feel the desire to begin to paint.

June 7, 1920, St. Huberts

Played ball with Jimmy, said on missing ball frequently "I got cuckoo clock hands." Why. "Because they open and shut and catch not'in." I was carrying camp basket under raincoat so Jimmy remarked "I got a great big snail. He is a good snail and his name is Uncle."

June 26, 1920, St. Huberts

Have worked over a week on the [*National*] *Geographic* article.[10] Finally sent off today 21 pages. Jimmy said "Uncle used to play the piano, now he plays

the typewriter, bang bang all day." Some thunder clouds piling up behind the mountains in the west, "See, Uncle, there's a camel and he's pullin' in his head, 'cause he don't want to get wet in that big cloud. What are the clouds made of, Uncle, rocks, rags?"

Harold to James B. Munn, August 3, 1920, St. Huberts[11]

God that dwelleth in the inmost heart of all things is, for me, felt more intensely in the solitude of nature, night and stars, of mountain and moving cloud. Perhaps it is just that the soul the more easily takes flight, undisturbed.

August 31, 1920, St. Huberts

Spent the first evening at my new home. *My* home. May God make me worthy of it. Delightful in almost every respect. If ever I have the ability or power to create it should be here.

October 20, 1920, St. Huberts

This morning spent an hour sorting over all my apples and picking out those starting to go bad. Made of these 2¾ fruit jars of apple sauce.

What a heavenly place this studio is. And the mountains! Live up to it, to them. In past eight days done about 32 sketches of which fully 24 have some good fragments. Hope to get another few days at lakes. Am using pencil too much, but perhaps can get over this in larger work. Must get impression quickly. Believe more in an interpretation of nature, emphasizing fundamental design. As Schumacher writes, make drawing expressive structural. Careful of *values*. Feel ought to make studies of two definite sorts, close to nature, freely interpretive.

Harold to his mother, October 29, 1920, St. Huberts

I found Tolstoi's "Anna Karenine" at the cottage and have just read it. Would you please find out if you can get any French translation of the greater Russian writers.

42. Cozier than you might think near the studio stove
when it was 20° below outside. The study for a painting
of Indian Head (ill. 45) rests on top of the doorframe.
Photograph by Harold Weston, 1921. Harold Weston
Foundation.

Yesterday, "l'hiver commence!" Yes, it snowed. I will not be able to work
out of doors so much. If it clears by tomorrow I shall probably go up to camp
again. I want to get up there as much as I can before there is danger of get-
ting frozen in.

The other night woken up by noise of falling. Heard licking. Got up got
light and found remains of ham on platter knocked down and curiously not
broken. Ham being appreciatively licked by porcupine! Have washed it and
continue eating (will be done in less than two more weeks now thanks to the
help of the porcupine.) It is now enclosed in a tin box.

November 5, 1920, St. Huberts

Snow on mountains, snowing flurries that turned to mist-like rain on lake. Scurrying clouds. Brilliant shafts of sunlight and aquamarine sky. Rainbows, fragments fading then gone only to reappear more gloriously over Gothics, or against the dull-toned softened winter woodland, the slope of Bartlett. God! That one could put the joy of life of living of nature in manhood before the winter's struggle with promise of spring of fruitfulness of hope, put this intangible something that was pregnant in the shifting scene, even just to be realized, ever fading and gone.

November 6, 1920, St. Huberts

Wunderschön, a day that bespoke the glory that is God's. Sweeping blue sky, immense unfathomable. Mountains crowned with silver necklaces. Soft low clouds. North wind on lake. Bigness, power, surety of strength and of righteousness. No hypocrisy no sentimentality. Bigness and strength. The wind ruffled the waters, the lake arched to meet the hills. Thus challenged they rose, with one accord only to be dwarfed in their majesty, only to lie prone, stunted belittled by the greatness of the heavens. Of the earth alone, of the unthinkable beyond.

The slanting sun through the woods brought every sunken log, every moss covered stump into relief. Long shadows played with the autumn leaves that were still stirring in eddies of wind. The woods took on a new perspective. One felt their solidity, their depth their third dimension more strongly.

November 8, 1920, St. Huberts

Here I sit in my own studio (by gift not by rights), with the lamp comfortably placed on the little meal and typewriter table—in a friendly arm chair, knees crossed before the fire, before the boxstove, I should more strictly say, on which with joyous sounds of bubbling a big pan full of baked beans is boiling. On the table lies *The Harbor* by Ernest Poole which I have just been reading. Also my pipe tobacco pouch and matches, a half finished fruit jar of home made apple sauce. Papers are scattered on the floor which, where not camouflaged by small Persian rugs, looks as though a good autumn breeze would stir many memories and give it a healthier surface. A couple of old barrels in the wood box most

untidily disgorge chunks of wood-shavings, small branches and wet rotten logs. The door of the clothes closet is half open, exposing an array of winter apparel, mingled with khaki uniform and a warm but decrepid pre-war wrapper. On top of the clothes closet in a rather perilous fashion a chafing dish is perched, beside it a brown vase that had withered blue asters until their odor became objectionable, and behind the corner a large and as yet unused pallet peaks out. So I could go on around the room. All has significance to me, all is wonderful in spite of the general chaos, and most wonderful of all is that I am here, here amongst the mountains, and it is November. There are patches of snow outside. Winter is about to begin. I am free to work, to paint, and yet, yet, Is it faith that one lacks? Doubts, inertia, God is so wonderful, the boughs stenciled with snow, the mountains, the lakes! So wonderful that one feels overwhelmed too small to begin, too insignificant to seize even those great facts of life nature eternity!! Hell! How trivial are one's efforts. Dreams and reality are not of the same fibre always. Heavenly it all is, yet, God give me power.

Black waters of a languid pool skirted by, autumn leaves, blackened leaves buried in its clear depths. About it a cloister of birch-white birch with fantastic black markings, from the graceful branches snow was dripping. A gothic vault was formed by the branches meeting from either side above the pool, behind, a delightful cluster of pines, dark, virile in startling contrast to the hyper femininity of the slender white birch.

Mrs. John Otis, "Do you like venison? Well if John gets one, we won't forget you"—"Gettin' lonesome up there?"

God, but it is good to have a home of one's own. Such as it is.

November 9, 1920, St. Huberts

Tolstoi, Turgenief, Tchernichefsky, Dostoiefsky. Letter to Chas [Walker]. "Painting, mostly rapid sketches out of doors, out on the mountains or up on the lakes. October, color beyond description from the most dazzling brilliance to unimaginable delicacies of soft ambers, then snow and bare trunks of trees, leafless branches swept about by the autumn winds."

November 20, 1920, St. Huberts

To valley. Walked both ways. Talk with [George B.] Parker—fear of doing work like his!

The mountains along the Lower were black by the contrast of great sheets of ice on the slides and projecting snow covered ledges. There was a stiff south wind and the spray from the oars and white foam bubbles darkened the slate-colored waters. Wedged boat in by the shelter of a big rock and tried to sketch but too cold.

November 22, 1920, St. Huberts

A fairy land, wonderland of snow. I walked up the river to Gill Brook. Through woods over a secluded knoll with great towering spruce trees to bridge around road. The glory of ~~God~~ nature opened my heart. Senses drank deep, intoxicated overwhelmed. Hands clutched snow to feel the tingle of delight. A ladened bough brushed my cheek as I passed. I tenderly kissed it. Passionately consumed the snow on my lips. Oh nature could you ever be more beautiful. Pure, spotless, immaculate. God is great! "Allahu Akhbar." All at once nature was cold, pulses throbbed within me and I felt more than ever before a still small soul, lost alone behind in the flurry of thoughts, struggling to comprehend seeing and not being able to understand, inarticulate with the depth of sensual joy of perception of the beautiful. How paint! My soul cries out, voicelessly. Will I ever be thus?

November 23, 1920, St. Huberts

Snow falling continuously all day. Late afternoon about 2 feet deep! Walked or ploughed to [Spen] Nye's. Only half a mile or so away and yet it took an exhaustive hour to get there. Driving snow clung on my glasses. It was dusk, that sepulchral light one gets on the snow at night, or just before night when the clouds are thick. Could not see the edges of the road. Sometimes plunged deep, three foot or more into drifts filled ruts. The spruce on the hill have never looked more weird, ghostly unreal, contorted by the weight of snow upon their boughs they swayed slightly, almost imperceptibly in the snow stinging wind. My cane slipped frequently, I would lunge and fall, but falling hardly is the proper word, one sank in the soft arms of the snow. Panting I lay there, so warm, so restful, my eyes closed. Light of the yellow lamp by the doorway of Nye's barn-like house. At last inside. Men sitting around as Persians "busy doing nothing." The box stove crackling. They give me a chair and waiting the arrival of the mail by a 3 horse sleigh, banter

stories of hunting. Then back up the hill taking an hour and a quarter for the snow was now above my knees.

Harold to his parents, November 23, 1920, St. Huberts

Frank Hale had visited me about noon bringing a pork spare rib which his wife had cooked! So I had my first Thanksgiving dinner totally alone. Emily sent box of home made maple sugar fudge. Great! And Aunt Nellie capped the climax by a *big* box of "hermits" (cookies) which captured Mrs. [Brown's] heart. I left as many there as I could with difficulty get her to keep. They are wonderfully good.

If you all send me such wonderful eats I will have to stay up here all winter just to dispose of them.

November 25, 1920, St. Huberts

Letter to [Hamilton Easter] Field. "Am living and painting in a little cabin-studio that I helped build last summer up here in the mountains. During the mild fall was able to do a lot of studies out of doors. Now two feet of snow makes me work inside. Plan to get to know these marvelous mountains whether accomplish anything in paint or not. Am totally alone now, nearest mail delivery over three miles away. Occasional lumbermen. Do my own cooking, live simply, and, if nothing more can be said for it, costs almost nothing. Have never before been so close to nature. Glory of the forest in the snow. Am anxious not to force things and must admit not yet sure of my point of view, just what paint can and cannot express. Try to keep to essentials. May be wrong method but do not want at present more of theory and feel if have anything vital to say must work it out with this great and ever changing source of inspiration about me. Do not expect to get any work done yet a while which I will feel is sufficiently interpreted, matured, or realized to exhibit. Want, if possible, to keep away from influence of success or failure of things done. Time will perhaps tell."

"God, I hope to hell that's not true," it was Frank Hale looking at the icicles, one over 6 ft long, hanging from my studio roof. He had brought me a spare rib and potato with dressing, as a Thanksgiving present. He then explained "Folks say the length of them damned icicles in November show how deep the snow will be the winter. Once before early snow like this. Hell of a winter. I was with Wes Otis up to lakes to shovel snow off roofs of camps. So

much damned snow on lakes not a chance for to freeze. Hope all this damned stuff (kicking snow) will go. God knows, long enough winter without having this three weeks ahead of time. Guess a lot a people got caught with their pants down, put off cutting their wood. You never can tell what it'll do next."

November 30, 1920, St. Huberts

Never before have I so felt the silence of mountains, sky and even twinkling stars, unless on the night plains of arid Persia. But even there a lonesome cricket or similar Persian night insect would be calling for his mate. This was the silence of the moon. Eternal, unearthly. Was it cold that suddenly made me shudder or a strange hooting, not that of an ordinary owl, more monotone, sadder indeed one involuntarily thought of the Persian "one lost soul calling to another."

Last light of sun on tip of Noonmark. Too much reminding me of German posters of Alps. Cold, well defined, brilliant in both subject and execution. Dazzling but transient.

Emerald green streak over Spread Eagle and lower mountain beyond. Rounded lines (Parker) solid immobility. How beautifully a Japanese print interpreting this would be!

And thus the moon came, not alone but with a bucket full of stars, as the Japanese school boy (supposedly) sang. It rose over Giant about midnight for it was an old moon, shrinking, with ashen sallow cheeks.

Painted for half hour on golf hill. Giant and Windy Brow. Giant very distant, withdrawn, immense. Good sketch but still "little." Open wider eyes. Mind breathe deep.

December 3, 1920, St. Huberts

Northern lights. I looked out my window to the north. It was past midnight but the moon had not yet risen. An amazing glow in the sky on the northern horizon silhouetted the low flying swift passing clouds, and more sharply the black forms of trees. Colorless cold, mysterious northern lights. Night lights, I thought of Hindu temples lit by yellow red glowing flares, air filled with the cries of sweating half-naked men tramping of tapestried elephants feet, smeared with mystic ashen signs ridden by man on their brown bodies, the turmoil the smell of life, crowded, human, groping towards bejeweled

insensate Gods, silent, man fashioned, half bestial, unfeeling. And again I saw the tremulous cold northern light, felt the chill winds, insensate nature, am I more fool than Hindu pilgrims, do I worship also but rock, lifeless trunks of trees, frozen rain, or the hand of God, God of love and life? And as I asked the glow that lit the northern sky had gone.

December 4, 1920, St. Huberts

Painted Giant, good, in many ways unfinished, but a step further, better than before. Try to get bigness, beauty, joy of life, if nothing more.

Harold to his mother, December 4, 1920, St. Huberts

Been [to Scott Brown's] again two or more meals and [they] sent over doughnuts and half a wonderful apple pie. As found in Mespot, to appreciate food, say a common thing as potatoes, go without for a while. So with deserts which I practically never have unless from or at the Brown's. They go permanently to Elizabethtown this week and I told them they had made me already feel that I would miss them very much. They have certainly earned my permanent gratitude.

Harold to his father, S. Burns Weston, December 6, 1920

You will be interested to know that I am now the proud possessor of a pair of snow shoes! I have bought, for $6, an extra pair that Mr. B. had. He offered to loan them but I felt it better to buy. I have tried them out and find that if the snow is not too soft I can use them very easily. I use a long 6 ft. pole that I had in '15 and found last summer at Icy Brook. Next time we have 2 ft. of snow it will not take me so long to get down to Nye's.

Have pickled 2 jars full of beets that were rotting and found from Mr. B the way to keep them buried in sand. Enough potatoes, beets, carrots for winter.

December 7, 1920, St. Huberts

Just getting up, heard knocking, but not at door. Thought someone playing trick could not see, went out and scared off a woodpecker from slabs on side

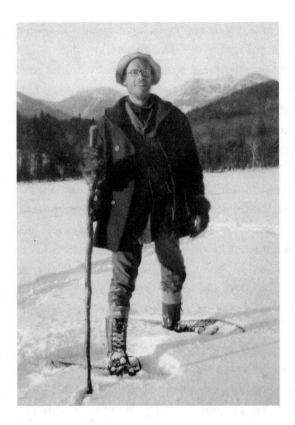

43. Harold Weston on snowshoes, Upper Ausable Lake. Photograph by Esther Weston King, 1921. Harold Weston Foundation.

of studio! Also flock of blue jays, about 20, in balsam and flying around apple tree.

December 8, 1920, St. Huberts

[My] walk [was a] series of breathlessly beautiful surroundings. Will note most impressive but wish could begin to give the joy I felt. Such days come rarely. Remember last summer on one perfectly glorious day, clear bright, Mrs. DeForest passing said, "This is the day we live a year for!" [Fourteen detailed descriptions of views for possible painting compositions follow.]

December 9, 1920, St. Huberts

The river-water rushing down channel in rock. Foreground cedar with dead branches in water, ice formed just like huge Persian camel bell—3 in a row about 1½ ft long.

Sky light green-blue streaked with copper colored clouds. Snow on Giant *startling* light white tinged with pink. Trees near slides dark, violet and blue, red glow in brook valley half way up and especially fine on trees by ridge running out to the Nubble. Lower woods darker still, green blue and soft pale red violet and blue violet. Every detail sharp. Towering lines of mountain. None of yesterday's powdered snows. Sky greener and more varied with streaky clouds tonight, everything's sharper, colder intensifying white red glow on top. Must paint this soon. Did one with good parts, esp. good general lines of Giant from Manguard road this afternoon, but not the pink or Alpine glow. Trees in foreground poor. Snow field in foreground not colorful enough and too high still in value. Note golf links (out window) was in impression almost as low as middle value (also sky thus) in contrast white top of mountain. Really much lighter as when looks at trees or side of mountain find is really almost bright. But paint has not the range of nature and one can only try to give the impression, the essential facts that impress one and contain its *chief* beauty. A thousand incidental glories have to be left out!

Generally am doing best when am not content with the result. Frank Hale this morning coming with milk saw pile of sketches on floor. "Been doing a lot of paintin' I see." "Yes, in number over a hundred, mostly just studies, mostly made on spot." Tried to pick out one or two commonplace ones to show him and was quite surprised to be unable to find more than a couple I thought he would understand. One of yesterday of Round Mt. "Yes," he said, "one can see that!" Which condemns it? Perhaps a good sign I found so few to show him, at least not just doing photographic stuff, whatever the value of what fragments I have tried. Would like a criticism other than my own (which is continuous and harsh). On other hand do not want influences. Yes, must stick it here, and perhaps the coming year will kill or confirm my desire to paint!

December 10, 1920, St. Huberts

Afternoon, after nervous tension of painting, suddenly felt faint. Lay on bed, thought of Mesopotamia, lying on bed in daytime I suppose, of days in Persian caravanserais, of Bushire, and whether psychical or real, nearly had an attack like there, got to chair by stove. Hands numb, looked feverishly for

that box of gaz tablets got at Hospital Bombay, could not find took aspirin, better, lay down an hour.

Harold to his parents, December 11, 1920, St. Huberts

Have to be cautious but when snow not too soft and on level ground can walk almost better than ordinarily as weight of snow shoes acts as a slight balance. Have heel cleat irons to put on for open ice.

As to getting frost bitten. When wearing shoes and only one pair socks and still sketching early last month left foot a little effected but no trouble yet with high rubber boots and two (or later three) pair socks.

Back to today's work. Took everything out and swept and scrubbed floor. Tacked down rag rug and over it have now six small Persian rugs and one small rag rug near stove where I paint and which I remove if leave stove door open. One rug is tacked up overlapping the edges of the door, which has several windy cracks. Room never so clean and snug. Intend have Harlan every Sat. to peal potatoes for the week etc. I boil a lot at once (better for steam) and then heat up thru week. Glad to have him and can help him earn a little cash this way. [See ch. 5, n. 5, p. 246.]

Things, you will regret to hear, getting rather "wilder." In own opinion doing better work than last two months but still very very far to go. Do not feel will have any things ready to try to exhibit this winter. Am sure by far best not to be influenced, which I would be very much in spite of myself, by the success or failure of any things done so far. If going in for real expression or real art, success is not wone in a day or a year. The perspective one must have to do anything of lasting value is not that of the immediate moment. One fact I rejoice in being here is that it costs so little, for in spite of your attitude of ungrudging and constant generosity to me, I do hate to think of the fact that I am now nearly 27 and not yet earning my own living, much less that of some one else as well. The gods indeed have, on the whole, been most kind to me, particularly in my parents. I have done little in return. And I regret particularly that the sort of work that I am doing or am likely to do is not apt and could not really be expected to appeal to you or to seem to you worth while when other fields less lonely and of more practical and financial value are possible.

There is not a chance to get me to come down now [to Philadelphia for Christmas]. I feel I am just beginning to get down to more solid work

and have before never painted consecutively long enough to know whether I would be able to do so permanently. In fact if the winter agrees with me I do not even promise to go down in Feb. After all I am attempting to try out what may be my life work and only a vital occurrence would interfere. What is a year when you think of the apprenticeships of the old masters. Today we try to get around such solid ground work and develop side abilities, as perhaps college did in my case, often to the detriment of the more essential gifts nature may have endowed us with.

December 12, 1920, Upper Ausable Lake

Sewed half sock on back seat of trousers! and got ready to go to camp with Scott Brown.

Began to get dark (about 5 P.M.) out on Upper, most startling effect. Late sunset or afterglow brilliant orange near horizon, above in deep green sky, new crescent moon, with full moon plainly showing, above ghostly streaks of silver clouds, feathers, bending down to the moon. To south a single bright star, wooed to the west by the moon. Mountains deep blue, forest along shore violet black. Ice reflected gold and green of sky. A conventional landscape setting, ordinary winter sunset effect but perfect.

December 15, 1920, Upper Ausable Lake

Started for Lower shortly after 7. The sun just on some of clouds, not yet on mountains. Gothics as a ship through great waves, enveloped by spray, divided and was wrapped up by now cleared leaping high from the rushing clouds. Clouds brilliant in southeast, violet gray in north with patch orange and salmon light one open patch of turquoise sky or startling and refreshing as dome of mosque suddenly seen on hot desert plain. Then as suddenly as a mirage it is gone! Wind on lake, water on ice from yesterday's rain. Down lake, snow hard, wind at backs.

December 21, 1920, St. Huberts

[Harold received a Victrola in the mail.] How can I write! Mischa Elman [the violinist] is playing Chopin's Nocturne in D flat! God, it is great.

Pictures or things noticed. Half way to valley, a sturdy pine on hill, life, strength vigor strong arms tossed out to feel the winds like a healthy boy romps, runs down the hill, with arms and legs tingling with life, all in sun and strong undermarked reflected lights from snow in shadows, against tracing of birch and balsam behind, against sky.

Now playing Lalo, Symphonie Espagnole distractingly glorious. Can hardly write. This music should help, does help me, I grow, my soul expands (trite but true). Played gramophone, 3 hrs, forgetting time, supper hopelessly postponed. Then played 2 more hours. Write home, gladly eat beans and potatoes a week and get another record.

December 24, 1920, St. Huberts

Evening to Xmas tree at Chapel. Tiny Frank Hale boy darling in up the chimney recitation to Santa Clause. Also Mason Hale's youngster in "nighties" with candle, very cunning, perfectly self-possessed. Walk home by Icy Brook. Marvelous moon. Cold enough so snow squeaked under foot. Vigor of life, joy of living. Music again. Have played Caruso, "La Juive," fully 50 times altogether and do not tire.

Harold to his parents, December 31, 1920, St. Huberts

When cooking, as now, it takes but a minute to put the things in the pan and while it is warming up I do other things, such as this letter. Makes my letters a little more disjointed but then better be thankful as so far I have made up in length. I cook a whole big pot full of mush of some kind about once a week and then have it fried or cold with milk and jam.

With the new year, I intend to start some larger paintings. Do not know how well they will go but feel time has come to tackle them. One learns sometimes more by failure than by success. I enclose a few more photos.

Harold to his parents, January 6, 1921, St. Huberts

Have had Frank Hale cut some wood for me back up old Noonmark road, and I have been splitting it up, some 2 cords or more as some is for Hale. Good fun tackling great 2 ft long and 3 ft diameter chunks of maple using

axe steel wedges and sledge hammer. For two nights did not bother to keep up fire. I keep it fairly cool here generally about 45-55. Much better when used to it and uses less wood. Would hate live at Nye's where feels about like 110 in Mespot when you come in out of cold.

Mrs. B. sent over a chicken and an apple pie when [Scott Brown] came to stay here. He seems to like bunking here very much. Great convenience for him. He may stay another night when comes out from camp.

Have been working this week on some charcoal drawings for some larger sized paintings. Intend start one or more of them next week. Last Sat. Harlan helped me an hour or so stretching some canvases.

January 10, 1921, St. Huberts

Afternoon walked part way up Chapelle Pond road taking photo of Roaring Brook Falls. Down through woods, across Artist Brook and climbed up right side of falls (woods by falls). Perilous places!! Joy of risking life, makes one breathe deeper and appreciate it more!

Harold to his parents, March 30, 1921, New York City

Went to see Ruth's doctor who is a very pleasant man. He suggested a light ankle brace but agreed it would be broken in a single day on an Adirondack trail and was hardly an essential help. Personally, unless vital to use it, I instinctively revolt from steel braces or whatnot. He was, however, very hopeful that above the knee by exercise night and morning for several months that I would regain sufficient control to be of some real use. The nerve contact there is strong enough to be utilized more than it is but the muscles themselves must also be built up somewhat. Below the knee there is practically no power, the only use of trying to develop that is that nerve impulses sent down below the knee help the nerves above the knee. None of this is really new and he made no suggestion of operations to connect up other nerves, but he was urgent or hopeful enough to stimulate me to plan to try the simple exercises he explained for the next few months. Though I can probably never get the power to step up, if I can learn to stand with left knee bent, then I could try some simple sort of dancing, if I wanted to, but it would be bound to be awkward.

Hang it all!! Just got word today after everything practically settled that the old foggy board of directors of that darned orphanage will not let

any kid get away from their clutches for so long a period as three or more months. Curses on them, just because never done before. They doubt that a single man can look after a kid. Narrow minded old women who think, I suppose, the child is happier in the institutional straight jacket, where its manners can't be corrupted, and where its life can be kept as dull as the atrophied brains of the directors themselves. Enough, Victor Gaudry cannot be obtained, and I must now start a new hunt, though there is still the Spring Street anemic ten year old.

Harold to his parents, April 8, 1921, New York City

I am due to leave Sunday evening with an Italian boy, Joseph Giustino, aged eight. Had him examined by a doctor who said no infections or contagious diseases but that he was "lymphatic," which does not mean much, and that he needed to be in the country for a few months to get over it. He is quieter than Jimmy, taller, paler, thinner.

Harold to Jim Munn, May 28, 1921, St. Huberts[12]

Father is well known as always building something on the slightest provocation and so when they came about 10 days ago he suggested that I ought to have an additional room complete enough to rent later on. [This extension to the studio had a living room, kitchen, and bathroom.] It is all being made with winter in view so that my sister could have house parties up here etc. It naturally means that I have quite definitely decided to stay up here half if not all another winter. The one great disadvantage of this building is that I am kept from painting for a good 3 weeks. To lessen the cost I am acting as asst. mason, carpenter, etc. I regret this interruption but hope to get in a lot more work before mid summer. It will make living up here very much more civilized and comfortable though, if alone, I do not mind in the least a most primitive sort of existence.

September 5, 1921, St. Huberts

Most of morning sorting the 100 odd enlargements of my winter photos which are being sold for the benefit of the chapel. Mr. Crittendon and Mate Ladd came to see paintings and have tea. Very appreciative of the sketches of Persia

and here and more so than I expected of larger things [oil on canvas paintings]. Very liberal attitude of mind. Admit many of their criticisms. Both enjoyed it a lot. Mate said "I see why Bill felt you have painted the mountains as no one else has with real interpretation." Mr. Crittendon said "not representation but an intellectual interpretation of nature." Mate said "I can see the influence of your study of Japanese prints." She also remarked on that Persian day when "distance remaining distant still seemed near at hand." Afterwards the clouds demonstrated my forms for Mother most admirably. Very weird Chinese dragons with great "octopagian" arms groping down over the mountains. Then clouds echoing mountain forms over Wolf Jaws. Pink shafts and great intersecting spear like forms over Giant and Nubble like those in the Marcy Brook painting. With all this recent appreciation I feel very much encouraged about going on with painting. *Thank God.* If only I could be worthy of showing this greatness, the virility and power of nature. Mate said "I can see what you are driving at though the result is not always beautiful." I answered that great literature was not always beautiful. I really now look forward to the winter months of solitude for work and prayer and deep living close to nature and God.

September 9–10, 1921, St. Huberts

About 4 P.M. Emily [Hartshorne, a first cousin], Esther and I got started up Giant. I had heavy pack, they took water from brook. I went ahead and did sunset sketch from zig zag lookout. No water in spring. Top about 7. A lone woman there, very curious character. German trained nurse. Camp alone in woods. After delicious soup coffee and sandwiches watched the half moon set. Lying with Emily and Esther on top, good wind but not cold. Interesting clouds, castles, yearning arms to the moon. Clear stars overhead. Limitless space. Haze over mountains. Tremendous depths. Moon shadows in valleys. Good fire, 5 blankets.

Got up about 4:30 A.M. to watch sunrise. Very beautiful but could not see the Green Mts nor Lake Champlain, orange and green, a few brilliant crimson clouds. Soft purples to north. In southeast great grey thunderclouds against orange yellow sky. They later lit up with brilliant pink light, and then blew off to the east. After an hour a weird storm came over the mountains from the west. Dark purple sky, pale sunlight on Wolf Jaw range, shadow of Giant below. Thunder then rain. We went back to the leanto and slept nearly two

more hours. After breakfast I made 3 sketches, one towards Champlain and two towards the southwest. I left at 10:15 and got down in 1 hour and 12 minutes to bottom of trail. 1.27 to house. Best time for me since ill [with polio].

September 13, 1921, Upper Ausable Lake

Up via Marcy Brook I had very heavy pack. Most glorious woods near Panther Gorge. Found 8 people already in little leanto. Haroldine [Kirkbride] and I took each a blanket and went up Marcy. Never have I seen such a thrilling sunset. Only at Jutogh in India have I seen such a marvelous *golden* light on the hills through a sudden break in the clouds. Then great winds drew aside the cloud curtains and we could gaze to the south, past blue range after blue range to a sharply cut horizon with shell pink clouds. The wind was penetrating. Haroldine was never more glorious to look at. She was completely enraptured and bubbling with delight. Her cheeks were more brilliant than the clouds. I kept the wind off her the best I could and we helped each other get warm. Her hands cold. Then sudden lift of clouds to west and a flowing sky or patch of *brilliant* red clouds on horizon like huge forest fire. At last getting dark and by 6.30 we unwillingly faced the winds and made our way down. Still glorious intervals in west with the black forms of stunted balsam silhouetted against the gray and pink clouds. Hectic supper and then singing led by Esther while I wept over a smoky fire and dried various stockings. 13 of us in a 7 ft x 11'6" leanto!

September 22, 1921, St. Huberts

In afternoon went up Noonmark with Esther and Haroldine. Great view cool wind. I made sketch of part of Boquette. Then started one of Giant but palette blew over cliff. Took 10 minutes to get it. Then did one of sunset. Flaming clouds. Esther went on down. H. and I slow as soon dark. Last bit in pitch black. Mr. Kirkbride [Haroldine's father] came out with lantern.

October 12, 1921, St. Huberts

Snow actually fell while I sketched a most dramatic light effect on golden trees with dark tragic clouds above and Giant dark as the avenging Furies. Again sketched on golf hill.

October 14, 1921, Upper Ausable Lake

Clear "typical" October weather at last. Up Pinnacle. Two tree or woods studies. Trail very slippery mud under leaves. Fell straining left leg a bit. Back on lake two studies. Gothics and Basin in late afternoon light. Fine glow.

October 16, 1921, St. Huberts

Migrating birds. Geese. White crowned sparrow. Caught a shrew eating apple right by my bed! While I was painting.

October 20–22, 1921, St. Huberts

Great weather. Painting still out of doors. Put all of last year's sketches on one side of room (Fall and Spring) and the ones of this last month on other side. General average much better but apt to be too "styled." Less of the lightness of touch (pencil). Several good studies for larger things. Not satisfied with style yet. Hope for better work before snow sets in. Have done about 80 in month.

October 25, 1921, St. Huberts

Down to 18°, snow on mts, glorious glorious day. Moving splashes of sunlight. Tried 4 sketches, half frozen. Did 3 more in afternoon. Gorgeous sunset. A red letter day indeed!

Harold to his father, c. November 1921, St. Huberts

Lower Lake black with the contrast of great sheets of ice and projecting snow-covered ledges. Tried to sketch but too cold in snow-carrying breeze. On Upper [Lake] passed some hunters coming down from near Boreas who had broken channel through ice at upper end. The ice extended from Inlet to near White's pine point. Had to use head of paddle and by hitting ice six or eight times could make holes and push on. Morrison came down about sunset with buck in boat, shot over beyond Marcy Brook. Quite thrilling as last light broke through rushing clouds, sometimes showing, sometimes covering the snow peaks, flurries of snow blown in swirling gusts from the

44. Hunters and deer at the Lower Ausable Lake. Photograph by Harold Weston, 1921. Harold Weston Foundation.

ice and dashed along edge of shore like high-blown spray from great breaking waves, reminding me of big storms at Monhegan. I paddled at stern of boat with Morrison at prow breaking thick ice ahead with seven foot pole. Glazed eye of buck looked at me with that embarrassing, humiliating gaze of silent, resigned brute suffering. Snow had frozen on congealed clots of blood. A shot had broken both forelegs. The buck had reared and plunged but could not stand. His misery was not long fortunately, but think of the many wounded who get away to suffer and perhaps to die, slowly with long suffering. I do not think the hunting fever will get me unless it was for food.

Coming down found the upper end of the Lower Lake frozen. Two men in Morrison's big boat poled ahead breaking the ice which was about 3 inches (or nearly) thick. Wanted to take photo of Morrison carrying buck across his shoulders on the Carry but light too poor. Big wind on Lower made things hum.

Harold to Esther, Thanksgiving 1921, St. Huberts

Tomorrow I am sending you a package—It does not attempt to rival yours! But it is a product of domestic inspiration. I cook by instigation of some benevolent Oven Muse. The basic material for the parcel was ground up pop corn. Next time I may try making a pudding out of corn flakes—and then I will find that was another war custom. It will probably be a bit squashed, heavy and stale when you get it.

November 20, 1921, St. Huberts

Have done a lot of charcoal studies. From letter to Ruth [Adler]: "I should feel much encouraged and at times do for in the charcoal the 'stuff' has come along mostly far better than last year. I keep them all around in the wall niches of the studio and see if the composition stands. I have gotten in the way of doing a lot of different ones more or less at once. They 'grow'

45. *Study for #34 (Indian Head)*, c. 1921, Harold Weston. Harold Weston Foundation.

better that way. But there is so much to do. The sketches this fall were almost too prolific in ideas and material. It will take 3 winters and it is hard to decide which to start on.

"Two things impress me as more needed in my work: consistent virility and convincing rhythm of form and of color. Whether or not that virility takes one to the borders of realism it must be latent in the rhythm. One of the pine tree on the DeForest Point, autumn, grasping clouds, has I think both virility and rhythm with virility stressed. The one of a Birch Tree called 'Blake-ish' has both, with rhythm stressed. Anyway I feel the things I am doing now have greater breadth but it all depends on what happens to them in paint. Many of this year's sketches have certain qualities that I cannot hope to get in the large.

"Now I hope I won't use more words about painting for another month but just go singingly blissfully on, whether right or wrong. Words about art are generally confusing prating idle things anyway. The point is to feel deeply, believe passionately in the worth of deep feeling, and to interpret that experience courageously in blind faith."

November 27, 1921, St. Huberts

I walked for an hour or more on the golf links watching patches of sunlight speed across the snow and with ragged clouds play jazzlike tunes with the sun, blatant clarionet chords, shrieking copper colored shafts of light, in syncopated broken rhythm and in the minor keyed interludes of deep dark bass, until the sun, wearied, fell voiceless into the quiet silver arms upreaching from behind Gothics. Jazzlike again in that the promised sunset then slipped away without the anticipated crescendo or fitting finale, lulled suddenly into the gray dusk of silence.

I got the new linen canvas and stretched 8. Also cut wood. On Wednesday last I had a man for the afternoon and transplanted 25 fir trees. Last week I received a *tremendous* fruit cake from Esther. Damned nice of her. Also a big box from Flukes of various good things from Mother and Father and a check for $10 from Mother.

The little bandit field mouse that I surprised with a search light at night with his poor nose so red with the cold (as he stood blinking at me) that I wanted to lend him my handkerchief. I must smoke less, get to bed earlier and take more exercise!! Damn it!

November 30, 1921, St. Huberts

Got "Trotsky" [the red squirrel] to climb up my trousers for peanuts.[13]

December 4, 1921, St. Huberts

"Trotsky" is on the go and has just stolen part of an apple tappioca I stood outside to cool, by prying the lid off! Rascal that he is!

December 5, 1921, St. Huberts

Worked on 7 paintings or drawings. Read Wells' *Outline of History*. Got about 6 letters and wrote to Mrs. Bell:[14] "The attempted path of the idealist is generally one on which few similarly oriented souls are met. Paintings—a thing incomplete, the undefined point of departure for the imagination is far less restricted in the amount of pleasure by potential beauty than it can give for the artist than the completely rendered idea. One must, however, be sufficiently concise and coherent for the less imaginative to be led on to corresponding even if less varied and intense thrills. The happiest days are when you start with throbbing enthusiasm. To finish a painting has some of the sadness together with some of the properly proud dignity of completing a well rounded life. I am as yet at a stage when I want to keep my children naïf and curly haired. I hate to see them grow up with the straightened looks of dogmatic assertion and express limited idiosyncrasies of character."

December 10, 1921, St. Huberts

To Haroldine: "Another point that caused such tumbling around of thought while my heels crunched the snow and the sunset passed. A propos one of your comments last fall. Is not nature typically and intrinsically only vital during or through the instant? The sum of instants gives eternity but in static art the instant more or less has to be seized upon and rendered with those idiosyncrasies that are peculiar to it. There is left the choice of that instant which pertains most to the eternal. Let's talk this over later. You, as a woman does, have far more power than I to approach things intuitively. I should like your point of view as to what the relation is between the instant chosen from

nature for its (eternal) qualities of beauty and beauty of nature (or its eternal quality) aside from the peculiarities of instants."

Harold to Esther, December 10, 1921, St. Huberts

I did hope you and at least one friend would come [on a winter trip]. Heavens why should I fuss about your finding a girl that would be just the one? Charles [Walker] expects to be here after Xmas until possibly Spring. That makes 2 men—so you could perhaps find a girl suitable enough between us. Father might come then and you could bring a giddy young thing suitable for him. Do think them over while at college and I shall expect explicit reasons later why one or more can't be found! Just think of offering them two unattached bachelors of 27 or 28!!!

Work has been going fairly rapidly the last two weeks or more and I have stretched 50 canvasses of which some thirty-odd are probably permanent beginnings.

To Faith Borton from her mother, Sarah C. Borton, January 13,
1922, Moorestown, New Jersey

What a wonderful invite for the After-exams holiday! I can't say definitely because father isn't here. John [Faith's brother] tells us thee is the best girl to skate with he knows, so steady, easy and graceful, so there! I would love thee to have one of those Arctic experiences. Snowshoeing would be glorious fun! I'll send this off today, so thee'll get it, and then father and I will talk definitely about the Polar regions.

To Faith Borton from her father, C. Walter Borton, January 14,
1922, Moorestown

Thee seems to have a continuous stream of wonderful invitations, and thee will have to continue to exercise thy discrimination about them. I have thought quite a bit about this one and am willing to leave the decision to thee. It does seem like an unusual opportunity, as they usually do, but I have been thinking that in the future thee may be kept down very closely to thy work, or to thy home duties if thee should be married; and perhaps this is

just the opportunity for this experience. It is one for which I have longed for many years and have not had, but it seems so wholesome that I rather hope thee can get off.

January 15, 1922, St. Huberts

Because of a few cigars given Xmas time I had three callers, "guides." They sat where they could in this littered room and from scanty local gossip—why there were no bear this year, how deep the snow would be by February, that thirty thousand(!) cords of pulp wood were being piled on the river banks to be floated down in Spring, that the ice harvest was unusually good etc.—we turned by way of "winter is warmer now than when I be a boy, this ain't nothin' like the old storms," to H. G. Wells and the cooling of the earth to the tides of the Paleozoic age when a day was but a few hours, and the beginning of man and the rock paintings of the Reindeer men. Then, when I and they were both floundering beyond our depths, not being amphibious in those waters, they commented on the one or two of my paintings that they were able to identify. Their cigars by then being down to the proportions where it is burnt fingers or a match stick as holder, they muttered "Well I'll be getting' along" and disappeared in the snow.

The "Adirondack Record" in their last issue printed that "The 'Hermit' of the Ausable Club has not returned" laconically implying that they did not think I would either.[15]

Harold to Jim Munn, January 15, 1922[16]

Please write out and send just what wording or the *complete* lettering required on your proposed book plate. Until I get that I will (must) let any ideas about it just simmer. "Man and Nature"—a small order I calls it!

January 31, 1922, St. Huberts

Letter to mother: "The paintings I am doing are very conservative, more so than I would like, realistic to a preponderating degree, but I feel I *must* do these this way in order to get them out of my head and since I have not yet reached the point where I can visualize clearly in a more "spiritual" (in the sense of the moderns) manner. I must reach that stage consistently and by

consequence of thought progression. A shallow mind often attempts to leap, especially in form of expression, where the more thorough person climbs slowly with intellectual effort, reserving his meager ream of vision, his staff of faith for greater heights when paths of others cease to mark the way. Again may I say how pleased I am to know that you get genuine enjoyment from that birch tree. One *has* to paint according to one's own pleasure but it is not for that object alone that one paints and struggles to express the beauty of form, color, nature, man or God. Plodding slowly, oh so slowly along this rather lonely path led by the two hands of ego and nature."

February 6, 1922, St. Huberts, winter party (see part one, ch. 5, p. 80–81.)

Gust of wind swept spray-like swirls of snow down. I was especially wet, as got the showers of snow from small trees going first, and was cold on ride down [from Ausable Lakes]. Very gay party. Sang a lot on way from Lower. Moon came out occasionally. Faith's remark "back to college refreshed and demoralized." Bed late. Played Victor and bridge until after 1 A.M.!

February 7, 1922, St. Huberts, winter party

Woke Faith by pulling off bed socks! After breakfast, Faith and I sawed and chopped down big yellow birch tree 8 ft 2 inches in circumference! Esther took photo. Faith a great sport but nearly passed out sawing, first time.

Harold to Esther, February 16, 1922, St. Huberts

The one thing you can do for me now is to get to know Faith better. I did like her a lot from the first and she certainly awoke or developed! Speak to her about summer at least in an indefinite way. I do wish she would come up. If you can tell her so without its meaning more than it does, please do. It would be *great* if we could get up a small canoe party in the Adirondacks.

Faith to Harold, February 21, 1922, Vassar College

If our visit to the Adirondacks seems a long time past to you who are still living in the same spot, imagine, if you can, how far away "Bergson" and

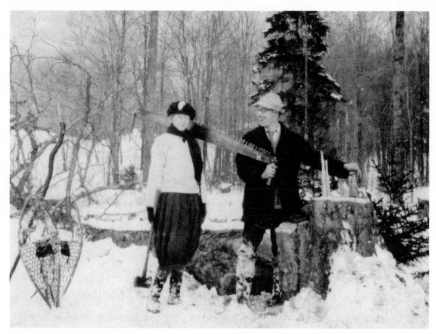

46. Faith Borton and Harold Weston, 1922. Sawing this curly yellow birch
that measured eight feet around was a tougher job than it may look. The major
task was sawing the "stick" into lengths for the studio stove and fireplace. Note
Weston's staff and snowshoes at left. Harold called it "the first real chance I had
to say anything to [Faith] alone." (Harold Weston to Faith Borton, 6 May 1922.)
Photograph by Esther Weston King. Harold Weston Foundation.

"Greek philosophy" and "Nineteenth Century poetry" must make it seem
to us. And imagine, too, the rejoicing with which we hailed the pictures you
sent when they arrived. They all bring back the jolliest memories of four
glorious days, and I haven't yet ceased to wonder that I should be fortunate
enough to have a share in them.

You would have been interested in hearing Amy Lowell lecture last night.
I very much enjoyed what she had to say on "Keats." We all wished she could
stay long enough afterwards to read some of her own poetry.

Harold to Faith, March 2, 1922, St. Huberts

Speaking of poetesses, do you know Emilie Dickinson's verse. She is ancient
comparatively, writing some fifty years ago, but is delightful, extremely mod-

ern in ideas, and worthy of more fame than has been accorded her as yet.[17] Charles W. had not read her things until recently here and has not yet ceased quoting and enthusing. She combines delight in nature with a piquant and rare sense of humor, combining the common place with the eternal. One in which she claims: "Inebriate of air am I, / and debauchee of dew."

Charles and I have been working very consistently at our respective arts and with some satisfaction. I am concentrating on snow things for the present.

Harold to Faith, March 12, 1922, St. Huberts

Trotsky is so jealous that he simply wont come near me any more. One of the chickadees has become so tame that he sits on my hand and eats bits of meat. I tried him out on a marshmallow but he didn't like it and after taking a few pecks at my ring he hopped on my shoulder and then up on my hat to investigate what those feathers were doing there.

Painting is going better but I almost wish the winter were not so nearly over, only a few inches of snow left. I have not finished anything like enough paintings to take to the city yet.

Harold to Jim Munn, March 18, 1922, St. Huberts[18]

I don't believe I could handle [the sketch of Man and Nature] in a wood cut as the man would (even if enlarged which makes the trees less impressive) be too small for me to handle. The man's realism intensifies the feeling that the nature seen is what he in spirit sees. He beholds but is not part of it.

Faith to Harold, March 22, 1922, Vassar College

To help my lamentable descriptions of our Adirondack trip I sent the smaller pictures home to my family, and they were charmed. So you see the trip is now part of family history and "belongs," as it were, "to the ages."

Harold to Faith, April 10, 1922, St. Huberts

Esther writes you may go home for this weekend. May I in a very humble voice say that I hope you do not, for I am definitely counting on stopping

over a day at Vassar this Saturday and Easter. Couldn't you or wouldn't you take a walk that Sunday morning with Esther and me?

About fifteen instead of five paintings are probably going to the Great City with me. This past ten days I have been almost overworking. I am glad to say that the work done has been worth the effort, but I probably won't think so when I get it to New York.

Harold to Faith, April 20, 1922, New York City

From the first, Faith, your eyes revealed. Though you may feel that I know very little about your inner self it is enough to destroy tranquility, and disturb nights when one should be overwhelmed not with vain hopeless dreams but sleep.

I long to expose nakedly to you my inner self, my soul, the strength of pulsing desires, aims in life, the distant, far distant goals of action, and the weaknesses, the petty modes of habit, selfishness. Oh, fear possesses me! My hopes in art, even as my hopes for you, Faith, are so presumptuous, so frail!

What can I ask, for what can I hope to give except wholehearted self with faults and potential talents frankly lain side by side! It is only a fool who lets himself hope that golden dreams might some day come true. Have pity, Faith, for such a fool am I.

Harold to Faith, April 23, 1922, New York City

Thursday morning with clammy hands and many misgivings, just after mailing that note [above] to you, I took fourteen of my paintings to the Montross Galleries. You know how you feel sometimes so full of an idea, a joy, that you simply *have* to tell those that you care about most. [Newman Montross promised the galleries for Weston's first exhibition in November 1922.]

When I think of my daring to step forth into a Fifth Avenue Gallery before the scrutiny of sharp tongued art critics, I wonder at the audacity of it. With absolute truth I can say that I have been *very* much surprised at the way in which my work has been received by the few, whose judgment I respect, who have seen it. Can, oh can I only progress the little bit more that will elevate artistry to genuine art.

Faith to Harold, April 27, 1922, Vassar College

What a blessing it is to have courage enough to beard lions like Mr. Montross in their dens, and so to be rewarded by willing arrangements for an exhibit! No wonder you are impatient to start in work once more.

Harold to Esther, April 27, 1922, New York City

I will appear on deck as arranged at the Lodge with one or two [children he is taking with him to St. Huberts (he ends up with one, George)] to have dinner with Faith and Jimmy [Faith and Esther's roommate]. Leave a note for me suggesting the least objectionable way in which I can get off for a walk with Faith. If it can't be done evasively it will have to be done openly—so prepare the ground as much as you feel you can. I feel I must see Faith alone again for a little while at least.

April 30, 1922, St. Huberts

[Describing his fourth meeting with Faith.] Trolley to Vassar. To Lodge. Met Faith and Jimmie at the "style" gate. F in blue and yellow. How good it was to see her again! She blushed at dinner when our eyes met. After lunch to Main Hall. Esther returned. We five walked around pond. Then Faith and I went off alone, across country to a stone wall by a field. Standing there I at last spoke to Faith and told her that I loved her. That I was confident we could be intensely happy together if she would share my life. Words fell incoherent, of religion, God, free breathing winds, of the richness of life, how each could add to the growth of the other. Her hand I kissed and she let me take her in my arms, her head lay on my breast, but she did not love enough to answer yet. She cared too much to say no, but felt it unfair to say yes. I was to wait. We were to be friends. I urged her to let herself go, but she did not feel as I. July canoe trip was promised or else I was to go down to Moorestown. She wondered what she could do in the mountains. She spoke of real desire to teach. Ah Faith, Faith, think earnestly and calmly, for I am not rational. I long too much for love. I fear I should love you with my ceaseless expression of affection if you also did not care passionately. If you do ever say yes, after marriage you would forever be true and I fully believe would care for love just

as passionately as I. Of course I am willing to wait, Faith, only how much happier I would be if you did already care enough. It is the one big thing that a girl can do with her life and I must give you time for full reflection. Oh I am by no means an ideal. You, Faith, have such a clear eyed frankness and such a richness of joyfulness in life that you would help me tremendously in all I do. The future for me is vague. I cannot guarantee that I shall succeed. It means a tremendous sacrifice for any girl to accept my love. Ah Faith, dear girl, if only you loved as I do and were here with me as my wife! God grant some day.

Nearly two hours passed before either of us realized it. We were an hour late for the picnic! I went on alone to Sunset Hill. Then Faith came later and we had supper as the sun set. Meadow lark and robin. Dark pines against a soft blue sky. Brilliant emerald grass down by lake and apple trees in tender yellow green buds. The sun set with hardly a cloud in sight. The new moon. In the common room at Main a few words again alone with Faith just before leaving. Asking her to forgive my impetuousness. Again a moment I clasped her hand. Her eyes far more beautiful in subdued light. Her hair so soft. Again I can feel the form of her shoulders beneath my arm. Oh girl, come to me and love. You would bring out the best there is in me and subdue the worst. You have far more to give me than I you. It is not fair that I serenade you. You must step forth fearlessly to join hands with me.

Harold to Faith, May 2, 1922, St. Huberts

Spring is just beginning. The trees are filmed with greens and red-orange and gold. Pale green shoots rise from the moulding leaves and ferns unfold. The morning dew kisses into birth pregnant buds. Pussy willows have lost their coquettish shyness and hang languorously replete with the sap of life. The earth leaps to the task of recreation. I feel impotent in this great moment of nature's transmutation. Paint—oh paint seems dead! Love is more intrinsically the core of life. Faith, girl, I yearn for your love.

Though you are not the sort of girl to consider this a moment, I am only too conscious of my physical deformity or incompleteness. It is a fact which can't be totally ignored in spite of any girl's true nobility of heart. As a barrier it may force love to greater heights. Thank God it is in a sense external and not inheritable!

Faith to Harold, May 4, 1922, Vassar College

Your description of early Spring in the mountains makes me wish there was time to simply drink in the beauty of these warm days. I'll keep in mind a walk, or perhaps, breakfast with you [at commencement in June] altho' I'm not at all sure when it can be worked in. My family will have first claims.

We must both get back to work, you to your painting and I to "China" which still spreads its monstrous problems before me. Good luck to you in yours!

As ever, Sincerely your friend.

Harold to Faith, May 4, 1922, St. Huberts

I went out this afternoon to shake from me the confines of four walls. On the top of the hill I stopped and turned up my face to the rain, arms outstretched to drink the fuller, to feel the soft caress. From out of the soft grayness of the dove feathered sky came drops, warm as tears, and the hill surging up beneath my feet bore me the closer towards God. I called to the lost winds that hid the gray mountain forms with clouds and the blind clouds, silent, answered with tears.

I stopped beside a big hemlock tree, big limbs hung black like festooned funeral silks, rain dripped down the rugged bark, and I sensed the contact of the gnarled roots with the earth. My arms reached around the great trunk to feel its vigor, its reality, its life existing essence. My ear, laid against the wet bark, seemed to hear the pulse, the flow of life creating sap from the ground to the tree, roots plunged into the soil, made it one with the earth and gave it life. Tree, how came it here, what is the meaning of its form! Wonders past the soft brain of man. As a primitive pagan I bowed before the mystery of the hand of God, that world spirit that giveth life to nature and to man. Faith, would that you were here that we together could search through these vivid nature pages for the meaning of life and of God. Would not love shared utterly, soul inter-woven with soul, reveal a deeper knowledge of this transient existence?

Faith to Harold, May 15, 1922, Vassar College

I must tell you how fine Mr. Sherwood Eddy was a week ago when he was here [giving a lecture]. He has just come back from the South where our race

problem has burned itself into his heart. There's so much to be done to make America as fine as it ought to be, it's hard to decide where one ought to begin.

A love as yours is, must be answered fairly and squarely. I tried to show you when you were last here at Vassar that I do not feel as you do, but that I do enjoy you as a friend. For the success and happiness of us both, there must be a mutual sharing and caring and I wouldn't be living up to my side of the contract by merely feigning this now. In fact, I think you'd hate it in me if I did. You know as well as I that there seems to be no reason in matters like this. Moreover I can't see now that I'll ever feel differently about it all. Your question whether or not it is "possible some day" is just this, you see, and I have to be frank with you in answering it, as I've tried to be all along. It does not seem as if it is, and I mustn't ask you to "wait" in the hope that someday I may change my mind if I don't see how it's to change, must I? There now! You've got the whole knotty problem before you. One of the things I like best about our friendship has been this very openness. I want to continue being pals if we may be so on the basis of fine, true friendship.

Harold to Faith, May 16, 1922, St. Huberts

You probably know some of my many faults or short comings. One is to get a bit too discouraged about things now and again. More especially now, for I feel very discouraged and, oh paint has not been going too well and, oh Faith, if I only knew that you would care! Do write even just a few lines.

As to paint, I foresee a lot, a whole lot of work to be done this summer or I shall not feel ready for an exhibition by November, and, as to love, I wish I could take such things more calmly, but when you know that life could be lived so much more fully, could be enriched and deepened, perhaps an artist's life stresses or his nature intensifies what any normal man some day desires. Since art is, for me at least, the interpretation of nature, of life, would not the fact of love shared, the utter and unimaginable joy of it, be of tremendous help in the struggle to progress along a rather lonely path to a vague and distant goal?

Harold to Faith, May 17, 1922, St. Huberts

I intend to ignore your fears, let them offset my original overweening confidence, and let hope be full hearted, let friendship grow.

Harold to Faith, May 20, 1922, St. Huberts

Modern artists, I feel, are far too enclined to ignore the great art of the past
and for painters I should include as essential a summary knowledge of great
literature as well as architecture and sculpture. My letters are so long I hope
they don't bore you. Also they are terribly self centered. Of course this life
alone makes one somewhat so, and my excuse is that I want to give you every
chance to get to know what sort of a guy this lanky lonely lad is! He needs
to be taken in hand soon, else bachelorhood will have ineradicably placed its
brand of selfishness upon him. Start reforming America at home!

Faith to Harold, May 28, 1922, Vassar

I was waiting in the parlor for a lady who wanted to make arrangements
for an "old clothes drive" on behalf of the Russians, and writing your letter
didn't get very far. We talked over all sorts of plans for getting clothes.

Let me tell you of my endeavor to get a novel of Tolstoy's from the
"Friends Library" in Moorestown. I went to the desk in high anticipation,
asked about novels and was told they had no novels, but I might find pleasure
in reading his "Confessions"!

Harold to Faith, May 31, 1922, St. Huberts

One of George's [the boy staying with him] questions, he asked while pad-
dling up the Inlet. "Why does the water sometimes have wrinkles?" My first
answer was that the best reflections are born of quiet, which, taken philo-
sophically, explains why I feel this simple life in the hills is best for painting
and for increasing one's scanty knowledge of nature and of God.

Oh how utterly vain is the man who hopes that his work may some day
be history, be a tiny cheerful sign post along the path of human progress. Yet
such do I! Do you realize, Faith, that when one paints for love, for self-expres-
sion, it is generally of negligible financial value, during the creator's lifetime at
least, and all that that means of sacrifice, of foregoing what one now considers
ordinary luxuries of life, on the part of anyone who elects to stand by that
person's work and life? Dear girl, I tremble to think of the extent to which
my conceit and my longing for you have pushed me in asking you even to

consider sharing life with me. Those who dare are sometimes given the power to breast the current and swim to higher hopes where spray falls laughing through the sun. Life has few tears to waste on those who stand and shiver on the bank. That portion of the river of life where Fate has elected that I should plunge is apt to be a fairly lonely one.

Paintings are, in a sense, like children. If people like them enough when they are full grown, they are taken or go away. To paint to sell is almost like bearing infants for the slave market. As an artist I once worked with called it, "a prostitution of one's ideals."

Harold's father to Harold's mother, June 2, 1922, St. Huberts

Harold spends his time painting, writing letters, splitting wood and getting meals. Dishes are washed about once a day and the same dish serves—with rinsing—for cereal, bacon and eggs or hash and fruit or whatever other variety of courses. Harold and George drink quantities of milk and no matter how sour it gets it is used in soups, souffles, cottage cheese, the latter of which he has quantities on hand all the time. He gets up a dish with every sort of combinations of left overs in it and it turns out to be very edible. George is very helpful and a quiet, well behaved boy.

I staid at the cottage, occupying your room. There was not a vestige of soap, or toilet paper or matches to be found as they had all found their way from time to time to [Harold's] Studio.

Harold to Faith, June 4, 1922, St. Huberts

There is a certain truth in the necessary abandonment of the rational or mental perceptive process in fully entering into the aesthetic appreciation of a work of art. If one would really sense the art value of even an old masterpiece it should be regarded without conscious relation to its historical setting or technique. Even more so in creating, if one would interpret the spirit of the thing depicted, one must be completely absorbed in the idea; the process, the impart ought not to ascend to consciousness. This is contrary to Flaubert who took 5 yrs for *Mme Bovary,* but I believe generally writers work at "white heat." In my larger things this is not yet true. In those sketches done rapidly in the joy of the actual presence of nature the process is almost automatic.

Harold to Faith, June 5, 1922, St. Huberts

This morning was the sort of day so perfect that the beauty of it seems to surge up and overwhelm your senses, exhilarates every pore as cool water after a plunge, and you simply have to sing, paint, or swim to keep afloat. And so I sketched quite madly for a while and tried not to think too much of you. It was no use. I simply had to try to write something to you, so on the back of a sketch I scrawled down with the stub of a pencil what I have enclosed.

The soothing patter of soft rain on the roof lures to sleep. It has been a full day with two hours of wood splitting this afternoon to let off steam. However foolish or incoherent my words may seem, know Faith dear, that I love you.

Faith to Harold, June 5, 1922, Moorestown

Then think, as I do, that in anything worth while the non-essentials are sloughed off and that if a thing is worth doing it's worth doing in spite of the hard knocks and sharp edges. I feel that way about anything that I may feel I have to do in the future, and I'm quite sure you wouldn't expect me to let any financial consideration stop me from doing what I thought was right. I can't help feeling that is not real consecration to the thing you care most about, but that it's a half-heartedness that we both hate.

Harold to Jim Munn, June 12, 1922, St. Huberts

Truly, Jim, she is the right girl for me though far too good. I don't deserve her. I am more than ever convinced. She does not yet love, though she cares a lot. She is the sort of girl who must feel an inward "call" to do what she thinks is God's will with her life. There is danger of foreign missions intervening. She is very much in that crowd and is one of Irene Mott's best friends etc. (Faith was Vice Pres of Christians this year). She is not yet convinced that what I desire, her spiritual and physical comradeship and help, is what she ought to do with her life. She said her one great doubt was whether we were sufficiently in spiritual accord. If she was sure of that she implied the rest would likely follow, or love might come.

By the way, Faith got "honorable mention" at graduation, which is equivalent to "Cum laude"! She is, I am so glad, an independent and intelligent girl and oh so fine in character and quality. I fear I have an element of coarseness that would jar. Perhaps not. I don't mean just sexually, I was frank about that and she felt there was good in all things God had given, even human desires.

Harold to Faith, June 25, 1922, St. Huberts

The wild iris have been most wonderful this year. They are so much more graceful and refined than the usual garden variety. I have, yesterday, tried a painting of some with a vivid Arab cloak in the background. Not yet finished.

Some of the Spring things [paintings] are coming along well. I so hope you will like them. Do not try to judge these things the first day. It is important to give them a chance to sink in. Their manner is apt to appear harsh, at first sight, to one who was used to looking at paintings from the older point of view. You will find them higher in color key than most of those of last winter. As yet I have few here which are as fully rendered, some fifty are only beginnings. Think of the work I have yet to do!

Harold to Faith, June 26, 1922, St. Huberts

Up, up, the exhilaration of overcoming, broadening one's vision, as the trees dwarf and grow smaller, you seem to expand until you climb up onto the topmost rocks feeling herculean in stature, towering above the trees, hillsides and valleys below you. Free breathing winds are your companions of the upper air. There is something pure, ennobling, infinite, soul expanding about it that even the immensity and tidal strength of the sea cannot give. Pettiness of life cannot exist in such surroundings. It withers frills, offshoots, but the gaunt stalk of essential truths and virtues with which man may be endowed are vital enough to remain. You know this feeling, do you love the mountains for this?

Harold to Faith, June 27, 1922, St. Huberts

I wonder if you will be too disappointed in these mountains in their summer garb. They are not half so impressive [as in the winter], I warn you. I find

them really more interesting to paint any time but summer when the greens of fir and deciduous trees approach an even monotony.

You speak of my love as sacred even if not shared. Perhaps by your wait-ing—oh Faith, would that God had helped me to become more worthy of you!

Harold to Faith, July 3, 1922, St. Huberts

Oh Faith, such a joy it is to hear from you that I can't resist writing a hasty line to tell you so. George brought me your letter while I was painting. It is a thing (the painting) which I hope and pray God will give me the power to finish with some of the beauty of nature in it which I feel or imagine from the sketch. It is rich with color, but has as yet many flaws. I wonder if you could get to care for these paint poems and feel the thrill of watching them grow. They are like children and are not always on good behavior by any means. Like kids, it is often the worst youngster than turns out best in the end.

Harold to Faith, July 4, 1922, St. Huberts

I had a visitor yesterday afternoon who, curiously, after looking at a few of the paintings, got excited and jumped out a window! The day before I had caught *by hand* a rabbit, wild one who was eating some roots just back of my studio. He cried so pitifully, like a baby, that I let him go, never expecting him to return. But yesterday he came back and decided to investigate my quarters more thoroughly. I was painting as he hopped across the porch and in the door. He came up by me, looked at the canvas on the easel, at one or two others, twitched up his nose in disgust at such a waste of time, went on leisurely into the other room. Finding door closed, he perched up on window ledge and, as I came in to greet him, he suddenly departed.

Harold to Faith, July 13, 1922, St. Huberts

Last night I slept on the porch hammock and watched the moonlight play through the balsam grove. From where I lay I could see the pale peak of Noon-mark bathed in moonlight, through the trees. Nature with its God given rest-fulness contrasted so violently with my own inner state. Love, I feel, can bring greater peace than all else, but if not shared it can be more disturbing almost

more destructive than any other experience. Oh my beloved, I have longed so for your love that the future will indeed be hard to face if there is as yet no responding feeling on your part. I must, I simply must believe that there is hope, that some day you will return my love.

Harold to Jim Munn, July 13, 1922, St. Huberts[19]

Oh Jim, if Faith could grow to love me I see no reason why life would not be made vastly happier, vastly more significant. By having someone to do things for I would be pulled out of myself and lose some of my egoism. She will inevitably draw me closer to God. She has already become very keen to see and understand the paintings and she could be a great help with them.

Harold to Jim Munn, July 16, 1922, St. Huberts (not sent)

I am very sad at heart and terribly discouraged. Yesterday Faith and the others came [for the canoe trip] and I had an opportunity to take a short walk and have a long talk with her. The situation is contrary to my vain anticipation, even much less satisfactory than at Vassar over a month ago. A remarkable missionary from China [Henry T. Hodgkin] has been staying with the Bortons the past two weeks and Faith is more than ever enticed by the "foreign field" appeal. Secondly she does not feel that art is essential and is fairly well convinced that she will never feel like consecrating her life to that sort of thing. She feels the call of Chinese millions and that she must do what is most essential, what will be of greatest good.

July 18, 1922, Saranac Lakes, on canoe trip

Lunch by Ampersand trail. Pitch tents then up mountain. Faith and I behind, step stairs. Beautiful view. Thrush. Others down, Faith stays to watch me sketch beginning of marvelous sunset. Glow of light on lakes. Down in dusk. Talk of the Quaker faith etc. Beauty of lake as late glow reflected in waters. Singing around fire after sandy supper.

July 26, 1922, Saranac Lakes, on canoe trip

Porcupine in night. I woke to hear gnawing, took axe, flashlight and Esther. Porc in canoe I after it. Chopped out quills. Porc in second canoe, I after,

47. *Sunset in the Adirondacks (from Ampersand Mountain)*, 1922, Harold Weston, the first sketch that Faith saw Harold paint, July 18, 1922. Private Collection.

chop canoe. Porc into third canoe, I drop into lake as canoe tips over. Porc on shore towards Esther who wakes others with calls "Harold are you there?" Out of lake and after porc who climbs tree by shore. Carl wakes to reprimand Esther. I soaked to waist. 3 A.M. Bed again.

Faith to Esther, August 3, 1922, Moorestown, after canoe trip

The beauty of woods and lake, sky and river sank deep into my soul.

Harold to Faith, August 6, 1922, St. Huberts (see part one, ch. 6, p. 98.)

I am anxious to tell you of Dr. [Henry Sloan] Coffin's sermon this morning. One point seemed to be of particular value to me. He felt that God was expressed in Goodness, Truth and Beauty. Some young man had recently stated to him that he loved God, was studying for the ministry to serve God,

but that he had never felt His presence, never "experienced personal rela-tionship to God." Dr Coffin then stated that he felt those who experienced beauty, felt the eternity in the mountain, the joy of color in the flower, did therein and thereby experience God. He made me feel even more clearly that what I am trying to do and for which I dare to ask your life long help is without question something that may be called "in the service of God." I only wish you had heard him. Oh Faith, if only you too could feel the call of that service together with the call of love. Love that would share with you all, that would enrich your life with untold joys.

I had a very interesting and high brow talk with Professor [Felix] Adler on art and nature for two hours the other night. He quoted Goethe, Dante, Plotinus, Ruskin etc and intellectually seemed prepared to grant the premises of my attitude towards painting. He felt too that the artist should most defi-nitely have a message to impart, that he should be in a sense a spiritual leader or educator. (Can I without thy help, Faith, ever really hope to be such!)

Harold to Faith, August 14, 1922, St. Huberts

One thing cheerful at least can be reported. That is great industry in slinging paint. I have done more in the last two weeks than I expected to accomplish. I have yet some twenty to complete before I can go down [to New York City].

Harold to Faith, August 16, 1922, St. Huberts

It is now near midnight. I have been carving frames [for the oil on canvas paint-ings to be exhibited at the Montross Gallery] again this evening and started a charcoal drawing for a medium sized large painting of that Ampersand sketch [done on canoe trip]. There are nearly forty of the larger paintings about done. I have about a dozen or more started or definitely planned. I foresee that the final two weeks will be given up wholly to frame carving as that goes very slowly. Ruth Adler has fortunately volunteered to help. If it rains while Bobby is here I think I shall appeal to her to do some sand papering!

Harold to Faith, August 21, 1922, St. Huberts

Have been working almost uninterruptedly. If I only thought you wouldn't mind I would send a little sketch as a birthday present, but then it might

seem as though I was urging you for more than you can yet give. Oh Faith.

Harold to Faith, August 24, 1922, St. Huberts

It would be so fine to show you all the things I have been working on during the last three weeks. Another New York man, architect of note, in to see the paintings recently expressed one thing well. He felt their "cosmic conscious-ness" which is after all in a sense God. As he is a man used to paintings I am encouraged to feel that something may "get across" to some of those who see the exhibit in November. I have been carving frames til midnight lately.

Harold to Faith, August 27, 1922, St. Huberts

Prof. Adler was the speaker this Sunday. It happened to be most appropriate for me, in part, Epictetus furnished the text. From every situation spiritual good can be gathered if approached or born in the right way. So, dearest, do I feel about the fact that you do not love me. At times I feel quite utterly dejected about it all, but it has been of spiritual value to struggle to overcome that sadness of heart.

Harold to Faith, September 9, 1922, St. Huberts

Three great crates packed, with frames (24) and paintings (62). Several score sketches will go down in my trunk. I had things (small portions) to correct in about four of the large paintings and repainted one almost entirely today in addition to sandpapering and packing.

Faith to Harold, September 28, 1922, Moorestown

It's really very amusing getting to know "Mr. Weston" in such a literary way as I have been this week. I began with "Caravan Sketches" trying to see the author in the article in far-off Persia, and found it most delightful. Now comes John Farrar's article that you enclose, a very real "write-up."[20] *What* shall I say to an article accompanied by your photograph and two paintings in color! It seems difficult to think of you as such a distinguished person, not that you don't fill the part admirably, only that I think of you rather in the

48. Letter from Harold Weston to Faith Borton, October 14, 1922. The paint smudges are from carrying the letter in his sketch box. Harold Weston Foundation.

spirit of simplicity and straightforwardness that fits Adirondack deepnesses, gentle amber streams, and my own home here. If you don't mind, I'll continue to think of you in that way, I think.

Harold to Faith, October 14, 1922, St. Huberts

I am writing this on the top of my sketch box, out in the canoe bobbed around by the waves. The sun has set but not on the hills up whose sides slow shadows creep. It is glorious, so big so silent. Ah dearest, what a meagre way it is to share this with you only by writing while it is all about me.

Silken spider web clouds are now tinged with golden light. The pale pink sunlight is still on the very tips of Gothics' peaks. By the shore of the lake the mountain ash berries stand out against the mauve branches of leafless trees, berries red as the reddest of bunch berries or holly and clusters as large as two oranges.

Last night was one of stars, myriads of stars and owls. The owls were having a confab or convention as they sometimes do, and about two dozen were gathered over on the side of the opposite hill and rarely one hooted alone.

I meant to write to you again in the canoe, but I did four sketches, two morning and two afternoon (one of the sunset which was simply great!)

Again I stopped on the Lower Lake to paint, Indian Head (poor result). While doing so I shored, for there was a *big* wind and some guides coming down from camp saw me there and called "Anything the matter!" as they seemed to think the wind had been too much for me! So I waved a paint brush towards old Indian Head and they sped on with the wind and away.

Harold to Faith, October 20, 1922, St. Huberts

Darn it, I have about two weeks mending to catch up on. So likewise do I save ten cents a quart by walking an extra half mile or so for milk.

I am beginning to feel a bit nervous about how little may sell! I have sent for 300 envelopes [for exhibition notices] and shall soon spend the rest of my evenings, before I go down, addressing them. One of the men (local) was talking to me the other day. I was telling him about the exhibition. "Well," he said, "of course you can't go out and do the heavy work like the rest of us, but seems to me you got a trade what suits you good and I guess in time it's probable you'll get as much for it as if you hired out by the day"!! I hope so! This evening for the first time in two months I stretched a new canvas. I am going to try to paint that drawing of man and nature. I gave you a tiny photo of it the day we were late for picnic supper at Vassar. Do you remember? It was a study for a bookplate for Jimmy Munn. [See ill. 49.]

Harold to Faith, October 27, 1922, St. Huberts

I have received four invitations to dine and stay with people in or near N.Y., just the last two days. Gosh, when anyone begins to do anything even in a small way then people start in to show how they always believed in what you were struggling to do without encouragement.

Faith to Harold, October 27, 1922, Moorestown

How do you *ever* in the world, with all your manifold business correspondence get the time to write me so much, or such a delightful amount of description? I simply don't see how you get as much in twenty-four hours a day.

Harold to Faith, October 28, 1922, St. Huberts

Sealing my letter to you this afternoon with something between a tear and a kiss, I went out into one of those moments which become stamped upon the memory when the threshold of the commonplace is passed and the poignancy of the sensation impinges upon ones inner consciousness. The hand of nature traces a pattern upon our nerves as the etcher on the waxed plate and contact direct with it pours acid into those lines which bite deep into memory. There was too something acrid about the sunset, in the sense of burning, almost painful, brilliance. Stencilled lines of gold jazzing up from behind ochreish purple ranges of looming hills, filamentous clouds that shot forth light as coils of illuminated electric wire in a globe, the great vault of the sky. Then as suddenly the current of gold played out, the molten metal ran down, a few eddies lingering, down behind the western range.

You ask about letters and time. I have always gone, from years past, on the principle of writing letters very rapidly (you probably add "They look it!"). Thus it really does not take much time and there are so many things, too many to say to you that there is no pause. I fear at times they sound it! I should correct the former statement. As you know, I am a rotten speller and therefore often pause a moment to correct an a-e-i-o or u by means of companionable dictionary. Many sly words probably slip by laughing at their quaint disguise.

Harold to Faith, October 30, 1922, St. Huberts

The last painting, the one that has caused so much labor, is just about done. A little more, here and there spots, will be retouched tomorrow. The minister [at St. Huberts] is a senile, dandruffed-brained creature who preached the worst-in-every-way-and-without-exception sermon I have ever had to endure. To listen to him was like the feeling one would have if one took a sharp chisel and rubbed it over a rough rock. No, it did not only dull, it antagonized. My one reason for being glad I went was that after escaping from the stale breath of his thoughts the living air of God seemed the purer, the more incomprehensibly magnificent and divine. The contrast between the exaltation I felt from the snow covered peak against morning clouds blurred with light and the mouthed, perfunctory incantations of a dried up specimen of manhood

was such that for the good of my soul I had better hold a Sunday service up here and foreswear that branch of the church until a new minister arrives.

Oct 31st Oh that cat!! She looks like a futurist painting and she can't half lick it off. She rubbed up against that painting that I struggled so with. My I was mad when I first saw her and then discovered where the paint came from. So instead of an easy day I have repainted part of it, most of the morning and now I am glad that she did act as a hand of fate to make me do over part as it is somewhat better I think.

Car is coming to take me [to the train to New York City].

Harold to Faith, November 3, 1922, New York City

Have addressed about 1100 envelopes the last 3 days and nights! Not so many more. [He addressed 1500 in total.] Looks as though the exhibit would go well.

Harold to Faith, November 5, 1922, New York City

Tomorrow I have to hang my larger paintings. Montross will criticize and rehang perhaps. Tues I am to do the sketches and Persian things.

The art critic of "The World," [Henry Tyrell] who is one of the few progressively minded critics on N.Y. papers, stayed 2 and a half hours with me, looking at and talking about the paintings! It was as fatiguing as a final exam. *Don't repeat,* but he said he thought mine was the biggest thing of its kind that had hit New York art world in the past two years. He was very appreciative. He said he was bewildered by the wealth of paintings and ideas. He intends to reproduce that "Man and Nature," which in the catalogue is called "Sunrise" and another one, perhaps, that has the studio in it. He enthused *a lot* over the frames. His write up, which will be much more moderate of course than what he said at the moment, is to come out next week Sunday.[21]

Some have remarked that I looked strained. It is unfortunate that the terrible effort to reconcile myself to your lack of emotional feeling towards me and to *your failure to appreciate my life's ideal,* happens to coincide with the worry about the show and how it will go. Oh beloved, what is success without love shared.

Harold to Faith, November 6, 1922, New York City

The hanging today was an all day job and some job! Thank heavens Montross assisted and in the end was very much pleased with the result. We not only got all the larger paintings in but am trying to have made one extra frame for a painting of Noonmark that I always regretted leaving out. That makes three that are not in the catalogue [the catalogue lists sixty paintings, twenty Persian sketches, and seventy Adirondack sketches]. I also got the Persian sketches hung and tomorrow morning being a holiday Jimmie Munn is going to help me hang the other sketches, about 100 of the Adirondacks (I purposely did not put that number in the catalogue).

Faith to Harold, November 7, 1922, Moorestown

When I opened your letter this morning with the catalogue enclosed, I can't tell you just the feelings I had. A kind of thrill vibrated through me and I felt a sensation that will not be put into words. When I opened the catalogue and saw number 5, "Sunset from Ampersand Mountain" a fresh idea of what the exhibition is, suddenly surged over me, and I felt a tiny share in it. I read what you wrote about the "World" art critic and was thoroughly, genuinely glad. It makes me feel how very, very much I want to appreciate your work, too. Oh! I could hang my head in shame that I am so slow to see what has been so understandingly and lovingly explained! I should think you would die of impatience and give me up forever! I wouldn't blame you in the least. I'd love to see you for one short minute, at any rate, before the exhibit opens to-morrow. Perhaps you wouldn't find me so utterly unresponsive as I fear you think me now. In any case, let this bring all the warmth of feeling and brightness of hope that my friendship with you makes possible, and again let me say a quiet, "God bless you."

Harold to Faith, November 8, 1922, New York City

Your letter this morning. Oh it was such a help to feel that perhaps you would soon let yourself seem and be less cold, that you might soon care intensely about what I have given my life up for and be willing to help in accomplishing that. After one day of the show I foresee that talking to peo-

49. *Sunrise,* 1922, Harold Weston. Harvard University
Art Museums, Fogg Art Museum, Anonymous Gift,
1941.304/76354. Photo by Katya Kallsen, © President and
Fellows of Harvard College.

ple one after the other for many hours is not going to be as restful as some
other occupations! Thank heavens the artists whose work I admire and who
are leaders have been most generally enthusiastic. There was one yesterday,
who is also a poet, who felt the great love of nature, glimpses of the truly
poetical and lyrical in my work and its strength. One critic today said he felt
my work started a new factor in American art (don't repeat as exaggerated,
he is a good publicity man but I don't trust his judgment.) He offered to
write an article about my stuff for the *International Studio.* That would only
appear a couple of months hence, but it counts for the future if not for this
show. He felt the strong tendency to the mystical, more the oriental mystical

in occidental manner. It is surprising that such critical welcome is found. I should not mention all this only, oh my beloved, perhaps it will help you to grow to care. It sounds darned conceited to speak of ones little bouquets received but the few flowers received from a "friendly" quarter have become so wilted by long guarding in my heart.

Harold to Faith, November 10, 1922, New York City

Your letter was as always welcome. A week from today, dearest, you will be here! Another painting that has caused some comment is the Ampersand sunset. Still another the "Sunrise" [formerly "Man and Nature"] in which I endeavored to put into the body of the man an expression of open armed love, my love for you. Let me tell you, and repeat this to your parents, of about the best appreciation I have ever had of a painting. It occurred today. A woman came in with a little girl of about seven. The child at once started looking at the paintings with discriminating attention. She soon wandered down the gallery to the end of the room where "Sunrise" hangs. There she stood gazing at it fully three or four minutes, a long time of concentration for a mere child. Another artist and I were watching her from behind. Then she raised her arms and moved them unconsciously in the rhythmic movement of the figure and she seemed to be pretending or feeling that she too was going off through the gateway of the two giant trees floating off to the sunrise over the mountain ranges beyond!! I was thrilled and amazed! Her mother saw us watching and later spoke to me saying what an inspiration to her (evidently an artist or artist's wife) the paintings were and that she had encouraged her little girl who, with pardonable mother's pride, she thought had great talent.

Harold to Faith, November 11, 1922, New York City

A little sketch of birch trees sold for $200! Darn! I put that extreme price on it as I wanted to keep it.

Harold to Faith, November 13, 1922, New York City

I helped Russell Cheney hang his paintings and took in two teas. Today a very fine artist [Henry Varnum Poor], who is to exhibit at Montross galleries

next month, had lunch with me. We saw together some *wonderful* African negro sculpture. Marvelous in abstraction, subtlety and eternal quality. But Montross scolded me for being out so long at lunch hour, for I missed the director of the Brooklyn Art Institute who seemed to like my exhibit better than anticipated.

Faith to Harold, November 13, 1922, Moorestown

I expect to hold a kind of private interview with father and mother soon in which I shall try to explain to them what you do in your work. I'm sorry it must fall on my incompetent shoulders to do it, but there seems to be no one else even as well informed as I am. We spent quite a while the other evening talking about your work and what it is, and I'm sure I make a very poor teacher, of art, at any rate, but I do try my best to be a good interpreter. I got out *The Younger Set* and showed the reproductions, then read the article opposite, so you see the clippings from newspapers are all in a good cause, and I can now continue more "officially" than before.

From November 16 to 18 Faith was in New York City to see Harold and his exhibition. Harold went to Moorestown to visit Faith on November 21. There, Faith told Harold she loved him, but she did not say she would marry him.

Harold to Faith, November 23, 1922, New York City

Oh Faith, joy wells up in my heart at the realization that now you share my love. Dearest one, let us trust God that our hearts and souls being joined our lives will not much longer be kept apart. Do not fear my passion. Safe would you be with strength tempered by love. I am tired, almost exhausted by the struggle to express and suppress.

Faith to Harold, November 23, 1922, Moorestown

In the evening father, mother, and I sat in front of our cozy back-library fire and I rediscovered how fine they are. Oh! if you could only have been a

mouse in the corner some of the time, and a member of our fellowship the rest of the time you would know better than I can ever pass on to you how they feel about what you are trying to do, and about you. They are *very* glad they went to New York—needless to say, I am!

"Not more than others I deserve, but God has given me more." Among the richest is your love to which I can so inadequately respond. I am still wondering and marveling at it.

Harold to Faith, November 25, 1922, New York City

By Wednesday the total of sales ought to be nearly $2000. I understand that amount is almost unprecedented for a first show.

My main reaction is one of prayer rather than of joy, that I be granted the power to live up to the promise made, that my future work justify the praise accorded. It is in a way a danger to start with a reputation bigger than one can perhaps live up to. I hope you fully realize that this first success is no guarantee of an easy and assured future. Dearest, your aid is *essential.* With it I have confidence that a worthy life work will result, and joy for us both will be constant in the doing for others, in the revelation to others through our lives and our work of the beauty, power and essential significance of God.

Faith to Harold, November 25, 1922, Moorestown

I just can't get used to such a tremendous love as yours. It leaves me breathless and awe-struck, as I think you know.

Harold to Faith, November 26, 1922, New York City

Montross told me yesterday, "Young man," he said, "this strain of society at night and the exhibition by day has made you less sturdy than when you came down from the hills. I am glad we can send you back soon." I could not tell him what had caused the real wearing down of vitality and flesh. I could appreciate his thoughtfulness. As said before, the success of the exhibition counts as negligible to me. Faith, dearest beloved, the taught intensity of this

situation, so unbelievable, hearts pledged and inviolably bound by love and yet by a thread of doubt held apart, cannot endure long.

Harold to Faith, December 11, 1922, New York City

This afternoon I went in to a big gallery where a famous Russian artist is having an exhibition. His name is Leon Bakst. I have known his work since 1915 when those first marvelous Russian dancers came to America with his costumes and scenery. At the gallery I recognized a very gushy lady who teaches at a very fashionable girl's school (not the "Madame" I told you about), who had been very enthusiastic about my work, and who had on several successive days brought in groups of beauteous maidens. She soon got off some rapturous phrases about Bakst's work and then told me that she knew I had been to Phila. because one of her girls, home for Thanksgiving, had recognized me (from having seen my portrait) when I was in a gallery at Phila! But I figured out later that was not the trip with you but when alone the previous Friday. Perhaps I will regret the day I put that *Selbstbildnis* [self-portrait] in my show! Privacy has gone.

I later met Bakst himself and had to talk to him in French. As the gallery was literally *crowded,* it was quite embarrassing trying to explain to him that in my army tent on the Tigris near Baghdad for part of a year I had reproductions of four of his paintings (costume designs) pinned up on the wall. The French I once knew seemed all to desert me because of the fact that I realized at least a couple of dozen pairs of ears were trying to overhear our conversation. I got along better describing bits of Persia. He knows the Caucasus and Algeria very well. I feel his work has not only not progressed since 1916 but deteriorated a lot. He did accomplish something very big then and apparently reached his limit. Very few men nowadays do not suffer disastrously from success. Repetition kills the spark of inspiration from which all Great Art takes its life. There is a terrible danger in doing too well one isolated type of thing. Though of course you can reply that with some people such a limited field is all they have the genius to cultivate. Better a few more flowers perhaps of such high bred development that their progeny soon dies away, than a lot of common field flowers, just like other gardens amany and sturdy prolific ventures that run the danger of being called weeds. The countless imitators of the few great leaders of art are the

artistic weeds. Bakst is distinctly of orchid quality, without quite the beauty and little of the variety that this word implies.

Harold to Faith, December 15, 1922, New York City

I appreciate deeply your writing to me. You have *many* pages of letters to make up if ever you would equalize the post! I really can't yet fully realize that you do love me as I do you. Each time you say it is like a sudden bird's song heard from the stillness.

Faith's "Diary of my engagement," December 17, 1922, Moorestown

When at last the long, long committee meeting was ended, I telephoned to Harold, who had been in Philadelphia since noon. Without delay, we arranged to meet at Wanamaker's as soon as possible. I was full of the conference for next summer. We were a little late to supper. The family "conveniently retired" at a suitable hour leaving us down by the fire, and there the whole question was once more opened and discussed. I knew, in my heart of hearts that I loved him, but my independence still hung on. We talked as we had often done before, and I would not give in. Then Harold said, "Don't you think we really should be married?" and, to his surprise I think, I said, "Yes," whereupon he shouted, "Do you realize what you have just said, Faith?" with great depths of emotion in his voice.

And so I had promised to be his wife and the eight-month struggle with him, with myself and our mutual peace of mind was ended. Joy transported us.

I let him slip on my finger the ring he has worn since he was fifteen, and so we went to bed.

Harold to Faith, January 5, 1923, New York City

How long it seems already since ~~your~~ thy last gesture to me of "fare thee well"! I spent the whole time from Phila to N.Y. drawing or thinking out plans for a bedroom [to add to the studio].

Went to see Montross this morning. Had lunch with the artist who does pottery—Henry Poore—and a good friend, Ruth Gates, psychologist, PhD at Oxford and studied with Sigmund Freud. They are both people of exceptional

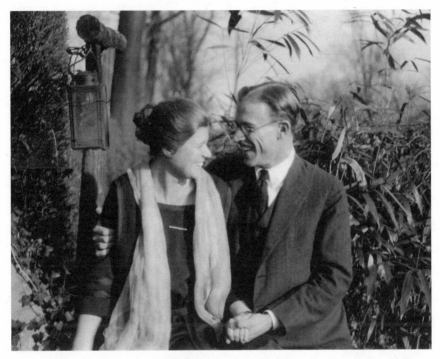

50. Faith Borton and Harold Weston on their engagement, in Moorestown, New Jersey, December 1922. Harold Weston Foundation.

minds. We went to a Russian Restaurant (where I left two borrowed books—alas my condition of fog still lingers) and where we talked from 1 P.M. to 4 P.M. so intensely we all forgot the time and even to smoke a single cigarette! They pitched into my conservatism and many other things thoroughly.

This afternoon to a tea, opening an exhibition of paintings by a girl I know, Adelaide Lawson, and also John Dos Passos. Some of their things very good.

Harold to Faith, January 6, 1923, New York City

Most of this day has been spent about paintings. Seven were selected to submit to the jury which decide on those to be shown at the Pennsylvania Academy of Fine Arts exhibition. The jury this year is very reactionary—the two progressive men who teach there are not on any of the committees. The chairman is about the worst possible; in my candid opinion his work is almost totally devoid of any merit except saleable craftsmanship—commercialized

prettiness—magazine cover girls. I shall be almost complimented if they refuse my work even though we picked out some of the poorest and most academic things.

Faith to Harold, January 5, 1923, Moorestown

Welcome home, dearest. My love reaches out to put arms about thee, to kiss thy lips and to tell thee how warm is the heart of the girl who has promised to be thy wife. We are not, we cannot be, separated from each other, for the strongest power in the world binds us mightily the one to the other. It is in this knowledge that thee can return to St. Huberts and I can stay on here at home, and that joy wells in our hearts.

Dear heart, I pray that I may live in that service with a completeness of consecration and a selflessness that will mean deep peace for us both. Because I feel already that I am to a very great extent so trying to live for thee, I long for this welcome to seem as if it were bringing me to the threshold of thy home where heart meets heart and I become wholly thine.

Harold to Faith, January 8, 1923, St. Huberts

What thoughts press themselves to mind! How impossible to describe my feelings. I always have a chaos of mental sensations on returning to solitude—memories, plans, hopes, desires. It is more than ever this time. Had I but someone to share all this with me, how much less difficult it would be to readjust after the whirl of the past two months. Some ways it seems all a glorious dream. But the impressions are far too vivid for that, especially those last two weeks with ~~you~~ thee. Darling, they were perfectly glorious. The beauty of ~~your~~ thy expanding love. The steady acceptance by thee of intimate knowledge of love. Moments I can never forget. Oh I love thee!

It is snowing *hard* outside at least a foot has fallen since this morning. Spent quite a while going over some of my winter vegetables, about half of which are still rescuable.

Harold to Faith, January 13, 1923, St. Huberts

It is easier (saves washing) if things are reheated in the same pot and not taken out each time into a bowl. Thus today I have the following in pots:

baked beans, potatoes, carrots, cereal, turnips, cabbage, grease (for French frying or fritters), two are for heating water, and one old one, I was boiling some handkerchiefs which I recently ironed on a cloth on the floor! P.S. this is misleading—I almost never iron!

Have gone over accounts recently and realize that we will indeed have to live simply. In a way, I am very glad. There is something so *fine* about it—thee coming to me for love when I have so very little but that and a tiny home to offer thee. *God bless thee for it!* May thee ever—every moment even in the many monotonous tasks there may be—find the joy and simple, deep, divine happiness that thee so completely deserves.

Flock of chickadees visited me this noon. Painted.

Harold to Faith, January 17, 1923, St. Huberts

There is a peculiar tang to the air this heavenly day. When I got up before the sun had dispelled the snow mist that hung over and diaphanously shrouded the great hills, the thermometer registered two below zero. How I wish thee were here! This experience of love and perhaps the greater revelation of what it will and already does mean because of solitude here is, I am convinced, the biggest thing without question that has ever come into my life. Does thee realize what deepening senses of beauty thee has given me?

The results of the morning's work were, a box of watercolors spotlessly cleansed and a paper now crumpled and black going through the last contortions of death in the fire. But the day called for the woods and there all afternoon I have been.

I no longer make the mistake of "you" to thee when talking with thee in my dreams. Did I ever tell thee, I think not, that one of the first indications that I was growing to care for thee was the constant recurrence of thee in my dreams shortly after thee left at the time of the winter party. I confessed that to Charles then and he urged the possibility of success which I did not at all feel confident of. The struggle and consequent months of worry in winning thy love have, too, made it so vastly richer than it otherwise could have been.

Harold to Faith, January 18, 1923, St. Huberts

No mail tonight, the wind blocked the roads with great drifts and the mail did not get through from Elizabethtown. Spen Nye said he never before

felt such wind in Keene Valley, where it always blows much harder than up here. Spen was amusing about the wind. He was sitting by the stove smoking a cigar. He turned to me and said "Someone of us must'a sinned awful." I wondered. "Otherwise, why did we want all this snow accrost th' road? Somebody runs these things, don't they? Why did they want to do this if it wasn't to punish somebody?" I tried to suggest perhaps difficulties were put in our way sometimes not as punishment but to test our strength in overcoming them. He then beamed around at the other men (for he, Spen, had been driving the snow plough out in the wind all day) and flicking off the ashes from his cigar with a proud wide sweep of his arm towards the stove he said, "Wall, then, they wasn't nobody down in the hull damn town what darst stick their heads out a'doors. I guess the Lord is figgurin' up tonight just *who's* got stuff in 'em alright!" and they all laughed so that you could no longer hear the dull roar of the wind up on the mountain.

Really, one has a feeling of awe, almost of terror, in contemplating such marvelous things—the infinite space and blueness of the sky, the great bulk of the mountain forms, the scintillating brilliance of the virgin snow, so immaculate, like myriads of tiny diamonds but more sensitive, more alive, each containing the prism, a world in itself of color. How hard it is to get close to nature's vital substance! When one would embrace it, it is illusive—has fled: there is but the fragrance and one torn petal of the flower left in one's hand! How make oneself more of it; it more of oneself? What is nature? What are these hills, or what great epic of love do they sing to the human mind? I marveled at some buds that were brilliant tiny red infants of life, wherein the leaf and flower, embryonic, lie curled, awaiting the breath of spring. I found a pussywillow half out—and I send it to thee.

Thee will be glad to know that I feel this day has been profitable. Towards noon I could stay in no longer and went out to fell a couple of medium sized trees [in the area where the bedroom extension is to be]. I really don't get exercise enough and am generally not out until after dark. Thee won't like my paling cheeks, I fear, and fortunately my conscience is clear about going out on such days as this for it helps one love and learn nature, which is essential for my job. So I took a short snowshoe walk again this afternoon for over an hour. At present reckoning I can recall at least four impressions that are fully worthy of being strived for in paint, or to be incorporated with other ideas, aside from the constant joy of the day, the air, and the feeling of winter

at mature loveliness. Such days are supreme and do not frequently recur; they are eternal in the sense of their rare beauty and their refined discard of all that is commonplace. How make weak paint and slovenly brush convey that to others?

Harold to Faith, January 19, 1923, St. Huberts

Last night Evangeline Nye [Spen's daughter] brought up my mail after teaching school all day. Then at ten-thirty P.M. she gave birth to a son!

I have made arrangements to get my mail further down the hill—just beyond the little chapel, for at Spen's they said "well, we'll be getting' the mail every once and a while, but we're too busy to send for it special-like every day." Imagine my feeling till I thought of a boy of 16 [young John Otis] who goes to the high school. I have appropriated the little bag we had on the canoe trip for utensils and, boiled, it is marked "H.F. Weston—U.S. MAIL." I am taking this down tonight, a good sized letter for him to begin on! [An approximately five thousand word letter.] After this, dearest, I simply must suppress or curtail my desire to talk to thee a little more. I don't get any reading done and I get to bed *much* too late.

Harold to his mother, January 22, 1923, St. Huberts

As you can well imagine it has been very hard to settle back tranquilly in solitude, harder than ever before. Particularly so because I am very much trying to be on my guard about not letting the results, either artistic or financial, of the exhibit weigh upon my mind and influence my work. Therefore it has been difficult to "get going." I am purposely trying another medium, watercolors, but with rather discouraging results. The Brooklyn Museum offered to exhibit a group of watercolors of mine at their annual show in April *if they* were at all equal in quality to the oil sketches. As yet not so but that is asking too much for I ought to have at least a month to get used to a new technique. Understand, I am *not* at all discouraged. This may be one of those formative periods that more or less necessarily has to be and precede a time of real creative activity. The essential is to learn and love nature and get constantly closer to it. It is death to ideas if you force them to an untimely birth.

Harold to his father, January 23, 1923, St. Huberts

Trees are cracking tonight; it is about zero. This morning when I woke up it was 32° inside! The fire had just about gone out and it was 8° below outside. Beautiful sunset this evening and fine moon.

Harold to Faith, January 26, 1923, St. Huberts

When cutting wood my eyes turned with amazement at the beauty of the snow shadows, the color of sunlight on the snow, the majesty of Giant, none of which things seem to lose their interest or power to thrill because I have seen them similar many times before. That is a feature of things which are of great beauty, they do not cease to give truly aesthetic enjoyment.

My own darling love, I have a new name for thee—*Mahabub* (pronounced like mah'boob) which is Persian for "beloved."

Harold to Faith, January 30, 1923, St. Huberts

Two sketches today, one is a little more encouraging. I must not be impatient. One of the criticisms made to me more than once about my work was that I did too much. I think there is a bit of good truth in that. Thee has so much of me in thy heart, that infinitely more than other years alone I feel incomplete and powerless to achieve the best, without thee.

The moonlight these nights is simply beyond description. The sky has a very definitely deep blue color and is extraordinarily light near the horizon behind the great looming forms of the mountains. I stood for a few minutes down in a grove of pines where the moonlight was filtering through the branches, a silver cascade, and a brilliant pool at the bottom encircled by the strong arms of great black shadows. Perfect silence and a peace that is truly heavenly. Would that thee were here!! The trunk of a white birch tree in the moonlight and a quivering snow field behind reaching up to kiss the sky.

Harold to Faith, February 6, 1923, St. Huberts

Thy letter which spoke of thy growth of love and the feelings thee had begun to experience of real desire was indeed appreciated because it reemphasized

the richness of our love, one of its most unique qualities, the *absolute* frankness with which we stand bared in thought and fact, in mind and body to each other.

Yes, beloved, my passion is greater but thy experience will be even more magnificent than mine. Never can I feel the child stir first in my womb, having none. Never can I have breasts as thine or feel the joy of the lover's naked breast pressed thereon, or the sucking child lips! It is really unbelievably marvelous—love and life, life through love! It is surely the most perfect gift of God to those who can share *all* of it unreservedly, simply, magnificently, through His great loving will. It makes me thank God daily the more reverently for simplest food and the warmth of fire, the pure mountain air in one's lungs, the beauty of His hills, because of the other greater gift, going even deeper into our being's experience, for which Christ sanctions our leaving all others we love, that marvelous blending of ourselves as one.

About thy physical "imperfections." *Dearest love,* I am as conscious of the deformity of my left leg, which will be a shock to thee perhaps when thee sees it, even though in swimming it is more or less seen, that any slight defect thee may have would almost seem to be God's will, that we be even thereby also mated. I will *love* thy back for the very thought of how wonderfully thee has endured it and recovered.

Harold to Faith, February 7, 1923, St. Huberts

A narcotic sunset tonight—a wild brief spasm of weird color, mauves and yellows and browns and slate grays, big wind upon the hills and almost a thaw. Slight snow during day. Now all is gray and heavy with dusk, slumber.

Harold to Faith, February 8, 1923, St. Huberts

Two nights ago the stars pierced through the heavens brighter than almost any night before. The air was still. I was returning from [getting] milk. It was about 14° below zero. I stood on the hill and could see my studio light at the foot of Noonmark, outlined against the stars. And I sang, sang for at least ten minutes as I slowly made my way across the snow to our home, sang and listened to the echoes from the hills.

If thee feels that our wonderfully mutual love now is almost more than human, remember that to win it caused far deeper than ordinary suffering and perhaps, because of that, God has seen fit to make our reward unbelievably perfect. How thoroughly worth while it always is to insist upon and struggle for the *best* in life, however impossible it may at times seem for that best to be obtained or achieved!

Harold to Faith, March 17, 1923, St. Huberts

Paint faces a much more difficult problem of dealing not in analogies (unless hidden, mystical, secondary ones) but in vivid portrayal of truth itself. The problem is so heart-, mind- and soul-searching that it is an agony at times. A recurring subjection of oneself to the pain of confessing inadequacy, if one is honest, the soul, protecting its abject humility by an armor of self assertion and pride, admits that to its secret self even though each time it reopens the new wound of conscious incompetence, powerlessness.

I have worked a little more on the portrait. It is, in my present opinion perhaps the best thing I have done since returning here. Thee won't like it. Neither will my mother at first. The glorious thing about it is that it does not compromise. That is a damnable tendency of mine in most of my nature watercolors. For sin it is, for innumerable reasons, desire to please or to be kind or to subject our ideas of what is right in order to cater to the standards of others. It will not be easy for either of us to live up to this. Half way is not good enough, is despicable since the way towards achieving the best has been revealed to us. We owe it to the depth of our love. We owe it for our endowment of life.

One of the best critics in New York told me he knew of one other artist who tried to face the hills in isolation for nearly three years—Marsden Hartley. Some of his work was akin to mine. At the end of those three years he nearly went insane. I refuse to give up, yet at least, and with the power of potential spiritual aid that thee brings to me I have courage for the future. That critic expressed the hope I would stay here ten or twenty years, for, he said, what is time to the individual if he really has something of tremendous value to give to posterity, to thousands of lives enriched by the sacrifice of his? (The difference between advising this and doing it is the difference between the true artist and the critic.) Ibsen stated once: "Friends are an expensive luxury; and when a man's whole capital is invested in a calling and a mission

in life, he cannot afford to keep them. The costliness of keeping friends does not lie in what one does for them, but in what one, out of consideration for them, refrains from doing. This means the crushing of many an intellectual germ." To a certain degree families too come under this category. It is well to face it from the start. Are we equal to the sacrifice of *all* for an ideal?

I was so engrossed in writing thee that a pot of glue I put on stove to soften up to stretch another water color paper, boiled over and made an awful mess.

Harold to Faith, March 19, 1923, St. Huberts

I can't tell thee what a deep deep satisfaction it is that utter frankness is our natural way—to share the most hidden things with thee gives an incomparable sense of dwelling in perfect union of soul. Oh I love thee.

Harold to Faith, March 21, 1923, St. Huberts

I am going to copy for thee what I have written Ruth Gates, in part, on sending back that book [*The Ordeal of Mark Twain* by Van Wyck Brooks]. "Some day I am very keen for you to meet Faith Borton who is to be my wife. I think she is, and I reassert it after reading this book, almost ideal in strengthening my 'patience, conscience, economy, self-knowledge, self mastery,' etc. She is a person who believes in following the Inner Voice, which is after all, when freed from conventions, the artist's soul. She is not the sort who cares a bit about money, prestige, social position or fame. She is a true Christian and, if you will permit the term, a true disciple in the broadest sense, devoted to the cause of "loving service to God." That phrase reveals a character that is preeminently fitted to aid an idealist (and every artist *must* be an idealist). There is no prudery, priggishness or seeking of "heavenly reward." There is only the incarnate spirit of high purposed unselfishness and a belief that life is worth while. She is a girl who would go through hell for a cause she believed in or a man she loved and fortunately she has faith, however blind, in my future and she loves intensely. Indeed she is a rare soul."

Harold to Faith, March 22, 1923, St. Huberts

[At noon] Oh I feel so virtuous! I had a moment of real courage and have torn up and put in stove one of the portraits I have tried, the second one.

Have done another today, the fourth which is the best yet in my present esti-
mation. There is still something of value in the first, though thee will *hate* it
and it is, from the superficial point of view, *most* uncomplimentary. Thee will
say it is not I at all. But it has in it something of the pathos of the struggle I
have been going through and there is a certain primitive sincerity about it.

[In the evening] No, the "portrait" I did this morning isn't much good
after all, but, anyway, I'm glad I got rid of one!

Harold to Faith, March 27, 1923, St. Huberts

I lay on my bed, half exhausted after a too long siege of concentration at work,
with love for thee coursing through my being. I need thee desperately for sane,
wholesome relaxation. I need thy laughter, thy smile, thy bit of song or cheerful
word, thy lovableness. Intensity consumes me. I fret through the days, striving
and not succeeding, ever discontent with what little I have accomplished. That
is the heritage of the artist or the seeker after truth, that is in part the wage that
is exacted for the privilege of forging ahead on one's own path.

Harold to Faith, April 5, 1923, St. Huberts

It is by far the finest spring day we have had—ground oozing and on main part
of golf links bare. There at one place I noticed some green moss, the most liv-
ing vivid green I have seen for ages, with the richness of a bit of Gothic stained
glass. Little streams had made rivers winding through the snow. I came to a
river that curiously resembled a bend in the Tigris, with the shallow island
where dead carcasses always got stranded and festered and I seemed to be look-
ing down on a map in miniature, but with real water flowing in the river, and
my imagination saw mud built towns and people burrowing about, and in
thought dynasties, centuries passed, while the river ran and built out its mud
flats further into the sea. And after all what was time or the world, might cen-
turies not pass in an instant if we were ageless enough to comprehend.

Harold to Faith, April 9, 1923, St. Huberts

Have been working on "still life" with my little green "Buddah." Have been
out pickaxing ice and shovelling it—also removing parts of woodshed—

chopping out frozen blocks of wood for about 2 hours. Has been beautiful day but below freezing except in direct sun and I fear another good week will go by before I can have foundations [for the addition of their bedroom] started. Can't be helped unless really warms up. Then I did a little water color of Giant. The sides of the mountains are getting redder every day, as the buds become that brilliant alizarin crimson color.

Dear girl, how I love thee and all the things that thee is doing for me or for our life together. [Faith is coordinating all of the wedding preparations.]

I can't help remarking that it seems an awful extravagance to have two good sets of china. What about the Russians? People die of hunger, needing 15 cents a week to keep a child alive and we have a set of plates put away as too good to use! No, it's not really Christian. Is it? If it were fair to thee, I could live in one room with thee and eat with camping utensils and be perhaps even happier, somehow it would come down more just to the realities, Faith and Harold. Nothing more just Faith and Harold united by love, giving their lives to each other and to others for love.

As I walked up the hill tonight there were patches of snow here and there. The smoke was coming out of the cabin by the trees and I had a certain joyous feeling of really being near nature, away from life's petty things. Since thee was here [for a visit in February] I have bought 2 loaves of bread 2 lbs of butter 2 doz eggs and 1½ quarts of milk a day. Have used only about 3 tins of food and am quite content and well nourished. Have saved oil lately by cooking some on studio stove, a pot of split peas boils there now and some turnips.

Aunt Nanna (Mary Hartshorne Weston's sister, Mrs. Percival Chubb) to Harold, April 10, 1923

Harold, You have won a girl in a hundred thousand, I should say, because the 20th century young woman usually appalls me, and Faith seems to me so far removed from all that is selfish, and materialistic, to be the kind of girl my mother, your grandmother, was, utterly unworldly and lovely.

Harold to Faith, April 12, 1923, St. Huberts

Well, this night quite a number of people are probably gathered in a certain room in Cleveland [Kokoon Arts Klub] to gaze at the paintings of "one of

the foremost modernists of New York City" and discuss them, at the "Weston exhibition"! Though I don't like the rather cheap tone of their notice, which harmonizes with their name, I only take real exception with the very poor taste of "for sale at reasonable prices" which might be said but should not be written like an "ad" for a new kind of shaving soap. I do not mind his personal comment about sales [since the group incurred expenses in shipping the paintings and they would like to recoup the money], it is only so *poor* a notice! "Life of a hermit"—ha, ha, where oh where will my press notices get to if they lose the chance to play up that note?

Faith to Harold, April 12, 1923, Moorestown

I am faint with love—and cannot go on reading thy letter without breathing upon thee my desperate longing for and living companionship in thee. Dearest, the emotion of it all *pains* me, it goes so deep, deep in. And I, oh! darling, am not big enough to competently take care of all the love thee pours into me, nor can I seem to hold what my share for thee is. Dear, love like this is *terrific.*

Faith to Harold, April 13, 1923, Moorestown

It does not seem possible that many people love as we do. The world is an absolute denial of it, at any rate, and one can only think of the present method of life as a direct result of the inner life and living. Dear, if we can hold to this intensity and conviction of love—forgiving, self-sacrificing, soul-stirring power of God that it is—no man can measure the contribution that we might make to an out-worn society that longs for the deep things in life which so few people have the opportunity or desire to discover for themselves.

Harold to Faith, April 17, 1923, St. Huberts

The first rafters [of the bedroom extension] are going up. Have come in for a few minutes to tell thee that I love thee.

The work day is over. By tomorrow night ought to have roof partly done. It has been absolutely essential that I be with the carpenters [Clarence Edmunds was head carpenter] to decide numerous detail points that were

not specified on plans. I am constantly reminded by them and by others coming in to see work, of the purpose for which that room is to be used. There is no use getting sore about it or they would just kid me more, but their jokes are exceedingly free! They don't miss any opportunities and it is just as they would talk to one of their own friends and on the whole I am glad that they feel about me that way.

Cool enough to need to light fire, so am doing wash tonight as saves oil when I boil clothes on wood stove.

Harold to Faith, April 22, 1923, St. Huberts

Yesterday we finished the roof and skylight all but the actual window. Also got walls on three sides and two windows set in place. The room seems ever so much larger than I thought it would. It should be most attractive when finished. I like the low roof, the recesses and the way it projects right into that darling grove of balsams. We will be chorused by frogs. They thawed out yesterday and started croaking in the little brook by the edge of our woods along that meadow.

Last night I again wiped dishes at Nye's. Those two poor girls certainly have a lot of work to do.

How inexpressibly glorious it will be to realize that there is no longer any hurry or parting, that day succeeding day will find us cleaving together knit as one in love!

Harold to Faith, April 29, 1923, St. Huberts

Behind the chimney in the sun on the roof I am sitting. I have come here after sweeping up our room and getting it ready for Father's inspection. After cooking up the rest of the beets to pickle, after doing part of the week's washing, after sleeping till nearly 9 A.M. I could no longer wait to write thee, oh my love!

With eyes closed I have been listening to the birds, frogs, chipmunks, sound of breeze in the balsams, the distant roar of the river and the flutter of these pages on my knee and all the while *loving* thee. One of the thoughts that in recent days has given increasing joy is that there will be the indescribably wonderful peace of realizing that thee and I are each other's *always,* no

longer transient friendly handclasp or embrace, but a living reality to which we can both turn. My, I do congratulate myself in falling in love with thee and in persisting until I wone thy love!

Harold to Jim Munn, May 20, 1923, St. Huberts[22]

A week and a day of married life has made both of us feel we never really lived before.

Harold to Jim Munn, June 12, 1923, St. Huberts[23]

Life is glorious. Faith fits in here perfectly and I feel no fears about the future. We can hardly convince ourselves that we have only been married a month, so thoroughly adopted to each other do we feel we have already become. I am *even more lucky* in having Faith than I thought. Did quite a lot of sketching until flies got back about a week ago.

51. *Xmas Greetings,* 1923, Harold Weston. Courtesy of the Archives of American Art, Smithsonian Institution.

*In February 1924, Faith got a triple, "spiraled" fracture in her
leg in a tobogganing accident, and drove fifty bumpy, cold miles
the next morning to the hospital in Plattsburgh. Faith's mother
came to tend to her in the hospital while Harold went back to St.
Huberts to paint. They had started work on the landscape nudes
and knew her parents, Orthodox Quakers, would not understand
the paintings.*

Harold to Faith, February 12, 1924, St. Huberts

Tell thy mother something of our work and the mountains. Get her to see
how trivialities, traditions, all but the essential, elementary, directly felt and
consequential to the inner existence, is swept away. How the soul's wings
are unleashed if the heart hath the power to soar. The beauty of thy body is
sacred because it is beauty, truth of womanhood, and cannot be fouled by
being seen as such.

November 19, 1925, Philadelphia

I can't possibly say how much I owe to Faith, only that she has altered my life
drastically, enriched it a thousand fold and given far far more than I can ever
repay, than I ever anticipated in wildest dreams of anyone.

• • •

Harold to Marjorie Phillips, February 21, 1972

Just about at the end of January when our life seemed to be basking in a
kind of mellow Indian summer, Faith discovered a lump in her breast. In
view of her own past history and that of her mother before her, this was very
disturbing. It was malignant, her remaining breast has been removed but the
surgeon believes it was done soon enough to pose little threat for the future.
She seems to be recovering most satisfactorily.

My own health has been good enough to be working—painting—quite
steadily, but, unless I am careful, my hiatus hernia may kick up at any time.
So Faith thinks I should not stay at our apartment alone and while she is in

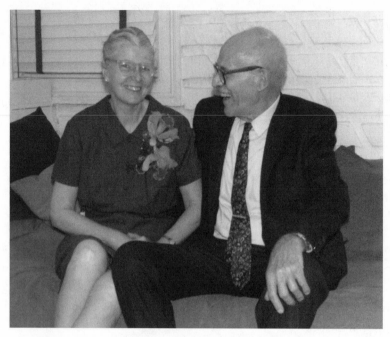

52. Faith and Harold Weston in their apartment on Bleecker Street in Greenwich Village, New York, 1967. Photo by Emil Halonen. Harold Weston Foundation.

the hospital I am living with our daughter Barbara and her family here in New York.

I am delighted you feel pleased with the way the reproductions from the Collection turned out [in *Freedom in the Wilds*]. I think very often of dear Duncan [Phillips, collector of Weston's work for his museum, The Phillips Collection], it is almost as if he were still alive. At times of self doubt he sustained my confidence and still does.

Seven weeks later, on April 10, 1972, Harold died at age seventy-eight.
Faith lived until February 1, 1997. She was ninety-seven years old.

Notes

Selected Bibliography

About the Author and Editor

Index

Notes

All letters, journals, and diaries cited in the notes are from the Harold Weston Manuscript Collection, Harold Weston Foundation, West Chester, Pa., unless otherwise noted. For archival material Harold Weston is referred to as "HW."

Preface

1. At the time Weston wrote this book, debates were raging in the Adirondacks about just how much management of the Forest Preserve was permissible or desirable. Some people, such as Weston, wanted the wilderness areas untouched; others advocated for limited logging, or "resource management," as occurs in such places as the Black Forest in Germany. By the time the Adirondack Park Agency was created in 1971, shortly after Weston completed the manuscript for *Freedom in the Wilds,* the debate quieted as the State Land Master Plan (approved by Governor Rockefeller just after Weston's death in 1972) set aside about half of the Forest Preserve as "Wilderness Areas." Special thanks to Tony Goodwin for his observations. Further reference: Philip G. Terrie, *Contested Terrain: A New History of Nature and People in the Adirondacks* (Blue Mountain Lake, N.Y.: Adirondack Museum, 1997), esp. 168-70.

Introduction

1. HW to Harold K. Hochschild, 4 Feb. 1971, Harold Weston Papers, 1916-72, Archives of American Art, Smithsonian Institution, Washington, D.C. (hereafter AAA).

2. HW to Page Edwards, 9 Jan. 1971, AAA; HW, draft manuscript of *Freedom in the Wilds,* viii, AAA.

3. Carolyn Payne King, in conversation with Rebecca Foster, 31 Jan. 2007.

4. HW, diary, 1 Jan. 1920.

5. HW, "Saga of the AMR," 1970, 1, AAA.

6. R. Stewart Kilborne, 14 Dec. 1971, in "Statements about Harold Weston's 'Freedom in the Wilds'" (unpublished ms.).

7. Editorial, *New York Times,* 10 Jan. 1972.

8. Morgan K. Smith to HW, 24 Nov. 1970, AAA; Paul Brooks, Nov. 1971, in "Statements about Harold Weston's 'Freedom in the Wilds.'"

9. Helen Appleton Read to HW, 19 Nov. 1971, AAA. Read wrote a review of Weston's art: Helen Appleton Read, "In the Galleries: Harold Weston," *Brooklyn Daily Eagle,* 22 Nov. 1931, sec. E, 6.

10. Ernest A. Weiss, "Art in Rochester," *Rochester (N.Y.) Herald,* 25 Jan. 1925, 11.

11. HW, diary, 5 Dec. 1921.

12. HW to Faith Weston, 4 May 1959.

2. People

1. E. R. Wallace, *Descriptive Guide to the Adirondacks and Handbook of Travel,* 9th ed. (Syracuse, N.Y.: privately published, 1881), 440–44.

2. Eleanor Alderson Janeway, "Random Recollections of the Early Days of the Adirondack Mountain Reserve and the Ausable Club," manuscript, 1951, 2–3, Keene Valley Library Archives, Keene Valley, N.Y. (hereafter KVLA).

3. HW, tape recording, 1 Oct. 1964. This information was not included in the first two editions of *Freedom in the Wilds.*

4. Alfred L. Donaldson, *A History of the Adirondacks* (New York: Century Co., 1921), 2:57–58.

5. That Brett Lawrence, a Keene Valley guide deeply familiar with local guide history and lore, had not heard this story all but confirms that this is an apocryphal tale. However, Lawrence told a variation of the story, a contemporary ruse some guides play on the city folk: They reach down to the ground and pretend to pick up and eat the "doe's bean," while actually eating chocolate-covered raisins that they keep in their pockets. Brett Lawrence in conversation with Rebecca Foster, 19 Aug. 2006.

6. It is unclear where Weston got this figure. Roswell Shurtleff is said to have counted forty artists working simultaneously in the valley in the 1880s or 1890s. Robin Pell, "The Artists of Keene Valley and Their Melieu," in *Two Adirondack Hamlets in History: Keene and Keene Valley,* ed. Richard Plunz (Fleischmanns, N.Y.: Purple Mountain Press, 1999), 144.

7. Verplanck Colvin, *Seventh Annual Report on the Progress of the Topographical Survey of the Adirondack Region of New York, to the Year 1879* (Albany, N.Y.: Weed, Parsons and Co., printers, 1880), 4–5.

8. "Three significant legislative decisions were made between 1885 and 1894. [The creation of the Adirondack Preserve in 1885; the creation of the Adirondack Park in 1892; and the passage of the constitutional amendment, Article XIV that used the 'forever wild' phrase and protected the wilderness from development in perpetuity in 1894.] All of them directly connected to Verplanck Colvin's unshakable belief that the Adirondacks needed protection." Nina H. Webb, *Footsteps through the Adirondacks: The Verplanck Colvin Story* (Utica, N.Y.: North Country Books, 1996), 141.

9. Colvin, *Seventh Annual Report,* 92.

10. Ibid., 97.

11. Ibid., 20. Webb describes the triangulation technique as "finding three geographical points on a map, establishing the true location of each site, and then drawing straight

lines connecting them to each other. In Colvin's case, the points were things like mountains, lakes, physical structures, and old boundary lines." Webb, *Footsteps,* 51.

12. Colvin, *Seventh Annual Report,* 89.

13. "Cinders" refers to the cinders, soot, and ash that coal-fired steam locomotives released from their smokestacks and that perniciously worked their way into the passenger cars even when the windows were closed. The "scenery" along the Delaware & Hudson line was spectacular. Weston uses this expression as if it were commonly understood, but it was not and is not known among transportation historians. It may, however, have been a jovial expression common among Weston's cohorts and family. Special thanks to Theodore W. Scull.

14. In 1968 Weston told members of his family how the Beedes cleared the land, but "didn't bother to take the stumps out at first." The potatoes, planted in virgin soil, were "large as footballs and even larger. That is not exaggerating. I wasn't there but I've heard it from the Edmonds." The family laughed and protested, but Weston defended the statement: "Now wait a minute, in virgin soil things grow perfectly phenomenally at first." HW, tape recording, 28 July 1968.

15. Helen Adler, "Felix Adler, one of the early pioneers in Keene Valley and at Beede's," manuscript, 6 Sept. 1939, KVLA.

16. William James, "Professor William James's Reminiscences," in *Memorials of Thomas Davidson: The Wandering Scholar,* ed. William Knight (London: T. Fisher Unwin, 1907), 118.

17. In a draft of *Freedom in the Wilds,* Weston wrote: "Father pitched into some of the then unpopular causes like women's rights and universal education. The prominent Philadelphian jurist, Roland S. Morris, declared that Weston made 'the greatest single contribution to freedom of thought in Philadelphia of any man of his generation.' And at the time of the 50th Anniversary of the founding of the Ethical Society, Felix Adler wrote, 'Between this man and the cause he has served has fallen no shadow of self.'" AAA.

18. This story and several other details in this section were not included in the first two editions of *Freedom in the Wilds.* They came from a tape recording made by Weston in July 1965 and a draft copy of the book.

3. A Wilderness Preserve

1. *Testimony in the Claims of the Citizens in the Valley of the Ausable River for alleged damages to their property occasioned by the breaking away of the dam across the South Branch of the Ausable River, September 30, 1856* (Albany, N.Y.: Weed, Parsons, and Co., 1858).

2. The moose population has gradually returned. By 2006 there were between 200 and 250 moose in the High Peaks area.

3. Wallace, addenda to *Descriptive Guide,* 9th ed.

4. Weston was friendly with Scott Brown, particularly in 1920–21 when he first moved to St. Huberts year-round (see part two, e.g., 178, 184). Brown told Weston that he was a first cousin of the John Brown who was a guide with a camp on the Upper Lake, and that *that* John Brown was, in turn, a nephew of the abolitionist John Brown.

5. The value of pine trees for masts had been long recognized. When the territory was a British colony, land grants "often contained the following restrictions: 'All mines of gold or silver and all pine trees fit for masts . . . are reserved to the Crown!'" Charles N. Holt, "Malloy Grant and Old Military Tract," manuscript, 1959, 1, KVLA.

6. Five years after he last had seen the site of the 1913 fire, Weston wrote in his diary: "I liked the burnt region better when blackened, scarred and rugged a few years ago. Now [it has] neither the richness of virgin timber woods with firs and moss grown logs nor the stern 'masculinity' of seared rocks and tumbled trees and boulders." HW, diary, 3 June 1920.

7. William G. Neilson, "A.M.R. Report on Forest Fires, for June 2, 1903," in "The Great Fires of 1903 Followed by Floods," by Lewis L. Neilson, 4, Neilson Family Papers.

8. "St. Huberts Inn and St. Huberts Cottage, The First Season, 1890," compiled by Lewis L. Neilson, 2, Neilson Family Papers.

9. See also Edith Pilcher, *Up the Lake Road: The First Hundred Years of the Adirondack Mountain Reserve* (Keene Valley, N.Y.: The Centennial Committee for the Trustees of the Adirondack Mountain Reserve, 1987), 53–58.

10. New York State Department of Environmental Conservation, Brian Swinn to Rebecca Foster, 27 June 2006.

4. Youth in the Mountains

1. Nancy M. Lee, "Adirondack Mountain Reserve: A Time Line," manuscript, 1987, KVLA.

2. Over the years many items have been dumped into the Upper Lake. In 1970 Weston told the following story: "Mr. Howell from Philadelphia was original secretary or treasurer of the AMR, and his relatives were close friends of Ben Franklin, and when Ben Franklin was experimenting with the Franklin stove idea he made different models along slightly different lines. One of those was up at the camp, and it was there in the early twenties. Now we went abroad [in 1926], and when I came back in the thirties, I found to my consternation they'd said, 'Oh we'll get rid of this old thing' and they dumped it in the lake. That would be a very valuable relic for some museum if you could get ahold of it again, but I don't know [in which part of the lake] they dumped it." HW, tape recording, 8 Aug. 1970.

3. HW, tape recording, 3 Aug., no year given, but most of the recordings were c. 1969.

4. Toward the end of his life Weston spoke of his polio frankly and at length: "When you realize that I was at that time so interested in athletics, I mean that was the summer when Carl and I, my brother, had gone on that canoe trip and I would carry the canoe for a half-mile portage on a trot. We came back the seventy-odd miles from Indian Lake in two days, bushwhacking up through Boreas Pond to the Upper [Lake] and so forth, and I ran the last part of that from the Lower Lake down in fifteen minutes. Well, I was doing too much, really; maybe that's why I got polio. I don't know . . . overexertion. But the point is, you just can't imagine how that [the onset of disease] hits you. . . . It was pretty tough. I knew that I'd never run, which was true. Of course, nowadays they know how to treat it. Then they didn't, and they treated it the wrong way and made it worse, so that I've never recovered any control

over the ankle and [can withstand] only about five-pound[s] pressure on the knee, which is only enough to hold it locked, not to stand on it bent. And yet I've climbed mountains with it and all that kind of, well, anyway. Let's talk about the reactions in later life rather than then, because I wasn't old enough at that time to realize the difference. I think you take the case of, say, [Franklin D. Roosevelt], he never amounted to much until he had polio. When something like that strikes you, nature compensates in some way. It gives you other things; it makes up, just as if a person goes blind they hear better. If a person is deaf maybe they see better, I don't know. At any rate, nature compensates in certain ways. At a dinner party just the other night there was this famous theater person, Miss Audrey Wood, [who] was asking me something about [my illness] (I had happened to mention that I'd had polio that kept me out of being in the war), and she said, 'Well, how do you feel about it?' I said, 'By now I think it's the best thing that ever happened to me.' She said, 'Was that what helped turn you towards being an artist?' I said, 'Yes, certainly,' because you can't do other things, you drop off those things, and you realize later that they were less important. I think that's helped give me that sort of energy which I've had, because I haven't been able to spend it in some ways, so I've more nervous energy, let's say. For instance, this afternoon the director of the Whitney [probably Lloyd Goodrich, the former director] was looking at the paintings, [and he] said, 'You did all these sixty paintings in how long?' I said, '[the years] sixty-eight, sixty-nine, and during part of that time—fifty-four days—I was in the hospital.' He said, 'How could you get so much done in that time?' I said it isn't anything to my credit, it's just that I have that kind of nervous energy to want to get things accomplished." HW, tape recording, 26 Mar. 1971.

5. What is now known as the New York State Department of Environmental Conservation had many forerunners. Its evolution is as follows: New York State Forest Commission established (1885); New York State Fisheries, Game and Forest Commission established, incorporating duties of the Forest Commission (1895); name changed to New York State Forest, Fish and Game Commission (1900); name changed to New York State Conservation Commission, which comprised the Forest, Fish and Game Commission, the Water Supply Commission, and the Forest Purchasing Board (1911); name changed to New York State Conservation Department (1927); name changed to New York State Department of Environmental Conservation (1970). (Information from Brian Swinn at the New York State Department of Environmental Conservation.) To avoid confusion, this book uses "Department of Environmental Conservation" for all periods.

6. At the time Weston wrote this book (1970), he could still identify that small burn spot.

5. Alone with Paint

1. Weston's spring water was replaced eventually by water from the Ausable Club's line, which got its water from Gill Brook. The flow from the Noonmark spring gradually decreased, stopping altogether in 1972, the year Weston died.

2. *The Adirondack Record–Elizabethtown Post,* 13 Jan. 1922, 6.

3. Faith Borton to HW, 3 Mar. 1923.

4. Weston is speaking of the days in the first half of the twentieth century when "everyone did it," as Dorothy Irving put it in conversation with Rebecca Foster on 24 Aug. 2006. By the time he wrote *Freedom in the Wilds* Weston judged that "less than a quarter" of the people made maple sugar, and by 2006 there were only four sugaring operations in Keene Valley (Robert Hastings to Rebecca Foster, 10 June 2006).

5. Harold wrote to his parents: "That delightful boy Harlan [*sic*] who was sent back under most extraordinary circumstances by Mr. Berthol. (In much worse clothes than when left here and had been put for no known reason for nearly a month in an orphan home instead of being sent here). I am helping a little get him some clothes. He was here almost all day today." HW to his parents, 11 Dec. 1920. The flying squirrel incident was in 1923, so the relationship lasted at least two and a half years.

6. Faith Borton Weston, "Life in the Adirondacks," *Newsletter* (Federated Garden Clubs of New York State) 22, nos. 7–8 (July–Aug. 1950): 9.

6. The Power of Nature

1. In the first two editions of *Freedom in the Wilds,* Weston tells the story as being about a Norwegian named Ingrid in the summer of 1922. In his diary entry of 9 Sept. 1921, however, the character is referred to as the "Ladd's Swedish maid (Anna)," and the rescue as "Like quite a movie. Cliffs looked very stunning in morning sun. Poor girl . . . no water for 24 hrs." The correct name, nationality, and date have been restored.

2. Henry Tyrell, "A Roundabout Modernist," *New York World,* 12 Nov. 1922; R[alph] F[lint], "Adirondack Hills and Persian Vales Painted by Harold F. Weston," *Christian Science Monitor,* 17 Nov. 1922, 8; Henry McBride, "Art News and Reviews: Attractive Shows in Many Galleries," *New York Herald,* 12 Nov. 1922, sec. 7, 7.

3. Paul Rosenfeld, "Harold Weston's Adventure," *New Republic,* 31 Dec. 1930, 190–91.

4. The details of the legend vary, but Hitch-up Matildas got their name from a woman who was carried above the water alongside the cliffs of Avalanche Lake by the guide William B. Nye in the nineteenth century. Another member of their party called out to her to "hitch up." *Harper's* magazine ran a drawing of the story, making Nye, the lake, and the expression famous.

5. Helen Comstock, "Air of Familiarity Marks Weston's Spanish Paintings," *Cleveland Plain Dealer,* 16 Nov. 1930, Society section, 17. (Also published as "New Works by H. Weston Now on View," *New York American,* 23 Nov. 1930, M5.) © The Plain Dealer. All rights reserved. Reprinted with permission.

6. Black and white reproductions of the 1934 portrait *Dr. Felix Adler* may be seen in Weston's *Freedom in the Wilds: A Saga of the Adirondacks* (St. Huberts, N.Y.: Adirondack Trail Improvement Society, 1971), 155, and in *Two Adirondack Hamlets in History: Keene and Keene Valley,* ed. Richard Plunz (Fleischmanns, N.Y.: Purple Mountain Press, 1999), 211.

7. The Bear and the Buck

1. These passages on France have been augmented by stories told by Weston in a tape recording from 25 Dec. 1965.

2. Duncan Phillips, *The Artist Sees Differently: Essays Based upon the Philosophy of a Collection in the Making.* 2 vols. (New York: E. Weyhe; Washington, D.C.: Phillips Memorial Gallery, 1931), 1:137–38. Reprinted by permission of The Phillips Collection.

3. Lewis Mumford, "The Art Galleries: Spring and Renoirs," *New Yorker,* 23 Mar. 1935, 30–32. Used by permission of the Gina Maccoby Literary Agency. Copyright © 1935 by Elizabeth M. Morss and James G. Morss. This material first appeared in *The New Yorker.*

4. The final draft of the manuscript for *Freedom in the Wilds: A Saga of the Adirondacks* was dedicated to Dos Passos, although this was changed at the last minute after the galleys had been printed. "Apparently of our classmates the only two of whom Dos Passos still feels close at all are Harold and Faith Weston." Lawrence S. Kubie to Mr. and Mrs. Robert Nathan, 18 Jan. 1962, AAA.

5. The experience of overseeing such youthful workers probably habituated Weston to enacting draconian rules he expected would not be followed. When the mature and responsible Jim Goodwin started to maintain trails in 1952, Weston warned him sternly at the beginning of the summer, "Remember now, it's eight hours a day, six days a week, rain or shine." At the end of the season Goodwin reported to Weston that he had indeed worked six days a week, eight hours a day, rain or shine, and Weston, in disbelief, exclaimed, "You *did?!*" They became lifelong friends. James Goodwin, interview with Rebecca Foster and Kevin Burget, 6 Aug. 2003, Keene Valley, N.Y.

6. The names of the early detectors of the fire were not included in the first two editions of *Freedom in the Wilds.* HW, tape recording, 23 Aug. 1970.

8. Forever Wild

1. Special thanks to Patricia Galeski for remembering Hermann Saurstein's name, which Weston omitted from *Freedom in the Wilds.* She remembers him as an exacting and intimidating colleague. The children of Ausable Club members recall him as "strong, fit, stocky, with long ears, and eyes that crinkled." He "expected people to be well behaved in his bar, went off and hiked as he pleased, getting back in the morning." Aurelia Bolton in conversation with Rebecca Foster, 6 July 2006.

2. The "warmer climate" referred to here and a few other places in the book is Weston's personal observation in 1971, long before the concept of a warming climate change became known to the public.

3. William O'Connor, AMR Warden of the Reserve, tells a story about a trapped bobcat whose carcass was completely and carefully hollowed out by shrews. In conversation with Rebecca Foster, 9 Oct. 2006.

4. O'Connor believes Weston was referring to the barred owls who, he has observed, do what Weston describes from one to one-and-a-half days prior to rain, as well as prior to mating. Ibid.

5. O'Connor relates that the AMR guide Bill Broe reasoned that this phenomenon is caused by fish coming to the surface to clean the silt from the bottom of the lake off of their scales. Ibid.

Part Two: Letters and Diaries

1. Mary Hartshorne Weston, *The Story of a Child: Harold Francis Weston,* 1898–99, unpaginated manuscript.

2. Transcribed in HW, diary, 5 May 1920.

3. HW, diary, 1906–7.

4. Donald B. Watt went on to become the founder of the Experiment in International Living.

5. John Daniel Revel (1884–1967) was a Scottish art teacher and painter. He served in India and Mesopotamia during World War I, and, like Harold, was an official artist for the Expeditionary Force.

6. Wu Ting-fang (1842–1922) was a prominent Chinese diplomat and lawyer who was responsible for reforming Hong Kong and Chinese laws. While he was mnister to the United States from 1897 to 1902, Wu was a spokesperson for the Chinese American community. Wu visited the Philadelphia Society for Ethical Culture and S. Burns Weston at his home in Merion, no doubt for their mutual interest in social reform. The most vivid memory of his visit for young Harold was Wu's extremely long pigtail.

7. Faith Borton, Esther's roommate, was in the crowd and spoke later about how impressed she was by the adventurer and tale-teller.

8. The exhibition's title was "Representative Modern Masters," 15 April to 15 May 1920.

9. During this period in New York City, Harold painted under William Schumacher's tutelage in the mornings. He also took a class with Boardman Robinson at the Art Students League.

10. Harold F. Weston, "Persian Caravan Sketches," *National Geographic Magazine* 39, no. 4 (Apr. 1921): 417–68.

11. James Buell Munn Papers, Correspondence, 1921–1967, letter, Weston to Munn (3 Aug. 1920), in Weston folder, HUG(FP)22.8, Box 5, Harvard Univ. Archives.

12. Ibid., 28 May 1921.

13. Weston probably named the red squirrel with Charles R. Walker, who lived with him in the studio for some of this period. Ironically, in 1938 Charles and his wife Adelaide Walker provided the introduction for Harold and Faith Weston to meet Leon and Natalia Trotsky when Trotsky was in exile in Mexico. They met on several occasions in June and July 1938. Weston's portrait of Trotsky was exhibited at the Whitney Museum of American Art's "Annual of Contemporary American Painting" in 1941 after Trotsky's death.

14. Gertrude Bell was a British diplomat with a large influence in Persia and on the creation of Iraq after World War I. Harold met her in Mesopotamia.

15. *Adirondack Record–Elizabethtown Post,* 13 Jan. 1922, 6.

16. Munn Papers, 15 Jan. 1922.

17. The "long silence about Emily Dickinson" started in 1897 and did not end until the publication of her *Life and Letters and Complete Poems* in 1924. "In the controversy about the new poetry carried on from 1912 to 1923 in the *Atlantic,* the *Bookman,* the *Dial,* the *New Republic, Poetry,* and the *Outlook,* one searches in vain for her name." Klaus Lubbers, *Emily Dickinson: The Critical Revolution* (Ann Arbor: Univ. of Michigan Press, 1968), 83, 110. Weston subscribed to the *Dial,* the *New Republic,* and the *Standard.* A few people were passing around Dickinson's work, which somehow made its way to Weston.

18. Munn Papers, 18 Mar. 1922.

19. Ibid., 13 July 1922.

20. John Farrar, "Showing Movies to Harem Ladies in Baghdad," *World,* 11 Apr. 1920.

21. Henry Tyrell, "A Roundabout Modernist," *New York World,* 12 Nov. 1922.

22. Munn Papers, 20 May 1923.

23. Ibid., 12 June 1923.

About the Author and Editor

1. Lewis Mumford, statement of support, 5 June 1952, AAA.

Selected Bibliography

This bibliography is limited to references related to *Freedom in the Wilds: An Artist in the Adirondacks,* including the works of art reproduced, and general citations of major importance. For a more complete bibliography of reviews and exhibition catalogues see *Wild Exuberance: Harold Weston's Adirondack Art.* Copies of almost all articles and essays listed below are housed in the archives of the Harold Weston Foundation.

The Adirondack Record-Elizabethtown Post, 13 Jan. 1922, 6.

Adler, Helen. "Felix Adler, one of the early pioneers in Keene Valley and at Beede's." 6 Sept. 1939. Keene Valley Library Archives, Keene Valley, N.Y. (hereafter KVLA).

"The Arena." *Magazine of Art* 32, no. 6 (June 1939): frontispiece.

Buchalter, Helen. "A Modernist Sees Life in Unique Symbols: Too Much Prettiness in Art Like Ice Cream Diet Claims Harold Weston, Artist, in Gallery Talk." *Washington Daily News,* 9 Jan. 1932, 11.

Burton, Hal. "Books . . . Adirondack Original." *Garden City (N.Y.) Newsday,* 18 Dec. 1971, Magazine sec., 16W.

Colvin, Verplanck. *Seventh Annual Report on the Progress of the Topographical Survey of the Adirondack Region of New York, to the Year 1879.* Albany, N.Y.: Weed, Parsons and Co., 1880.

Comstock, Helen. "Air of Familiarity Marks Weston's Spanish Paintings." *Cleveland Plain Dealer,* 16 Nov. 1930, Society sec., 17. Also published as "New Works by H. Weston Now on View." *New York American,* 23 Nov. 1930, sec. M, 5.

"Death of Harold Weston." *Congressional Record,* 21 June 1972, S9848–50.

Donaldson, Alfred L. *A History of the Adirondacks.* 2 vols. New York: The Century Co., 1921.

The Expressionist Landscape: North American Modernist Painting, 1920–1947. Text by Ruth Stevens Appelhof, Barbara Haskell, and Jeffrey R. Hayes. Birmingham, Ala.: Birmingham Museum of Art, 1988.

Fair Wilderness: American Paintings in the Collection of The Adirondack Museum. Text by Patricia C. F. Mandel. Blue Mountain Lake, N.Y.: The Adirondack Museum, 1990.

Farrar, John. "Showing Movies to Harem Ladies in Baghdad." *World,* 11 Apr. 1920.

Federation of Modern Painters and Sculptors, 1955–56. Introduction by Harold Weston. Foreword by Duncan Phillips. New York: Federation of Modern Painters and Sculptors, 1955.

F[lint], R[alph]. "Adirondack Hills and Persian Vales Painted by Harold F. Weston." *Christian Science Monitor,* 17 Nov. 1922, 8.

Foster, Rebecca, and Caroline Welsh. *Wild Exuberance: Harold Weston's Adirondack Art.* Syracuse, N.Y.: Syracuse Univ. Press and the Adirondack Museum, 2005.

Goodwin, James A. Review of *Freedom in the Wilds: A Saga of the Adirondacks. Hartford (Conn.) Times,* 26 Dec. 1971, sec. C, 7.

Grafly, Dorothy. "Crudity Vies with Culture in Weston's Rough-Hewn Art." *Philadelphia Public Ledger,* 19 Nov. 1933, 12.

Harold Weston. Text by Ben Wolf. Philadelphia: The Art Alliance Press; London: Associated Univ. Press, 1978. Includes interview with Faith Weston.

Harold Weston: A Bigger Belief in Beauty. Digital video documentary. Blue Mountain Lake, N.Y.: Adirondack Museum; Brooklyn: Wide Iris Productions, 2005.

Harold Weston: Early Adirondack Landscapes. Text by Frank Owen. Elizabethtown, N.Y.: Adirondack Center Museum, 1976.

Holt, Charles N. "Malloy Grant and Old Military Tract." 1959. KVLA.

James, William. "Professor William James's Reminiscences." In *Memorials of Thomas Davidson: The Wandering Scholar,* edited by William Knight. London: T. Fisher Unwin, 1907.

Jamieson, Paul F. Review of *Freedom in the Wilds: A Saga of the Adirondacks. Forest History* 16, no. 2 (July 1972): 27.

Janeway, Eleanor Alderson. "Random Recollections of the Early Days of the Adirondack Mountain Reserve and the Ausable Club." 1951. KVLA.

Lee, Nancy M. "Adirondack Mountain Reserve: A Time Line." 1987. KVLA.

Lubbers, Klaus. *Emily Dickinson: The Critical Revolution.* Ann Arbor: Univ. of Michigan Press, 1968.

Mackinnon, Anne. "A Passionate Nature: The Consummate Art of Harold Weston." *Adirondack Life* 25, no. 1 (Jan.–Feb. 1994): 28–35, 65–66.

McBride, Henry. "Art News and Reviews: Attractive Shows in Many Galleries." *New York Herald,* 12 Nov. 1922, sec. 7, 7.

Mumford, Lewis. "The Art Galleries: Spring and Renoirs." *New Yorker,* 23 Mar. 1935, 30–32.

Neilson, Lewis L., comp. "St. Huberts Inn and St. Huberts Cottage: The First Season, 1890." Neilson Family Papers.

Neilson, William G. "A.M.R. Report on Forest Fires, for June 2, 1903." In "The Great Fires of 1903 Followed by Floods," by Lewis L. Neilson. Neilson Family Papers.

"Notes: Freedom in the Wilds." *Adirondack Life* 3, no. 1 (Winter 1972): 42. Book review.

Passantino, Erika D., ed. *The Eye of Duncan Phillips: A Collection in the Making.* Washington, D.C.: The Phillips Collection, in association with Yale University Press, 1999.

Phillips, Duncan. *The Artist Sees Differently: Essays Based upon the Philosophy of a Collection in the Making.* 2 vols. New York: E. Weyhe; Washington, D.C.: Phillips Memorial Gallery, 1931.

Phillips, Duncan. "Original American Painting of Today." *Formes* 21 (Jan. 1932): 197–201.

Phillips, Stephen B. *Twentieth-Century Still-Life Painting from the Phillips Collection.* Washington, D.C.: The Phillips Collection, 1997.

Pilat, Oliver. "Art, Food and Freedom." *New York Post,* 6 Jan. 1945, 7.

Pilcher, Edith. *Up the Lake Road: The First Hundred Years of the Adirondack Mountain Reserve.* Keene Valley, N.Y.: The Centennial Committee for the Trustees of the Adirondack Mountain Reserve, 1987.

Plunz, Richard, ed. *Two Adirondack Hamlets in History: Keene and Keene Valley.* Fleischmanns, N.Y.: Purple Mountain Press, 1999.

Read, Helen Appleton. "In the Galleries: Harold Weston." *Brooklyn Daily Eagle,* 22 Nov. 1931, sec. E, 6.

A Retrospective Exhibition of Paintings by Harold Weston (1894–1972). Text by Jean C. Harris. South Hadley, Mass.: Mount Holyoke College, 1975.

Rosenfeld, Paul. "Harold Weston's Adventure." *The New Republic,* 31 Dec. 1930, 190–91.

Sayre, Ann. "Exhibitions." *International Studio* 97 (Dec. 1930): 96–106.

"Solid, Rugged Things Make Up Weston's World." *Art Digest,* 15 Mar. 1935, 23.

Terrie, Philip G. *Contested Terrain: A New History of Nature and People in the Adirondacks.* Blue Mountain Lake, N.Y.: The Adirondack Museum, 1997.

Testimony in the Claims of the Citizens in the Valley of the Ausable River for alleged damages to their property occasioned by the breaking away of the dam across the South Branch of the Ausable River, September 30, 1856. Albany, N.Y.: Weed, Parsons, and Co., 1858.

Tyrell, Henry. "A Roundabout Modernist." *New York World,* 12 Nov. 1922.

Wallace, E. R. *Descriptive Guide to the Adirondacks and Handbook of Travel,* 9th ed. Syracuse, N.Y.: privately published, 1881.

Watson, Jane. "Weston in One-Man Show at Phillips." *Washington Post,* 23 Apr. 1939, sec. 6, 6.

Webb, Nina H. *Footsteps through the Adirondacks: The Verplanck Colvin Story.* Utica, N.Y.: North Country Books, 1996.

Weiss, Ernest A. "Art in Rochester." *Rochester (N.Y.) Herald,* 25 Jan. 1925, 11.

Weston, Faith Borton. "Life in the Adirondacks." *Newsletter* (Federated Garden Clubs of New York State, Inc.) 22, nos. 7–8 (July–Aug. 1950): 9.

"Weston Gives Up Painting to Work On Aid for Allies." *Syracuse (N.Y.) Post-Standard,* 11 May 1941.

Weston, Harold. *Abridged Guide to Adirondack Trails: St. Huberts and Keene Valley Regions.* Keene Valley and St. Huberts, Essex County, N.Y.: Adirondack Trail Improvement Society, 1948. New ed., 1960.

———. *Freedom in the Wilds: A Saga of the Adirondacks.* St. Huberts, N.Y.: Adirondack Trail Improvement Society, 1971.

———. "Freedom in the Wilds: A Saga of the Adirondacks." *Adirondack Life* 3, no. 1 (Winter 1972): 32–35.

———. "Interlude in the Adirondacks." In *Paul Rosenfeld: Voyager in the Arts,* edited by Jerome Mellquist and Lucie Wiese, 182–85. New York: Creative Age Press, 1948.

———. "A Painter Speaks." *Magazine of Art* 32 (Jan. 1939): 16–21. Reprinted in *Painters and Sculptors of Modern America,* intro. Monroe Wheeler, 85–88. New York: Thomas Y. Crowell Company, 1942.

———. "Persian Caravan Sketches." *National Geographic Magazine,* 39, no. 4 (Apr. 1921): 417–68.

———. "A Visual Happening." *In The Adirondack Reader,* ed. and intro. by Paul Jamieson. Glens Falls, N.Y.: The Adirondack Mountain Club, 1982.

"Who's Who Abroad: Harold Weston." *Chicago Tribune,* Paris ed., 7 July 1926, 4.

Archival Sources

Harold Weston Manuscript Collection, George Arents Research Library, Syracuse Univ., Syracuse, N.Y.

Harold Weston Manuscript Collection, Harold Weston Foundation, West Chester, Pa.

Harold Weston Manuscript Collection, Library of Congress, Washington, D.C.

Harold Weston Papers, 1916–1972, Archives of American Art, Smithsonian Institution, Washington, D.C.

Harold Weston Papers, Harvard Univ. Archives, Cambridge, Mass.

James Buell Munn Papers, Harvard Univ. Archives, Cambridge, Mass.

About the Author and Editor

Perhaps because of his Adirondack training, **Harold Weston** was a trailblazer in a wide variety of activities, some on behalf of confreres in his profession and others of national or international scope and significance. Most were causes to which Weston dedicated himself over a period of years on a voluntary basis. Only three of these will be described in detail.

Weston's most important achievement outside of his art was his vision and unremitting work from 1942 through 1947 to promote international relief during and after World War II. Weston had witnessed famine in Persia in 1918 while he was attached to the British Army with the Young Men's Christian Association. Consequently, early in 1942 he suggested to the White House a huge United Nations relief effort to help secure the peace. Eleanor Roosevelt later stated, "[Weston], more than anyone else . . . was responsible for the original conception and carrying through of UNRRA [the United Nations Relief and Rehabilitation Administration]."[1]

Few people are aware of the scope of UNRRA, which during 1946 had more tonnage on the seas than the combined military, naval, and other forces of the United States any year during the war. Without UNRRA the Marshall Plan for Europe would not have been possible. Weston founded Food for Freedom, Inc., to develop citizen support in the United States for UNRRA. He was the executive director, and major labor, church, and civic organizations were represented on its board. Within two years Food for Freedom won the backing of more than ninety national organizations with a total of sixty million members. At crucial times Food for Freedom became their voice and by astute maneuvers doubled the amount of food sent overseas by the United States for relief from 1946 to 1949. Weston was personally responsible for the continuation of food rationing in the United States for the sake of relief supplies for three months after the surrender of Japan. (The Food for Freedom, Inc., papers can be found at the Library of Congress.)

Weston also played a prominent role in the creation and development of the International Association of Art (IAA), an affiliate of the United Nations Educational, Scientific and Cultural Organization (UNESCO). He served as IAA's vice president, president, and honorary president, and was a delegate at the triennial

congresses from 1954 to 1966 in Venice, Dubrovnik, Vienna, New York, and To-kyo. He organized its fourth congress in New York City in 1963 and edited *Art and Artists in the U.S.A.,* which was published in French and English for that event.

Weston was one of the major organizers of the National Council on Arts and Government (NCAG), serving as vice chairman from its inception in 1954 to 1960 and as chairman for the next ten years. The NCAG, consisting of some sixty out-standing representatives in all fields of the arts, deserves major credit for winning acceptance in the United States for the idea that government—federal, state, and municipal—has a degree of responsibility to sustain the arts and crafts. When the NCAG was first organized, advocacy of government subsidies for the arts was con-sidered almost subversive in many quarters. Now millions of dollars are appropri-ated annually for the arts, and every state has its arts council. Weston wrote key portions of the legislative act that established the National Foundation on the Arts and the Humanities, which passed in 1965. Over a period of sixteen years he took the lead in proposing policies, testified before Congress numerous times, and pre-sided over at least seventy meetings of the NCAG. During seven crucial years he wrote the NCAG *Annual Report,* which had a significant influence on members of Congress and civic leaders throughout the United States.

Other activities to which Weston devoted considerable time include:

As charter member and president (1953–57) of the Federation of Modern Paint-ers and Sculptors, he initiated and ran a museum gift plan that placed thirty-five examples of members' work in major museums.

He proposed to the American Federation of Arts an international museum gift plan, and to that end visited thirteen European countries as a consultant for the United States Information Services in 1957–58. This endeavor helped the Tate Gal-lery in London to establish a substantial collection of contemporary American art.

Weston took part in the United States Treasury Relief Art Project, executing twenty-two mural panels (820 square feet) for the General Services Administra-tion building in Washington, D.C., (1936–38), demonstrating that machines for modern construction could be used as exciting elements in mural design. During the construction of the United Nations headquarters he painted a series of six small-scale mural panels titled *Building the United Nations* (1949–52), now owned by the Smithsonian American Art Museum.

Weston has had fifty-six solo exhibitions, and he has been represented in over two hundred group exhibitions. Roughly four hundred of his oils, watercolors, and graphic works are owned by museums and public collections. He was listed in *Who's Who in America* from the mid-thirties and was included in the first edition (1971–72) of *Who's Who in the World.*

On account of Weston's humanitarian efforts and his professional accomplishments, in 1963 he was elected a Life Fellow of the World Academy of Art and Science.

Rebecca Foster was guest curator of the exhibition and coauthor and editor of the catalogue *Wild Exuberance: Harold Weston's Adirondack Art* (2005). She codirected the documentary film *Harold Weston: A Bigger Belief in Beauty*. She is the founder and president of the Society for the Preservation of American Modernists and the Five Elements Project. Harold Weston was her grandfather.

Index

Italic page or plate number denotes illustration.